THE ART OF

MISADVENTURE

MISADV

THE
ART
OF
ENTURE

Dave Brosha

RMB

For information on purchasing bulk quantities of this book, or to obtain media
excerpts or invite the author to speak at an event, please visit rmbooks.com and
select the "Contact" tab.

RMB | Rocky Mountain Books Ltd.
rmbooks.com
@rmbooks
facebook.com/rmbooks

Cataloguing data available from Library and Archives Canada
ISBN 9781771604635 (paperback)
ISBN 9781771604642 (electronic)

All photographs are by Dave Brosha unless otherwise noted.

Cover and interior design by Colin Parks
Cover photo by Paul Zizka

Printed and bound in Canada

We would like to also take this opportunity to acknowledge the traditional
territories upon which we live and work. In Calgary, Alberta, we acknowledge the
Niitsítapi (Blackfoot) and the people of the Treaty 7 region in Southern Alberta,
which includes the Siksika, the Piikuni, the Kainai, the Tsuut'ina, and the Stoney
Nakoda First Nations, including Chiniki, Bearpaw, and Wesley First Nations. The
City of Calgary is also home to Métis Nation of Alberta, Region III. In Victoria,
British Columbia, we acknowledge the traditional territories of the Lkwungen
(Esquimalt and Songhees), Malahat, Pacheedaht, Scia'new, T'Sou-ke, and
W̱SÁNEĆ (Pauquachin, Tsartlip, Tsawout, Tseycum) peoples.

We acknowledge the financial support of the Government of Canada through
the Canada Book Fund and the Canada Council for the Arts, and of the province
of British Columbia through the British Columbia Arts Council and the Book
Publishing Tax Credit.

To my children: Luke, Liam and Lily.
May you have many safe and wonderful misadventures.
I love you beyond.

To Amy. Home.

To all the people I have travelled, laughed and walked with.

Also, the following people have provided invaluable
fact-checking assistance, support and details, and have
helped me fill in the blanks on various recollections:

Martin Hartley
Robbie Craig
Erin Boyle
Sam Shannon
Aaron von Hagen
Eleanor Brosha
Paul Zizka
Stephen DesRoches
Therese Ludlow
Collette Kaizer
Natalie Gillis
Micheil Cameron Hill

The characters within are all real, even though some names
have been changed to protect the guilty.

Variations of these stories have previously been published
in *Photo Life*, *Up Here* and *Adventure Kayak* magazines.

CONTENTS

FOREWORD

by Curtis Jones

I'VE SPENT OVER A DOZEN YEARS TRAVELLING AND DOC-
umenting some of the world's most remote and beautiful
places. Collaborating with athletes, production teams and
local cultures and communities, I've built a career around
shared appreciation for adventure with others, but above
all, I consider myself a collector of interesting stories. Trust
me when I tell you, the collection you are about the read is
among the best.

A WARNING TAKE BY ME The events playing out in the
following chapters may surprise, baffle and even impress
you. Prepare for tales of dubious adventure, ambitious travel
and harrowing escapes, but beware. I caution you against the
charms, the wit, the swashbuckling romanticism. I'm here
to impart a generous serving of reality before these fables
can crawl into your brain and take purchase, morphing into
legend. Think of me as an ice-cold bucket of seawater with
all the salty fixings. Brash ice, kelp, jellyfish, right in the
kisser. As you turn these pages, inescapably becoming more
and more smitten with Dave and his exploits, I implore you
to refer to this foreword periodically, lest you risk becoming
a fan for life.

I remember the first time I ever heard of Dave Brosha. I
was standing in my friend's kitchen in Iqaluit, Nunavut. It
was one of those perfect arctic spring days. It was a Friday,

kicking off a four-day weekend. Folks were outside again after a long winter of hibernation. Dogs and children ran freely while neighbours indulged in long-form conversation, no longer bound by the frigid temperatures or the impermeable protective gear necessary to brave them. Things were lighter, the whole town seemed to collectively wear a smile. After a morning of skiing on the frozen bay, we were headed back into town to grab lunch. Somewhere between soup and sandwich, the conversation fell on photography. As I had recently started taking pictures somewhat seriously, I was very interested in this topic and felt I had much to contribute.

Over several years in the north, I had gained some small recognition as a photographer around town with a taste for adventure and limitless curiosity. (My reputation, in reality, was closer to man-child with a camera and questionable balance.) So, naturally, when asked if I followed another northern photographer making waves in the Arctic, to save face, I lied and said yes. I don't think I'm a petty guy, but when I heard the torrent of compliments, superlatives and audible gasps when Dave's work was described to those gathered around the table, it stirred something primal inside of me — I felt an instant distrust of this man, this arctic photographic legend. Dave Brosha — the name would haunt me all the way home. How could one guy have so much talent and the unwavering admiration of my closest circle of friends, yet I had never seen one of his images? Reaching my door 30 minutes later I realized two things. One: I had lost my house keys somewhere on the sea ice; and two: I needed to go full Batman and open an investigation on Mr. Brosha.

As it turned out, my investigation was short-lived — alas, the internet has ruined my antiquated fantasies about what vigilante detectives must go through to find answers. After a quick Google search, it was blatantly clear that I had seen Dave's work before, a lot of it. Not just seen, but perhaps had been ripping off. Much of it was sitting in a folder on my

desktop titled "Inspiration." Lesson learned: label and credit your screengrabs appropriately, kids.

Let's fast-forward a couple of years. I've been hired to assist/guide a team of filmmakers from Colorado into Auyuittuq National Park on Nunavut's Baffin Island. I'm living my best arctic life, running with the sled dogs, snow-kiting across ice caps and coming into my own as an adventure photographer. I'm the perfect unbearable storm of pluck, overconfidence and knowing so little I make the mistake of thinking I know everything. After a quick layover in Iqaluit, we were off to the beautiful northern town of Pangnirtung, to meet the rest of the team and finalize logistics. It was late on our second day of filming that we returned, exhausted and hungry, to our rented room in a local family's home. Walking into the dining room, I noticed that in addition to our hosts were three grubby-looking lads. They looked hungry like they'd been out in the thick of it. You know those images of expedition parties from the early 1900s, dishevelled and ravenous, as if they had been slapped incessantly by a polar bear and left in the sun for days? Well, a smidge sadder than that. I took a seat and nodded to the guy sitting across from me as he eyed the caribou stew like a convict.

"You guys have been in the park?"

"Just got back. We were pinned down in that windstorm that blew through. It was insane!"

"What brought you up?"

"Looking for a fun adventure with a couple of friends. We always wanted to hike this pass and it's been on my bucket list to photograph for years."

"You're a photographer? Me too! I'm Curtis."

"Nice to meet you, I'm Dave Brosha."

"Of course you are," I mumbled under my breath.

The truth was that I had become a big fan of Dave's work. He is a world-class photographer, undeniably one of the best we have, but I believe his greatest strength lies in his ability

to build community. I was honestly pleased and surprised to be sharing a fine northern meal with a guy I looked up to and had only just met. He cares deeply about others; it's one of the qualities that makes him such a fine storyteller. In many cultures, the role of the storyteller assumes numerous responsibilities. To educate, entertain, pass on knowledge and morality, but consistently the storyteller is also the heart of the social structure, its soul. Dave's stories inspire because he lives a life inspired — it's contagious. With this book, he has collected the spoils of this wonderful ability, revealing a vivid tapestry of moments, memories, people and place. A community of people just like me. People Dave has tapped, nudged, influenced and moved to action. To pursue a passion, take a chance, believe in themselves and live their own misadventures.

The following year Dave came to St. John's, Newfoundland, to hold back-to-back workshops. Two days of portrait education and two days of landscapes. The moment they went on sale I signed up. The weekend would be a turning point in my career. That's the thing about Dave, he makes an incredible impression and 100 per cent lives up to the hype.

It wasn't until several years later in PEI that I would get to hear Dave's account of our first meeting. It was the inaugural year of Land and See, a week-long photography conference designed by Dave and Erin, held in their backyard. Dave had invited me to present and teach; honoured, I accepted and made my way to PEI. Here, in Dave's barn, I watched as presenter after presenter was brought to the stage, where Mr. Brosha introduced each in succession with warmth, respect and admiration. Finally, it was my turn. Me, the witty rapscallion Dave had come to know and love. Nervous and already blushing a little in anticipation of the flattery that was about to rain over me, I stepped into the spotlight and shook Dave's hand. I was still holding Dave's hand when he looked me in the eye, just as he had over caribou stew years

before, and told the audience, "The first time I met Curtis Jones, I wasn't too impressed. I thought to myself, who is this pretentious hipster?"

Dave and I have worked together in Mongolia, Greenland, Antarctica and all over Canada. We've become close friends and colleagues. Shared many terrible airport meals and sunset campfires, and belly-laughed to tears. When you share adventure like this with another person you get to know them on a deeper level. Something about being on the road together, and the emotional roller coaster of remote travel; it either breaks or it binds. I feel fortunate that in our case it has been an experience in bonding. Dave has become one of my most trusted confidants, a mentor and an inspiration in the truest sense of the word. I am motivated to be better and to create better work because of his example. All that said, some things are better kept to oneself. Some facts, too personal, too revealing, to divulge. But still, life finds a way.

It was the summer of 2016. Rio was hosting the Olympics, people were walking off cliffs playing Pokémon Go, and Canada's own Tragically Hip were entering the final stretch of their farewell tour. Dave and Erin had brought the entire family to Newfoundland on a road trip. To see the island, take in the hospitality, landscapes and wildlife. The visit was planned to culminate in a three-day creative photography workshop in the lovely coastal town of St. Bride's. Dave had asked if I'd be interested in lending a hand with the workshop and spending a few days hanging with the Brosha clan. As a proud Newfoundlander and devoted friend, I eagerly accepted. After reaching the island's east coast, Dave and Erin had set up camp in a city park in St. John's. The night before we departed for the workshop, I joined them at the campsite to watch the Hip's final show and catch up. The evening, like many before, was one filled with story, laughter and witty banter. According to some in attendance (namely

myself and the Brosha children), I was a frigging delight I left the camper feeling a little light-headed, and very light-hearted. I proclaimed that come morning I would begin my duties as a proper local island guide. Secretly I vowed to never mix drinks in a camper with the Broshas again (a vow I'm proud to say I've broken countless times since). With hangovers hiding behind sunglasses, Dave and I hit the road bright and early the next morning. With coffee in hand, we drove through the colourful, twisting streets of the "City of Legends." Along the way, I pointed out interesting bits of geography, history and local culture.

"Oh! Check this out! This gazebo is where every Newfoundlander takes their oath to never leave home. Look over here, Dave, this is the pond where we keep the Royal Ducks, a fowl line that dates to the 17th century. And here is where our politicians sleep."

"Puns? Really, at this hour? And that's a pothole. Is there any truth to anything you say?"

"Don't be so cynical, Brosha, I'm full of truth. I just nudge the goal lines a little from time to time."

"Whoa! What the blazes was that? Did you see that? That just happened, right?"

"What are you going on about?" I asked, half-listening.

"The woman. The woman in a housecoat, jumping a hedge with a fistful of flowers and crazy hair!" Dave exclaimed.

"Oh that. That's my mom."

"That's your mom! It's not even 6:00 a.m."

"Yes, but it's never too early for high-stakes flower larceny, David."

"This explains so much." Dave sighed through a grin.

Remember that bit about some secrets revealing too much? In a laughable twist of fate, this exact moment had exposed in one instant more about who I was and why I was than years of globe-trotting buddy adventures ever could. My mother, the hedge-hopping flower bandit, had finally broken

the illusionary wall in the Dave–Curtis bromance. There was no turning back. Our friendship had been sealed by fate masquerading as my mother's latent insanity. Opportunistic and fearless, story came into being. A story to share, one we both love to retell every chance we get. Imposing it on those too polite to tell us to shut up, or in this case put a book down before finishing the foreword.

I grew up in a tiny town in rural Newfoundland and Labrador. Tree forts, snowmobile paths and swimming holes stretched out in every direction from the unfenced boundaries of our manicured lawns. As kids, we followed our parents into the wilderness, foraging for berries, tracking rabbits and cutting wood for the winter. I lived for these backyard adventures. Food tasted better, my brother was funnier, sleep came easier. Looking back, I can see that my parents were offering a part of their world, their adventure, to my brother and me. We were creating stories.

I've given this a lot of thought and I believe stories are the cornerstone of society. Shared experiences, for better or worse, are critical to the human condition — to witness and to be witnessed. What is better in this world than a true connection to a place or person? What better way to connect than with story? This book is a treasure trove of adventures missed, captured and earned. Between the humour, the lessons, the wonder and the close calls there is proof of a life lived. The life of a man who takes chances, dreams big and then works to turn dreams into cherished memories — into stories.

AN INTRODUCTION

My mom always said life was
like a box of chocolates. You never
know what you're gonna get.

— FORREST GUMP

HI, I'M DAVE. I MIGHT EVEN BE ONE OF THE DAVES YOU KNOW. As a man named Dave, I've had many misadventures. You might even say I've been artful in them — although we all know that art is in the eye of the beholder. You don't need to be named Dave to have misadventures, of course; it just so happens that I am. You might be named Devon, Emma, Tyree, Ali, Alejandro, Tabitha or Samantha, and that's okay. You're quite allowed to have misadventures too. Chances are you've had a few in your time, and someone, somewhere, would love to hear them. I'd love to hear them too, if we ever have the chance to share a pint or a stroll in a park. Stories are the thread that have kept us all together, in community, over the course of history, from sitting around the fire to sitting around the hookah to sitting around the radio, to sitting in front of the fireplace, with friends, at the local pub. To share stories — to share a lived experience — is to be human.

To Devon, Emma, Tyree, Ali, Alejandro, Tabitha and Samantha — and everyone else reading this, even if there's another Dave or two — I'm going to take you on a bit of a

journey, Through time, through a life and through a hodge-podge of happenings.

Now, it should be stated that this is not intended as a biography, even though it will deal with stories — real stories — from a life. *My* life, to state the obvious. Rather, this is a non-sequential reordering of disjointed chapters. It's a recounting of various puzzle pieces — pieces that make up a life, lived. It happens to deal with my life, and therefore some of the events in my life — but it's really about the very notion of *experience*. Many books speak to the triumph of the human spirit and celebrate successes, or adversity overcome. This tome is a little different; it is an offering that dives into some of the things that went *wrong*, rather than right. It takes a certain flair — a certain eloquence of soul — to have a good misadventure. It's one of the few things I'm eloquent at, to be honest.

Even the ineloquent have misadventures, though. We all do. It just takes some courage to be able to recount them — to be able to poke a little fun at oneself, and to look at where you may have failed. To be able to look back, and *share forward*. That's what I'm going to do here. I'm going to share those stories, those snippets and those pieces that have collectively formed a larger life, lived. I'm going to present to you an exhibition of misadventures.

* * * * * *

Now, for one to have had a *mis*adventure, you would *think*, logically, a person must have had a lot of *adventures*. In order to have many adventures, one would also suppose, a person would be somewhat of an adventurer. If you've followed this logic so far, the next presupposition might be that if one were an adventurer, they would look, feel and seem adventur-ous. Envisioning an adventurer is easy: try it! What do you

picture? Rippled, sinewy muscles? A flowing mane of shiny hair? People in bright North Face or Patagonia apparel? At the very least, a long beard or braided hair that would cake epically with frost in the winter and would blow dramatically to the sides while evading dust storms in Mongolia. No beard or braids? Maybe the true mark of the adventurous is in a person's eyes — windows to a deeply adventurous soul. Steely, deep eyes that may have seen the greatest beauty the world has to offer, and eyes that have surmounted some of its greatest challenges. Eyes that haunt you. Eyes that melt you. Eyes that scream, *You will find me intriguing. Or else.*

Sorry to disappoint, but I am decidedly average looking.

Over the course of my life (so far), I've gone from having a head full of luscious hair to dealing with the constant, shiny glare of light bouncing off my mainly clear scalp. This phenomenon intensifies by the year. My waist is always a little softer than I might want, and when I push my finger into it, that finger sometimes disappears. There's more squish than thud around those parts. I am not tall, but I also wouldn't consider myself short. My eyes are deep brown. "Shit brown," as my mom used to say. I have a humble home in rural Prince Edward Island, and I have three extraordinary children. Every parent is supposed to say *that*, though, so I suppose even *that* is ordinary — even if it's true. Even though my mother calls my eyes shit brown, I think she still considers me extraordinary.

Despite Mom's opinion, I have my own. I have always thought that I have lived a life that is, to me, rather *ordinary*.

At least I have always felt it was, on the surface. I've just put one foot in front of the other, day after day, year after year, and just *lived*. It's what we do, right? And if you're like me, you may think your life has been, on the whole, pretty *boring*. Well, okay, boring is a bit of a harsh word. Maybe my life, or yours, hasn't been quote/unquote "boring," but perhaps a little *understated*? A little benign? A continuous

succession of days, followed by more days, where all the usual things just happen daily: wake, coffee, shower, work, interact with people, errands, traffic, remember to pay the endless bills, relax, eat, family activities, a little TV, an evening wine, read, nod off. Repeat.

Some days, of course, deviate from this cycle. Not all days are linear, and some days a hike happens while on other days you find yourself making a trip to Costco for toilet paper. Some days a friend pops in for a visit, and on other days you're heading to the doctor to see about an ingrown toenail. Sometimes you hear of something tragic, and on other days you're jumping like a maniac as Joe Carter has just hit the World Series-winning homerun; your popcorn flies into the air on those days. Sometimes Mondays happen and other times — thankfully — Saturdays happen. Some days you love, other days you lust, and a lot of days you just feel, well, *tired*.

The hope, however, is that when the evening light fades and your body tells you it's time to lie down and close your eyes and try your best for a good night's sleep...that you go to bed, at minimum, *happy*. You hope that the day that passed — even if the day was all-too-similar to so many days prior — was at least, on measure, more good than bad. You also hope that the day that follows will bring a 24-hour succession of hours that's pleasant — even if it, too, is just as unremarkable as the day that just passed.

Unremarkable.

At the time these words are hitting paper, I'm 43 years old. This means I've lived the better part of 16,000 days — or approximately 375,000 hours. And counting. That's the simplest of measures of my life. Most of those days have been solidly *boring*, but thankfully — overall — happy. That, I'm happy to report. Life has ticked on for 43 years, and within those years have been countless hours of *unremarkable*. That's not to say I've had a terrible existence. Within those

hours are also countless laughs and smiles and conversations with friends and loved ones, cups of coffee, work projects completed, games of catch with the kiddies, walks through the park, elegant, impossible sunrises, and drives with no real destination. I live for all of that. I will continue to live for that. In fact, I can't wait to do more of that.

Yes, within the unremarkable are many days of feeling reasonably accomplished, or creative, or simply *satisfied*. Today, for example, I woke up at 5:00 a.m. to the sound of birds chirping. I slid into the bathtub to soak a sore back and slowly came to life. I made a steaming cup of coffee (and I'll probably make a couple more before this day is done). I cursed some fruit flies that were hovering near my bananas. I wrote 1,000 words. I paid my Visa bill, and I cringed. I answered a few emails. Later, after writing, I'll head to the post office, and then I'll pack up the kids and drive from Prince Edward Island to Nova Scotia to go visit Grandma. It's summer and we're just coming out of pandemic border restrictions; seeing family and loved ones feels paramount, and pressing. That'll be my day, today. Simple. Unremarkable. Solid. A day *well spent*.

These types of days happen a lot in a life. They're the baseline of my own life experience, and that's all I can recount. My life living in Prince Edward Island, Canada, is going to be remarkably different from that of a goat herder in rural Egypt, of course. We have dramatically different lives, to be sure. I'm sure, though, the goat herder has many satisfyingly boring days too, and has good days and bad days and all the days in between.

Not everyone will have an endless succession of simple, satisfying days. Some people — no, many people — struggle, day after day. For health. For safety. To put food on their table for their family. To escape violence. Although not every day in my life has been easy — I've faced my own share of adversity — I can say unequivocally that adversity is not my *usual*. Real

21

hardship is not my existence, or my overall life experience to date. I recognize my privilege. I'm simply recounting my story. Or stories. Because we all have them. You have them too. As the years have progressed and the step count has grown impressively, every now and then I get reflective. Experiences and memories emerge from the depths through that backwards gaze. Oh Dave, buddy, remember *that* time? (I talk to myself, at times.) Oh, man, and remember that *other thing that happened*? *That was really wild!* And, wow...I guess *this* happened too! Stack these occurrences, these happenstances, these fragments of converging people and places and time together and, well, I guess life really *hasn't* been that ordinary. But isn't that just it? Aren't we *all* rather not-so-ordinary when we really think about it? And isn't that what makes this life extraordinary? Isn't that the beauty of this all?

* * * * * *

Now, let's step back a moment.

This is a book about misadventures. I mean, it says so right in the title.

But what is a *misadventure*? Why did I choose to write about misadventures? And why should you care? I'll try to answer these questions, of course, but before I do, let us first look at what an *adventure* is.

I grew up loving a good adventure story. My earliest foray into the world of adventure was through classic books like *The Swiss Family Robinson* and *The Hardy Boys* and *Treasure Island* and *Lord of the Flies*. As a lad, I was fascinated by the idea of a person, or a group of people, overcoming obstacles. I dreamed, at night, of being shipwrecked and having to make do on a deserted island with whatever meagre possessions I could scrounge. I had romantic notions of building elaborate

treehouses in the South Pacific, hunting and fishing my meals, dodging cannibals and licking fresh morning dew off jungle leaves. I had an incredible imagination and, as all 8-year-olds should be, I was naive and a hopeless dreamer. I wanted a spear for fishing and materials for booby traps against intruders and a life spent sitting by the campfire telling stories — with perhaps a hammock to sleep in at night. Just please, God, don't let there be bugs while I sleep. Or snakes. Oh, and if the nearby fire could also keep itself burning through the night, much appreciated.

Eventually, I graduated from stories about deserted islands to reading about real-life adventures from real-life adventurers. I read of mountain climbers, Antarctic explorers and desert crossers. The words and works of people like Jon Krakauer and Joe Simpson and Cheryl Strayed and Ed Viesturs. These were *real* people doing extraordinary things and encountering staggering difficulty in impossible places. Their tales told of overcoming the odds (most of the time), or of friends and acquaintances perishing in the most memorable of ways. Their stories showed determination, heart and gumption. Their tales *inspired*.

I have always loved a good adventure story, even though I know they're not for everyone. Some people consider that very concept, self-induced *adventure*, to be a meaningless pursuit in a world where so many struggle. I can't say I completely disagree. Is it selfish to go down the path of adventure? *Perhaps*. Is it a waste of time, energy and even life, at times, for someone to dedicate themselves to a seemingly pointless goal when they could be putting that same energy to something practical — like planting tomatoes, helping the poor or picking up litter? *Maybe*. I like to believe, though, that a person can both seek out adventure and still have something "left in the bucket" for *other things*. I'll go out on a limb here and say that when one meets a calling — when one pursues what they're inspired

or driven to do — it can actually fuel one's soul and in the process *fill a person's bucket* even fuller so that they have more, and not less, energy and desire to put into all the less adventurous pursuits in life. Like cooking their child's favourite meal. Or bending down to pick up that trash on the trail for the betterment of all.

I, personally, have never had a death wish or a need to go out "spectacularly." I will turn back from the edge of a cliff, both literally and figuratively, if something doesn't look or feel right. I don't mind, however, a sprinkling of carefully calculated risk in my life. I've always had a strong appreciation for anyone willing to experience this big, beautiful world around us rather than hide from it, or let it pass by. I've always had an appreciation for those who choose to *be*.

When we envision *adventurers*, we picture people who excel at *being*. Fit, determined, athletic, intense, weather-hardened men and women who can dig deep, go the extra mile, push on and complete impossible feats of stamina in the name of exploration, or pushing themselves to their absolute maximum (and beyond), or doing something that simply has never been done before. Although I am not an adventurer, I have so much respect for these types of humans, because I believe that we, the *rest of us*, must have the capacity to be inspired and to dream. Sometimes we need to look upon the successes — or even the failures — of others to nudge us along our own path. To help us believe that anything can be done — that anything is possible. Give me the stories of greater, and not fewer, adventurers. The world needs them — now, more than ever.

* * * * * *

Now that we've looked at adventures and adventurers, let's look at the **other side**.

Isn't any adventure (heading off into the unknown, over-coming obstacles as they arise), by definition, also a bit of a misadventure? It's at the sharp edge of shit going wrong, after all, where stories really take root and capture the imagination; if something was too easy, it wouldn't grab our collective attention in quite the same manner. If something was too easy, would we even pursue it? Would we recount the story, after, with the same *gusto*? We humans like to push ourselves, and take risks along the way; we take risks because there's something to be gained on the "other side" of that very real chance of failure — it makes this journey through the days, weeks, months and years memorable. Sometimes taking the risk results in an overwhelming success; other times it results in the downside of risk being realized.

A misadventure, at its heart, is what happens when you set out, confidently, in one direction and life says, "No way, hold up, *not so fast.*" Life has other plans for you: one well-worn road might get washed out, the next road is peppered with potholes and the road after that has endless, bumper-to-bumper traffic. Misadventures don't always result in a textbook success story. The road less travelled sometimes *hurts*.

Still, just as not every adventure is epic, not every mis-adventure is a life-or-death experience. Some are, of course, but many of the "misadventures" you'll find within these pages are just little snippets of weird, of impossible or of the life absurd. These are the moments in an existence that sometimes make you shake your head in bewilderment: *Did that really just happen? How did I find myself here?* I could be anywhere, right now, and yet I chose a succession of events that led me to this unfortunate spot, right now. Somehow I keep *doing it*.

* * * * * *

So why should *you* pay any attention to this book, or the words contained within? Chances are you don't know me, haven't heard of me and won't know me, personally, in the course of your life. I think I'm pleasant enough, however. If you ever want to get to know me, come to Prince Edward Island and I'll share a pint with you. Why should you invest your time and energy in reading about the misadventures of a stranger? Give me a little rope, is all I ask. Give me a little leeway and I'll try to hook you in. If you do, I hope you will cringe a little, smile a little bit more, but maybe — just maybe — you'll end this book with an appreciation for the fact that everyone's got a life story, and maybe you'll see a little of your own in mine. Maybe you've got a more interesting story than you've ever given yourself credit for. Chances are, you do.

My story, in a nutshell: I was born in northern Canada to a Grade 5 schoolteacher and a housewife-turned-small business owner — Louis and Eleanor. I went to school, and then went to more school. I have five brothers and sisters, four of them still living. My mother is living, my father is not. In my life I have been, in order, a video store clerk, a traffic control person, a Tim Horton's server, a convenience store clerk, a deejay, an ESL teacher, a quality assurance manager for a pipeline insulation company, a web developer/marketer, a hot dog stand owner, a sealift off-loader, a grocery store clerk, a hotel manager, an assistant operator at a power plant, a polar logistics assistant, a telephone technician, an internet help desk technician, a manager of process, policy, implementation and support (winner of the longest job title), a manager of a call centre, a marketing product development manager, a photographer, studio owner, freelance writer and an international travel and photography education company owner. I am a father to three beautiful children — they are my life. I play guitar, I love hiking and I mentor people. I am fiercely loyal

and I like being outdoors. I look for the good in everyone, sometimes to a fault. I am excellent at multitasking. I am an extremely hard worker — but I love down time even more. I love cooking, Radiohead and Ricky Gervais television series. I make a mean rack of lamb, and I administer way too many groups on Facebook. I have been married to a great person, Erin, and together we've created three beautiful children together. You will see her name throughout this book. Eventually, Erin and I parted romantic ways — but we have maintained a beautiful friendship. I am thankful for that. I have since found love again, and I am also so grateful for that.

I don't climb mountains (well, okay, once or twice). I don't run marathons. I can't swim with my head underwater for more than a few seconds. I have never had abs, and let's be honest: I likely never will. I'm the opposite of a grizzled, lean adventurer — I'm always looking to lose ten pounds, and if I lose them, I always seem to find them again. I've never crossed the Greenland ice cap and I've never paddled the Nahanni. I've never had to fight off bandits in the middle of the night, and I've never had to escape from being kidnapped (although I know someone who has).

An adventurer, I am not. Still, I have a tendency to get in misadventures of both the inconsequential and epic varieties.

* * * * * *

I'll get to the misadventures soon enough, but one final note before I do.

What you're about to read is true. Everything I wrote in this book happened. In retrospect, however, it does sound a little crazy, but, quite frankly — *you can't make this shit up.*

The experiences happened, to the absolute best of my memory (and checked against the memories of people who

were there); it's the exact words and conversations I'm taking a few liberties with. Do I know exactly what I said when I was 6 years old? No, and I doubt you do either. I'd be lucky to remember, without checking, what colour underwear I'm wearing as I type this. Bottom line, I have no clue exactly what my mother said after I ran away, or what Chris O'Neill said to me after I sucker-punched him, or the exact progression of words in my brain when I found myself face to face with three polar bears. I *think* I can imagine what those words were with a high degree of accuracy, but I'm going to take a few leaps here and there. The words may not be verbatim, but the spirit of the conversations, thoughts and interactions I'll stand behind, completely. In the case of the polar bears, there might have been a cascade of not-so-safe-for-work language that would make your mother cringe. You'll have to excuse me when my language in this book is a little "colourful" here and there. It reflects reality.

This is not a how-to guide, a proclamation of the virtues of being misguided or an extolment. I'm not advocating for anything in particular, even as I share many specific words. These are simply misadventures, both in the world of outdoor adventure...and in everyday life. This is a collection of stories, recounting — simply — *what was*. Why? Because shared stories are found treasures — and we could all use a little more wealth. I hope you share your own treasures, someday.

1

FLEEING THE FORT

My mom said I was a handful.
Now I'm helpful.

—JAMIE LEE CURTIS

EVEN FROM THE YOUNG, NAIVE AGE OF 8, I SHOULD have realized that perhaps I was destined for a life of misadventure...or, at the very least, a life of misguided adventure. There was that moment, for starters, when I found myself in the middle of an uninhabited island, by myself, in –25°C, with nothing more than a knitted blanket and two chocolate chip cookies. That should have set off some sort of alarm bells. It should have been a dead giveaway. It should have been a sign of things to come.

In fairness, though, I was 8 years old. With apologies to all the intelligent 8-year-olds out there, reading this, I can't say I was in your league at the time. My life at that time revolved more around Nintendo, the Edmonton Oilers and sneaking a flashlight under my covers at night to be able to read past my bedtime than worrying and dreaming of what my next 35 years would look like. Or worrying about simple practicalities like safety, rational thinking or how to avoid freezing to death.

Back to the deserted Island. How does that even happen? I mean, Jesus…I was 8.

It was a Saturday, and I was doing what most northern kids do on a Saturday in Fort Vermilion, Alberta, in the middle of winter: just sitting joyous with the appreciation of the fact that it wasn't a school day. Weekends ruled my world: pyjamas until noon, not one but two bowls of cereal (the sugary kind!), non-stop cartoons followed by Hulk Hogan and Rowdy Roddy Piper doing their thing in the wrestling world, outdoor explorations when my mother finally had enough of me and my five siblings (*I just want some peace and quiet! Outside, all of you!*), and a *Hockey Night in Canada* game on the CBC sometime in the evening.

I don't remember precisely what triggered it, but on this particular day, sometime around late afternoon, I'd had enough. Since they'll all read this someday I won't blame it on any particular sibling (I'm looking at you, Brother Kevin), or my parents. I was always a chill child to the point of being semi-comatose, and not one to generally get worked up over anything. Something was said to me on this chilly winter day that I didn't agree with, and I just figured the time had come to split from our split-level. Leave. *Run away.*

All of you will be sorry when I'm gone.

Serious business for a guy who had spent the morning eating Cinnamon Toast Crunch and playing Super Mario Bros. I'd like to believe, now, that I was taking some sort of principled stand. The reality was someone probably found milk spilled all over the fridge and blamed it on me.

Mad, I had decided that I could live life on my own. A life of adventure. On an island. In winter. *I'll show them!* I went to my room and quickly filled my backpack with a brightly coloured blanket Mom had knitted a couple of years earlier, a couple of cookies and some matches. Mom, if you're reading, you shouldn't leave matches out for kids to pack when they run away to deserted islands: that's dangerous and irresponsible.

30

Next, I snuck down the downstairs hallway and found my winter jacket and toque and slid on my boots. Mom and Dad were upstairs in the kitchen, visiting and conversing with company who had dropped by. I could hear the roar of laughter floating down the stairs. Of course, they wouldn't notice if I quietly left by the back door. They wouldn't notice me gone at all.

Click!

That was that. I could see my frozen breath in the air as I looked out in the direction I knew I needed to go. It was a cold one, sure, but it could get a lot colder. It wasn't a 40-below day. A *damn cold* day, as Dad liked to call them. This was just a cold day. It hadn't yet worked its way to *damn* status.

The life and soul of "The Fort," the affectionate name for our tiny little town of 850 souls in the far north of Alberta, was the mighty Peace River. The Peace flowed over 1900 km from northern British Columbia down through Fort Vermilion and other parts of vast Alberta, where it would eventually join the Athabasca River before turning into the Slave River. As it passed through Fort Vermilion it was a seemingly endless mass of muddy brown water in the summer months; in the winter the crisp cold would turn this impossible body of water into a frozen wasteland. When you looked out across the Peace in pretty much the dead centre of town, you saw a large, uninhabited island that probably ran about a kilometre long and a half-kilometre wide. *The promised land*, I thought.

According to my Swiss Family Robinson mental checklist, the Peace was devoid of people, and had trees for fuel and shelter, and lots of snow for melting into water. Also, I wouldn't be easily found there, which would sort of defeat the purpose of running away. As a bonus, if I really needed a bag of chips or a chocolate bar, the gas station was just back across the river. I mean, if I had money. I didn't.

After I walked the 15 minutes down gravelled roads from my parent's house to my destined launch point along the

frozen banks of the river, I slid down the icy rocks lining the shore and found myself standing on the snow-covered Mighty Peace. I really had no clue if it was thick enough to hold me — and upon retrospect it probably would have been wise to have some certainty about that — but I had bigger fish to fry: I had to get across this river to the island before they discovered I was missing. Maybe I would even find fish to fry. Well, if I had an ice auger, some fishing line and a hook.

My short, stubby Grade 3 legs could only carry me so fast postholing across the deep snow, and I stopped often to catch my breath. I looked back over my shoulder to see if anyone was following me — if anyone was pleading with me to go back. *Dave, please come back. We miss you. We're sorry.* No one was there. Just a series of footsteps, my own, vanishing into the void. *Good, I don't need them.* I adjusted my toque, which was lined with frozen sweat, and carried on.

Within a half-hour or so, I found myself standing on the shores of the island. *Success!* I smiled, proud of myself for being, well, epic. I, young Dave Brosha, was an adventurer! And I had successfully run away — I didn't know anyone else in my grade who had done that. If I decided to return to school, I was pretty sure I would be considered cool.

I couldn't self-congratulate myself for long, though. I had a fort to build, a fire to spark and cookies to eat. I took stock of my immediate surroundings and saw that my deserted island inventory wasn't quite a tropical treasure island: I saw trees...and snow. Lots of snow, actually, and many, many trees. There definitely wasn't a Nintendo, and the endless supply of partridges and rabbits that I planned on hunting (maybe by trapping them in my backpack?) hadn't gotten the memo that I was coming. *Whatever.* Food would be a problem I would solve later. For now, I had a fire to build. Rome wasn't built in a day.

I collected a bunch of small sticks and dead leaves — per my Boy Scout training — and was really feeling quite proud

of myself as I munched on my cookies. I had only brought two, and after the first I continued on to the second. They were delicious. Mom made a mean cookie. If the Robinsons could survive on their island with coconuts, surely I would find something else. This is what I'd trained for, after all, through countless Cub Scout meetings. Food would be a problem I would solve later, though. After my fire, of course. I rummaged in my bag and dug out the match box and with icy, numb fingers, attempted to slide it open. The matches flew everywhere, embedding in different positions in the snow. Sighing, I retrieved a few of them. They were all soaked. My heart sank as I tried to strike each, unsuccessfully. As Jeff Probst would wisely say in later years on *Survivor*, "Fire represents life. Once your fire is gone, so are you."

This whole running away thing sucks, I decided. *Surviving isn't all that easy. I wonder what Mom has on for dinner?*

I set back across the river in the grey flatness of late afternoon, cloud-covered light, retracing my steps. It was easier on the return, with my postholes clearly established. I could occasionally see cars and trucks flash by atop the riverbank; the main drag was just over its lip. *I wonder if they can see me? I'll bet you they're impressed.*

I scrambled up the riverbank, dusted some of the snow off me and started off down the road. I saw our split-level atop the hill and smiled at the warm light emerging from the windows. I quietly let myself in the back door. Any worries about my mother greeting me with frantic tears quickly went out the window when I heard the same laughter coming from up in the kitchen as when I left: more company had dropped in, and no one had even noticed I was gone. I shrugged, took off my winter clothes and joined them. There were more cookies on the table, and I quickly devoured one.

"Where were you? Playing Nintendo? We thought you would have smelled the food and joined us a while ago."

"Me? I ran away but decided to come back."

"You ran away? Oh, okay. Well, have another cookie. Did you tidy your room as asked?"

* * * * * *

POSTSCRIPT A couple of days later I was driving along the main riverfront road to the store with my mother (she would have me run in and buy her cigarettes at the gas station; don't judge — it was the '80s) when I could see her squinting across the river toward the island as she drove. "That looks like a blanket out there on the ice, doesn't it?...Isn't that odd? Who would be insane enough to cross the river in winter? There's nothing on that island to go to."

I agree, Mom. That's crazy talk.

2

THE POOR
LITTLE BOY WITH
THE BROKEN LEGS

It's all that the young can do for the old,
to shock them and keep them up to date.

—GEORGE BERNARD SHAW

THE DAY I BOUGHT MY NEW-TO-ME USED LIGHT BLUE
Honda Civic was one of the proudest moments of my life. I
was, as of yet, still young, but at 16 I felt I knew pretty much
all there was to know about the world around me: be nice,
work hard, save your money, be good to your friends and
family and stay out of trouble. Have some fun along the way.

I had worked hard (open to debate, I'm sure) at my par-
ent's store, Brosha's Short Stoppe — a convenience store
literally metres from the busy Trans-Canada Highway that
passed through the Antigonish area of Nova Scotia and made
its way toward beautiful Cape Breton. The store sold the
usual convenience store fare: a nice mix of food staples like
bread, milk and eggs, and convenience items like chocolate
bars, candy, processed sandwiches, cigarettes, fireworks,
ice cream, lottery tickets and (mainly old) coffee, served in

terrible Styrofoam cups. The Short Stoppe was a huge part of my life growing up, and being behind the counter or wandering its narrow aisles, or picking out a new movie off its shelves to watch after an evening shift was, well, *everything* to me. Our regular customers became family in many ways, and our store was a popular stopping spot for all manner of personalities and characters. Business professionals on their way to or from work. Drunks. Blue-collars. The Acadians from Pomquet. The truck drivers. The folks from the trailer park up the road. The masses of tourists in the summer months. The elderly, cashing in their scratch lottery tickets. My own teenage friends often stopped by, and I would always give them an extra scoop when they bought an ice cream (sorry, Mom!)

Through all this hard work, and grabbing as many shifts as my mom and dad would give me without being reported for child labour, I was able to scrape together enough money to buy my teenage dream: a $4,500 shiny piece of sporty perfection off a guy named Wade. My parents looked upon the purchase with a healthy mix of happiness, relief and fear: months earlier, I had smashed up their Ford Ranger truck while driving with my girlfriend on a sunny Sunday. Maybe I was enamoured by her smile, or maybe the sun got in my eyes. I couldn't really say. All I knew is that I took a turn a little too wide, the elderly woman coming the other way took the turn a little too tight, we clipped corners, and my wheel flew by my driver's side window. I ended up in one ditch, she ended up in the other, and when I went to see how she was doing she just blinked at me, wide-eyed, and said, "What just happened?" Oh, lady, I wish I knew. *I'm sorry.*

Since I was young the RCMP decided I was at fault. (Looking back, I probably was.) I got a ticket for "driving over the centre lane," or however they worded it, and my parents watched as their beloved truck disappeared into the body shop for weeks and weeks. They were down a vehicle,

and the only option for driving was to borrow their second vehicle: a wood-panelled station wagon straight out of a National Lampoon movie. The epitome of teenage cool it wasn't. But at least it drove to a destination, and that's all I needed. Freedom. When your Grade 10 girlfriend lived about 30 minutes away down the Cape road, that freedom was a life necessity.

As much as I appreciated having access to the station wagon, I knew I needed my own solution. The next month or two was a whirlwind of work hard, save, beg, borrow, plead, cash in savings bonds and somehow come up with an envelope of cash for Wade, who took it, threw me the keys to my new Honda Civic and disappeared as quickly as he could.

My God, I loved this car. It had a tape deck that boomed out my many mix tapes (a combination of Spin Doctors, Nirvana, Pearl Jam and even Ace of Base — with apologies to my future music snobbery) and a nice low profile that hugged the road. It was a stick shift with a baby blue interior that I shined up with Armor All about twice a day. God help the person who tried to leave a fast food wrapper or drop a french fry in this thing of beauty. After a couple of months of owning my Civic, it had become part of my identity. "Where's Dave?" "Oh, he's outside polishing his tires...again." "*Of course he is...*" My work plan had shifted from trying to save up for a vehicle to working for gas money. Something I needed a lot of. The open road was heaven, and that stick shift in my right hand was the stairway to it.

That all changed on a fateful hot, muggy evening sometime in the earliest days of summer vacation. I was still dating Collette, the same girlfriend from my earlier crash with the truck. Our dates and time together often meant a mix of either just driving around the streets of Antigonish and going for pizza at The Wheel, hanging out around the beaches and pathways of her beautiful little seaside community of Cape George or going to meet our collective

circle of friends for laughs or boozy shenanigans. My circle wasn't into drinking and driving, thankfully, but that didn't mean there weren't all ends of other craziness that happened both in and out of vehicles on the back roads of Antigonish county, at house parties, on the beaches or around the town itself. I remember laughing a lot. It was everything 16 should be, until it wasn't.

One evening Collette and I snagged an invitation to head to her cousin's house for a musical gathering, a *ceilidh*: fiddles and dancing and down-home Nova Scotia fun. Although many of us teenagers in Antigonish (and many parts of the Maritimes, for that matter) kept up with the popular music scene on MuchMusic and what was happening in the Seattle grunge scene, like many generations of East Coasters before, our hearts and souls often yearned for traditional music. The fiddles and pianos and bagpipes of our many settler Irish, Scottish and French ancestors. Celtic and Acadian music — it wasn't just something for "old people." Especially in nearby Cape Breton, which to this day has one of the healthiest traditional music scenes in the world. Cape Breton lives and breathes traditional music, and it was just a stone's throw across the causeway from us. When an invitation came in for a chance to see some talented fiddlers in action, to go to a ceilidh — on either side of the causeway — well, it was an opportunity that was hopped upon.

The day of the ceilidh I was working an afternoon-to-evening shift: 3:00 p.m. until 8:00 p.m., and one of my co-workers, Therese, was to close the store at 11:00 p.m. As luck would have it, it was one of the dreaded "lotto nights" — one of the twice-weekly nights that the Lotto 6/49 winning numbers would be selected. Usually lotto nights meant for busier-than-usual evenings at the store, but this particular evening the jackpot was exceptionally high and, well, as the cool kids say, people *be crazy*. As the clock ticked closer to 8:00 p.m., I was eyeing up at it anxiously as I knew that I had

a half-hour drive to go pick up Collette, and another half-hour drive from her house back toward the gathering, and if I didn't get out the door at 8:00 p.m. it was going to make for a pretty late arrival — I felt a sense of dread as I knew getting out of there was going to be impossible.

Well, 8:00 p.m. came and went and the lineups for lottery tickets just seemed non-stop. *Jesus, people. Calm down. You had all week to buy these tickets.* Collette was expecting me around 8:30; it wasn't until 8:20 that I finally had a chance to break away from the lotto machine and sneak a quick call.

"Collette, I'm going to be late. I'm really sorry."

"Oh."

Close to 9:00 p.m., the madness finally died and I was pretty confident I could leave Therese alone without her wanting to murder me the next day. I quickly ran out of the store, avoiding eye contact with Therese, and contemplated a Dukes of Hazzard–style slide across the front of my hood. Thankfully, I remembered I had the elegance and grace of a one-legged emu. I fumbled with my keys and got in the Civic the normal way, and squealed out of the parking lot.

Driving out to Cape George was always an adventure. The first third of the journey from my place was essentially good highway, the Trans-Canada, and reasonably straight-ish roads. The second two-thirds, basically from Hospital Corner onward, became a hilly, curvy, turny, narrow mix of blind crests and tree-lined coastal road that felt, to a thrill-seeking 16-year-old, like Mario Andretti's dream race-track. Except on Sunday afternoons, when every old driver in the county seemed to flock en masse to the Cape Road for a dreaded Sunday Drive, in which they proceeded to drive 30 km/h below the speed limit and test early-onset road rage in anyone younger than 60. I digress.

I had driven this road so many times that I knew every turn, heave, side road, pothole and nighttime roadside pee break paradise like nobody's business. I knew when to

upshift, when to downshift, when to slow down because an upcoming bump was likely to shake my muffler loose and what intersections over a blind crest where there might be a tractor turning off. My foot would hover over the brake pedal in these spots. I even knew where most of the deer hazards were. At least I *thought* I knew this road like the back of my hand: truthfully, though, I had only been driving it for four or five months, and my nighttime driving skills were pretty basic. And let's be honest: Who has really studied the back of their hand in any detail anyway? Such a stupid saying.

I'll come clean here. Because over 25 years have now passed and it's time to just put it out there (and I'm pretty sure I'm over the statute of limitations). I was driving fast. Like, way, *way* too fast. Like "what were you thinking, you idiot" fast. Much of the road had a posted 80 km/h speed limit, but truthfully in many parts of the Cape Road, 60 km/h would be much more appropriate. But teenage bravado, a girlfriend who was a little upset that I was so late and breaking my promised pickup time and a sense of foolish invincibility fuelled my evening thoughts and actions. I found myself driving closer to 110 km/h down this dark and twisty road. It was really a matter of time.

Time caught up in the worst possible way.

I approached a series of turns I had driven a hundred times before, but this evening as I went around one small turn, down one dip and started up a hill into another turn, right at the top of hill — a blind crest — I was immediately and blindingly met by another set of headlights coming my way. They had their high beams on, as they should have. I came out of nowhere fast, and they didn't have time to flick them down. Driving so fast, I had little time to react. I was blinded. My only reaction was to pull my steering wheel right, away from the centre lane, and give some breathing room (so I thought) to the approaching headlights. Pulling

right on a narrow road with a minimal shoulder, however, just brought me to the road's edge, and I felt that sickening feeling you get driving when you feel — even slightly — that you've lost absolute control of your vehicle. I felt the tire dip over a sharp edge and hit gravel, which caused the tail end of my car to slide *ever-so*-right. Panicked reaction and inexperience made me haul the steering wheel hard left and I hit the brakes hard at the same time. I just wanted the feeling of sliding to stop.

I stopped, all right. As my car came back fully onto pavement it slid across my lane, across the centre lane and directly into the oncoming vehicle. Head-on.

Everything went dark.

*　*　*　*　*　*

I woke. The smell of burning was putrid. Rubber and metal and plastic. I could see billows of smoke, and a noxious mix of ignited chemicals filled my nose and burned my throat. I looked around me and didn't really register what I was seeing, but I do remember the glass. Broken glass, everywhere. All over me, my legs, my lap. All over the seats. Well, seat. Where the passenger side of my car used to be was now open space. It was simply...gone. The night air was now my car companion. The stars, my co-pilot.

I had no concept of time. Eventually, I heard a voice in the darkness, which I later learned was a doctor. This madness fortuitously happened in front of a doctor's house. The universe is strange, at times.

My own words were hard to come by but involved, I remember, a lot of the word *fuck,* a word I didn't really use a lot as a teenager, even around my friends. I hadn't yet registered the damage to *self* — only the damage I was seeing around me. My beloved car was a tangle of crumpled metal

and demolition. I was in shocked disbelief that it was gone, but also that I had hit something — *someone*. Fuckfuckfuck. It just all happened...so fast. *Dave, what did you do??*

In this avalanche of terrors, I finally noticed the damage inflicted on me. Well, parts of it. First, I noticed the blood. My hand was dripping and I saw a piece of glass deeply embedded in it. That was nothing, though, compared to my knee. My left knee was almost entirely open and I could see down to the bone beneath. While I was pondering my knee, almost removed from myself, I noticed the worst of it: my right leg, which was a moderately skinny 16-year-old teenaged leg, was seemingly twice its normal size in diameter and busting through my jean cut-off shorts. I didn't know exactly what was wrong, but I suspected (correctly, I would find out) that it was broken. I just knew I couldn't move it, or my left leg, for that matter. For good reason, I guess. The dashboard and steering wheel were pushed right up into me, my body a tangled mess around it. This is *not good*. I stopped floating, watching this in third person, and started hyperventilating.

The next 45–60 minutes are a bit of a blur. The voice trying to calm me down and assessing me the best he could, with me pinned. A distant wail of sirens coming closer and closer. Ace of Base's "The Sign" booming on the speaker, improbably, until someone reached in to shut it off.

Fire trucks and ambulances arrived. As I drifted in and out in my state of shock, I remember at one point the jaws of life being used to pry open my door. Someone cut my shorts off to let my leg "breathe" in its swollen state. The pain as I was lifted out of the car and placed onto a stretcher. Then, a rush of something...and sleep...beautiful sleep. I woke briefly in the Antigonish hospital and remember my mother hugging me and seeing my father put his hand on my shoulder. And then when I woke, the next day or the day after, I was in Halifax, about 300 km away. My sister was there, and my parents.

I would learn later that when I slid across the road I ran almost directly head-on into a large pickup truck heading in the other direction. Our corners met, just off-centre, and my car took the greatest force. The passenger side of my vehicle was largely ripped off and came to a stop in the ditch. What didn't fly off crumpled inward, making it unrecognizable. The other vehicle (miraculously) didn't take much damage. I don't know how. I really don't. The passengers in that vehicle were taken to the hospital for observation but were luckily fine. To this day, I am eternally thankful for that.

I, however, didn't fare as well. When I regained drug-hazy consciousness in Halifax I would learn of the laundry list of damages to my body: a broken tibia and fibula in my left leg. A broken femur in my right leg. Four or five bad gashes that required stitches. Where my seat belt — my saviour — went across my chest and caught me from flying through the windshield to my inevitable end was black and purple from the top of my shoulder across my pec and down across my stomach. Days later I would find chunks of glass in my hair and in my scalp. I was a mess, and this mess would take a long time to sort out: almost two months in hospital. I got a titanium rod inserted down my hip and put alongside my shattered femur down to my knee, where it was bolted in place to effectively become my new, temporary femur. This surgery allowed me to improbably put weight on my right leg almost immediately as I regained my overall strength. My left leg, however, was doomed to a year of slow recovery: no pins or rods would replace my shattered "tib" and "fib." Just a full-leg, itchy, dreadful cast and an abundance of time and patience. I had plenty of time, but patience wasn't my virtue.

Eventually, the extreme pain lessened, and it really came down to waiting it all out. My time in hospital was largely spent watching the Toronto Blue Jays play through their summer season, watching MuchMusic run an endless loop of early '90s videos, including Soundgarden's "Black Hole

Sun" and Green Day's "Basket Case " (appropriate for me, looking back), and rehab appointments where the hospital staff would try to get me, begrudgingly, out of my wheelchair to spend some time on the rod-replaced right leg. I hated every minute of physio. After the initial week of the accident, I was transferred back from Halifax to Antigonish, where at least there I could receive visitors. Classmates and cousins would walk sheepishly in and look to the ground and not really know what to say, but I didn't care about the social awkwardness. I was just happy to see people. It meant a lot. If they brought me a Big Crunch from KFC and saved me from the endless bland hospital food — bonus. Instant saviour status. I still remember you KFC heroes to this day.

The summer came to an end and I was released: almost the entirety of July and August was spent in hospital, and although I was greatly relieved to know that I was finally "out," little did I know just to what extent my recovery was truly just starting. In total after release, I did two months in a wheelchair, about eight or nine months on crutches and another couple of months with a cane. I became an expert on "trick" wheelchair driving and could spin and pop wheelies. Come to think of it, I was much more adept at driving that than gas-powered vehicles! I didn't let a little temporary disability stop me, and my parents would let me still work the counter, at times, in the store. A little bit of normalcy. One kind woman who saw me perched there with my legs a mess of recovery would later go home to say to her daughter, "Oh, that poor little Brosha boy with the two broken legs...my heart goes out to him!" She would later become my mother-in-law, in a little instance of "small world" happenings.

I was on crutches for months and months. Those two padded sticks became an extension of my body, and I began to feel as if I was Jackie Chan. I used the ends of them to hop over obstacles. To jab my siblings. To support my weight while I Ninja-kicked anything and everything. To grab socks

off the floor. To bring me wherever I needed to go. I got comfortable, and then kid-cocky, using them. I was within weeks of that hallowed date when I was due to have my cast cut off when I was descending the stairs at school one day using my crutches. The safe way (read: the smart way) would have been to hold my crutches to the side, use the handrail and take each step slowly with a point of contact. I got into the habit of going down large flights of stairs with the crutches wedged under my arm pits — the same as I would if I were walking down the hallway — and basically "hop" down each stair. Fortune caught up to me once again (as was bound to happen) and another kid at school accidentally nudged me as they hurried up the stairs with their head down, sending me down seven or eight stairs. I landed directly on my cast-covered broken leg, breaking it once again. Another trip by ambulance to the hospital, and a large delay to my recovery. You can't make this up.

That year was one of the toughest of my life, but it gave me a lot of the tools I would call upon again and again in later years: endurance, patience, determination and a self-deprecating sense of humour. Pooping in a bedpan will do that to you. I had to relearn how to get in a vehicle again without feeling debilitating fear. I learned once and for all how important a seat belt is, because I wouldn't be typing this if it weren't for that. I learned that relationships don't always last forever, and that's okay: while I was in the hospital Collette and I would split. I learned what doesn't break you makes you stronger, even if it leaves you with some lifelong imprints. A year or so after everything happened, I realized, with horror, that I now had one leg an inch shorter than the other, and that I had lost about 90 per cent of the flexibility in my right leg. I would struggle the rest of my life to even tie my shoe on that leg, and I would forever more walk with a limp...but, hey, you adapt. Scars. So many scars. But I look at them now and they are as much a part of me as

any other part of me. They are a ring in the centre of a tree's trunk, a wrinkle in a face. A part of a life story — a story that continues.

* * * * * *

POSTSCRIPT It was only weeks and months later that I learned more about the people I had hit. They were fine, and they wanted me to know that. They — the kind people they were — even reached out afterward to see if I was okay. This accident was my fault. I fully own that. I was 16 and, well, an idiot. I should have known better. Between the first accident and this one I had the distinction of having completely "written off" four vehicles in three months: the two I was driving and the two I hit. Luckily, this was the lesson I needed. Knock on a big piece of shiny wood, I have never been in any sort of real accident since. And I feel, honestly, like I'm one of the safest drivers out there now — and work hard to keep it that way.

Life lessons.

NOISE ON THE LINE

*In the grand scheme of things, polar
bears are the least of our problems.*

—EMILY CALANDRELLI

"UM, ERIN…" MY VOICED CRACKED AS I FOUND THE right words to say. Truthfully, though, there weren't any right words — and the only words I could find were the real ones. "I'm stuck up a pole and there's three polar bears trying to get me. Can you call the RCMP?" Not the call that anyone wants to receive from another human, especially one they love. To Erin's credit, she took me seriously. "Okay," she replied. I hung up. It was not a time for wasting words.

I feel, though, that we should back up.

In 2002, I was a reasonably recent graduate of university and the school of hard knocks. Post-university employment didn't come easy — but in fairness, I didn't really go after a degree with a long list of immediate employment options upon its completion. I graduated with a Bachelor of Arts, with a major in English and a minor in History. Prospective employers weren't exactly lining up. My real dream was to become a writer, but I didn't really know how to make that happen. I was met with a string of disappointments and

zero income while half-heartedly pursuing that dream, and quickly gave up. Practical realities first took Erin and I overseas for a teaching gig, attempting to teach English to Taiwanese children and adults, followed by a stint designing and marketing websites, followed by a moment of truly rock-bottom when Erin and I realized one day that we had a maxed-out credit card and a single toonie left between us — that was all — with our next paycheque not coming for another three or four days. Hard choices had to be made: buy a newspaper, which we always loved devouring, or buy and split a cup of coffee at the neighbourhood Tim Hortons. The coffee won out, and over coffee we realized we had to shake things up in our lives. This meant doing something truly desperate: I borrowed a couple of hundred dollars from my parents to buy a barbecue, which I set up in the parking lot of their convenience store, and proceeded to sell hot dogs to anyone I could convince.

Remarkably, the BBQ was a hit — and not only did I quickly pay off the loan from my parents, within months I expanded the operation and bought up a second stand from a local vendor. This BBQ I would set up outside the university pubs in the wee hours, selling cheese-filled sausages to inebriated students and the local barflies. Not content with a small operation, I decided I wanted an empire. I also purchased a food truck that drove to area businesses, selling all manner of sandwiches and snacks. At the same time, Erin found employment at a local home building supply business. Between us and an incredible work ethic, we were now surviving...but we worked long, hard hours and really getting ahead of all that life dumped upon us seemed impossible. Student loans, bills and credit card statements seemed to arrive daily. Each one would be viewed with a cringe, and an increasing sense of despair.

Then one day the phone rang. A call that would change our lives forever. I answered and I struggled to hear the voice

on the other end — it sounded as if they were on the other side of the planet. Turns out, my assessment was pretty much correct. Their faint words crackled through, and it was someone claiming to be from Resolute Bay, Nunavut. They wanted to talk to Erin — something about a job interview.

Erin, there's someone on the phone from Nunavut. Something about an interview? No, I didn't catch who they're with.

Erin disappeared into the tiny office in the tiny trailer we rented, and after about two minutes she came back out with eyes wide. "They want to interview me for some position about public housing. Should I do the interview??"

Well, it's not going to hurt. Where is this again? What job? "I'm not really sure!"

Erin disappeared again, and after about 20 minutes she came back out and looked as if she'd seen a ghost. "Dave... they want me to take the job. Manager of Public Housing for the Resolute Bay Housing Association!"

After learning the proposed salary, which was more than either of us had ever dreamed of — more than we were currently making, combined — she went back to the phone said yes. She accepted the job on the spot. Only then did she learn that they wanted her to start the very next week. She came back out of the room and looked at me, and I looked at her and I said, "Well, I guess we're moving to Resolute Bay. Erin, where is Resolute Bay?"

Neither of us knew. We took out our atlas (this was in the dial-up internet era, and people still used atlases). Our eyes got huge. Resolute, apparently, was not just in Nunavut but at the *top* of Nunavut. Like way the hell *up* there! The second-most-northerly community in Canada: it puts the *high* in High Arctic. Yikes, could we do this? And next week? I had a hot dog empire...and, well, this was crazy, wasn't it? Who moves to the High Arctic with a week's notice?

We moved up to Resolute. Not the next week but the week after — after I sold off my hot dog empire to my sister and

Erin happily gave her notice at the home building supply company. We stored, gave away or sold all the meagre possessions that weren't coming with us. Plane tickets were sent to us. This was *really happening*.

* * * * * *

Resolute was a magical and terrifying place — a mix of barren, remote nothingness and an environment filled with an abundance of intricate, understated beauty. I bounced through a series of jobs trying to figure out what one did in a tiny community of 220 people when you weren't the Manager of Public Housing. I swept the aisles at the local grocery store for a while, offloaded pallets and boxes of chips from a resupply ship for some extra cash (and, well, mainly out of boredom), ended up becoming an operator at the local power plant doing oil changes on multi-million-dollar generators (my English lit degree qualified me nicely) and even did a stint doing logistical support for a company that supported polar explorers as they made their wild attempts on the North Pole. Eventually, I would find my job that would become the basis of my career for the next five years: as a telephone technician.

Now, how does one find a job as a telephone technician with an English lit degree? I mean, they both utilize language (telephone lines carry conversations and literature contains conversations), but beyond that the similarities end. I got the job the same way one often gets a job in the weird, wacky and completely wonderful place known as the Canadian North: by showing a little ol'-fashioned initiative. Truthfully, I got it through eavesdropping.

One lunch hour, a few of us were sitting at one of the only restaurants in town, staring down our plates of greasy, tasty french fries and Cokes, when I overheard the stranger (you tended to know everyone in a town of 220, so you spot a

stranger immediately) at the next table complain to the wait staff about being sent to Resolute. "No offence, but I really hate coming up here. I really wish they'd hire someone local to do this, but they can't ever find anyone interested." I guessed that he worked for the telephone company because his jacket said so, and he had a bunch of telephones with him. His name was Harold, I learned later.

I was curious. My stint changing oil at the power plant was coming to an end and there really weren't a lot of jobs in Resolute — at least the type that paid a decent salary. I asked, and Harold gave me the phone number of his boss down in Iqaluit. "Please phone him. You'd be doing me a favour."

I phoned an hour later and the call — I kid you not — went somewhat like this.

"Hello, I heard you were looking to hire someone to be a telephone technician in Resolute Bay?"

"Oh, yes. You live in Resolute Bay? Well, you're hired!"

It was that easy. Rob — my new boss — only asked my name much later, after he committed to hiring me. I found myself being flown down to Iqaluit the next week for a few days of basic telephony and climbing training before being shipped back up to Resolute with some shiny new tools and a directive to basically "fix any issues that come up with commercial and residential service in a timely manner, and to install new services as they're ordered." Okay, boss! Let me at it. I'm ready!

But, right...the polar bears. Let's get this misadventure back on track.

* * * * * *

A few months into my new job as Community Service Technician, my life would change forever. On my daily check of the CO (Central Office) fax machine, I noticed a paper in

the tray; something had come in since I last checked the day before. It was a trouble ticket. A trouble ticket meant that someone had reported a problem that required a field technician (like me) to go and investigate. Irene Eckalook's phone had noise on the line.

It was November in Resolute Bay. Wintertime. Not only were the winter months in the High Arctic bitterly cold and harsh — it also meant it was largely "dark season." Resolute was so impossibly *north* that the sun would ungraciously disappear in its entirety for three months; even during midday lunch hours you would find yourself in pitch, all-encompassing blackness. Many people went squirrelly in the Arctic during dark season: it was a real thing. We basically hibernated aside from work; movies, unhealthy food and endless sleep. A month into dark season, you started literally counting down the days until the sun would peek over the horizon again.

Dark season, from my work perspective, meant that I had to ensure I always had a headlamp with me, and a flashlight. I bundled up in my full-body polar suit, grabbed my tools, fired up my Polaris snowmobile (a snowmobile being the most practical and affordable means of transportation in the Arctic in the winter months), and headed toward Irene's house. Irene's house was only about five houses from my house and I suppose I could have walked, but I suffered from boys-with-toys syndrome: have snowmobile, must travel. Damn, I loved firing that thing up and revving it, loud. I would eventually discover the joys of pure physical activity and moving without the aid of machines, but in those days "health" wasn't really a strong word in my vernacular. Vroom-vroom.

After saying hello to Irene and doing some quick tests inside and outside her house on her phone wiring, I determined the problem was "up the pole," so to speak. This meant that the problem was either with the phone line running from her house to the telephone pole or perhaps with one

of the main phone lines itself. In any case, I groaned a little but started gearing up for the climb. At that time, I was fresh to the world of being a telephone technician, and climbing still scared the bejesus out of me. I was a young man who had grown up with a healthy fear of heights (I was *that kid* who got stuck in a treehouse and needed his dad to come save him), and climbing still didn't come very naturally to me. With any trouble ticket or service request that came across the fax machine that I knew required climbing, I would close my eyes and will the ticket to disappear. It never did.

With my spurs tightly on my boots, my tool belt cinched around my waist, my climbing safety device (called a pole shark) that wrapped around the pole solidly strapped in and in place and my headlamp turned on so I could see what I was doing in the thick of the afternoon night, I took a deep breath and kicked my first spur into the icy pole. I took a tentative step up. The spurs held my weight and I allowed myself to breath.

I took another step, pushing my body upwards, and kicked in my spur again. I repeated with another step, and then another step. My spurs were always a bit on the dull side; also, with inexperience I tended to "kick out" or slip every third or fourth step in those early days. This was an annoyance when I was near ground level; 25 feet up, it was terrifying. This afternoon was no exception and on the fourth or fifth step up, my spur didn't quite catch and I felt my heart flip and my breath escape me as I started to fall. It was only a matter of inches, thankfully, as my pole shark did what it was supposed to do, gripping the pole with its embedded metal spikes and holding me in place. *Whew*. I took a deep breath and tried to calm my nerves. I continued up.

I was about six or seven feet off the ground when I heard the dogs barking.

Dogs barking, in Resolute, was not a particularly rare event. The tiny town has many of them, and a walk around

the remote community would bring you face to face with countless dogs — house pets that were often chained outside, and full dog teams, often kept on the outskirts of town, that were used for more traditional dogsledding.

Here, however, it was the way the dogs were barking that put a chill in my spine. It wasn't a lone dog, horny in the darkness, looking for a mate or a bite to eat. It was a chorus. One dog started, but quickly others joined in, barking and yipping and howling in unison. Dogs serve many purposes in remote Arctic communities and have been part of Inuit life for ages. One of their functions is providing communities with early warning detection systems — and this is the part that gave me chills. I wasn't expecting Russian bombers in the skies overhead (although in retrospect, that might have been easier to deal with); rather, when the dogs start howling together, it usually meant one thing: polar bears.

Fuck.

Polar bears aren't uncommon in Resolute Bay, and in fact it's one of the Arctic communities that is frequently visited by these very majestic but very dangerous animals. It's one of the aspects of living in Resolute that we really enjoyed in our time living there up to this point: we had had the opportunity to see countless polar bears — always from the safety of a vehicle or a running snowmobile — and every time we saw them, we felt an incredible sense of awe (and healthy fear) when faced with the size, grace and sheer power of these remarkable animals. We had no misconceptions, however, that polar bears were simply the "cute" animals of Coke commercial fame: the dangers of polar bears were very real, and during our time there (and in the years that would follow) we heard tales of attacks across the Arctic. Polar bears have no natural predators, and they're simply trying to do what we all do: eat and survive. While they normally give humans, with our noise and environment-encroaching ways, some degree of space, they don't have the same level of skittishness that

a southern black bear might have. They are looking to feed themselves, and if you put yourself in a position where you're idiotic, not careful or unfortunate...well, user beware!

Of course there's a polar bear out there. It's not enough that it's pitch black and it's almost 40 below and my fingers are almost frozen.

Harold left out that part when he was selling me on the job.

I heard the barking in the distance and felt a sense of dread; fear swallowed me for a second. My rational brain soon kicked in, however: Resolute, while not massive, also wasn't a pinprick, and hearing dogs barking in the distance — even if it was a polar bear — didn't really mean, probability-wise, that a polar bear was going to show up in my little dark corner of the community, grinning and offering me a chilled soft drink. *Right?*

I put my weight on the straps of my pole shark and I leaned back into the icy night air. I looked over my shoulder.

My heart stopped.

Coming around the corner of Irene's house, just ten metres away from me, were not one, not two, but *three* polar bears. Directly toward me. *Fuck!*

Polar bears move remarkably fast, and by the time my brain registered what I was seeing, they were at the bottom of the telephone pole. I don't know how my body reacted, but it did. Without thinking — on pure instinct — I took one... two...three more steps up. Kick and heave, kick and heave, kick and heave. My spurs splintered some of the wood on the poles, but somehow I didn't kick out and slip this time. Someone or something was watching out for me.

I was now about ten feet up the pole. Still not high, but also not on the ground where I had been just moments before. A minute earlier I would have been strapped to a pole on ground level with no easy way to move. And, really...no defence. *That would have been it.*

I looked down and I met the eyes of the largest bear — the mother. She was with her two cubs. When you hear the word "cub," you think *small and cute.* These cubs were anything but. The younger bears were probably year-old bears and in the five-to-six-foot-long range. The mother bear I pegged at eight feet, although it's hard to be certain given the circumstances. As I stared down at her the two of us connected eyes.

I'm going to die. Pleaase make it fast?

The moment our eyes connected was probably one of the most terrifyingly beautiful and profound seconds of my life. My heart felt moments away from imploding. Improbably, my body was calm. My head? Rational. As we looked at each other, breathlessly, I took two more steps up. I did this on pure instinct. In retrospect, perhaps never a more timely action in my whole life. Our eyes broke connection and the mother bear did the unspeakable: she stood up on her hind legs and reached her giant paws toward me.

Where I was just resting on my spurs, just seconds before, her claws now dug in. At about eight feet in core body length, with her arms extended, she was likely ten or 11 feet extended. 11 feet? I, myself, was now at about 12 feet. Just out of reach. My whole system felt like it was shutting down. My heart beat incessantly in my ear — the sound was overpowering. My adrenaline was on overdrive. I can't even describe what this level of fear was like, because I have never felt anything like it before or since. Somehow, my body and brain reacted. To this day, I don't know how.

Move, Dave. You can do this. What fucking choice do you have?

Like a programmed robot, I took another step or two up, moving even farther out of reach. I was now within reach of the telephone cables. *Maybe, just maybe.* I reached to unbuckle an attachment on one of the telephone junction boxes: this is where the lines from the houses intersected and connected with the main lines running through town.

I was met by a mess of wires and round metal connectors. My limited training, thankfully, kicked in. I unsnapped my buttset (telco talk for a portable phone set with clips — technicians use them in the field) and took off my gloves and stared at the jumble of wires. Some of them would be "live" — actual telephone lines with telephone numbers belonging to residents and businesses of Resolute Bay.

One is as good as the next. I took a guess and clipped my buttset into the first wires that stood out to me — literally tapping into someone's phone line. This was an emergency, and I didn't think twice. To my surprise and eternal happiness, it was a live phone line. I heard a dial tone. I am not religious, but all I could think was *thank God.*

At that time, Resolute Bay and all the Canadian arctic communities had no 911 service, and my mind was drawing a complete blank on the phone number for the local RCMP. I could only remember one phone number: my own. Glancing down and only seeing paws and claws below my feet, reaching for me — trying not to think about whether polar bears can climb — with cold, exposed fingers I clumsily punched in my phone number. As it rang, I held my breath.

Erin answered. "Hello?"

Um, Erin... My voiced cracked as I found the right words to say. *I'm stuck up a pole and there's three polar bears trying to get me. Can you call the RCMP? I need help. I'm near Irene's house.*

"Okay," she replied. I hung up.

* * * * * *

The RCMP never did come. Or maybe they came after it was all over?

All I know is that what *saved* me, in a sense, was that within a minute of me making that fateful call, the polar

bear, in all her massive might, dropped back down (bless her heart) and started sniffing the ground. My heart racing, I watched on, detached, as if I were watching a movie...with the best(?) seats in the house. She beelined toward the corner of one of the houses opposite to Irene's, sniffing. The two smaller bears followed behind. Her massive head and the front of her body disappeared under the house, and for a few seconds I could only spot her furry butt and powerful hind legs in the bits of stray streetlight that spilled into the darkness. Moments later, she emerged, sliding a big, dark mass out from under the house and into the open space roughly below me. I was confused for a moment, but then recognized her treasure — my *saviour*. A seal. A dead seal. A gift.

Many Inuit in northern communities feed their dogs seal meat (not to mention eating it themselves — part of an incredibly healthy diet of "country foods" that have sustained their life in the polar regions since pretty much the dawn of human life in that area of the world). I have respect for all life, human or "wild," but in this case I could have cried with happiness at the fact that there was, improbably, a dead seal under the corner of a house in the darkness of this tiny little community. Some hunter's treasure. A gift to his or her own family or dogs.

The bears wasted no time and tore it apart, filling their bellies with some early winter nourishment. As bloody shreds flew across the pure white snow, the cubs jostled for a superior position alongside their mother. I just shifted back and forth on my spurs, above, watching the spectacle. It was impossibly cold, but I felt heat pulsate through my body. I dripped sweat under my polar suit. *What madness. Why me?*

Within minutes, further salvation came in the form of a random snowmobile emerging from the darkness. It rounded the corner of one of the nearby houses, following the same snowmobile track I had used — presumably just a local on his way home. The snowmobiler had no knowledge

of the polar bears being right there at that moment. He certainly didn't know that I was 12 feet up the pole, watching both him and the bears as if it was a TV special. The noise of his snowmobile and the blinding headlights caught the three bears' attention, and they quickly scrambled off, dragging what remained of the seal carcass with them. It left a bloody trail. They were gone, the snowmobile disappeared around the corner of the next house...and I was alone. It was over. The afternoon was deathly quiet after the drone of the snowmobile faded away. Just a slight rustle of wind...and my heart.

I don't know how long I remained up the pole; my legs started shaking uncontrollably as the immediate danger passed. I made my way down the pole, half-sliding down. I didn't care if my spurs kicked out. Tears streamed down and froze to my cheeks. I took off my spurs, fired up my snowmobile and made my way the short distance back to my apartment. I could see Erin open the door, greeting the sound of the approaching snowmobile. She peered out into the darkness, worried, not knowing if I was dead or alive. I pulled up to our place and turned the machine off. Walking in the door, I silently hugged her. I couldn't speak. I tried, but nothing came out. I undressed, went to our bedroom and collapsed. I was home. *Safe.* I was *done.*

* * * * * *

POSTSCRIPT A week later, my phone rang. It was Rob, my boss in Iqaluit.

"Dave man, wow, how are you doing? I mean, that was crazy with what happened with the polar bears!"

"I'm okay, Rob."

Truthfully, I wasn't. For the first and only time in my life, I had to take time off work for stress leave. Breathing that

week had been tough, let alone contemplating work. My nights were filled with terror. Replays. All I could see, over and over and over…were those paws, inches away.

"Good? Well, good! That's great then! I mean, I hate to bring this up, but *you know*….um…so that trouble ticket? You never did finish it, and Irene's still complaining about noise on the line…"

4

TEQUILA AND MACHINE GUNS

It takes only one drink to get me drunk.
The trouble is, I can't remember if it's
the thirteenth or the fourteenth.

—GEORGE BURNS

OH, TEQUILA. HOW MANY PEOPLE HAVE UTTERED THAT phrase over human history? Tequila never results in a good ending to a story, even though, at the time, it always seems to make sense as a proper start. No matter how many times you think you know better, you somehow find yourself, once again, saying, "Okay...but just ONE..."

* * * * * *

The year was 1999 and life was pretty innocent — all things considered. Kaohsiung, Taiwan, was the scene: a large port city in the south of a small country, geographically, that always seemed to be in the news in those days due to constant tension between the nation — which just wanted to be

left alone to be an autonomous country — and nearby China, which still believed that Taiwan was a part of it (and would roar and bark and threaten hellfire semi-frequently). Over 20 years later, in 2022, not much has changed.

Erin and I had been teachers (teaching English to school children and adults looking to improve their conversational English) in Taiwan for maybe three or four months. After the initial shock, we were starting to become comfortable in this new and foreign place, getting the lay of the land and starting to enjoy this strange city, its people and its unique culture. This was a far cry from our first couple of weeks there when we were afraid to walk much farther than a block from the safety of our apartment. Trips "out" were focused on getting down to the 7-Eleven to buy whatever Western food like peanut butter and Pringles we could find, but we didn't do much more than that. As much as we were brave enough to move to the other side of the world to embark on an adventure, being *adventurous* was still very much a facade, and fear of communication, food, new smells, city life and overwhelming humanity (coming from a place with a few thousand people to a city of almost three million people) made our earliest explorations pretty tame. My mindset would change dramatically over the years to follow, but we all start somewhere.

I can remember the day we finally worked up enough courage to eat *local* — that is to say, to eat out in a Taiwanese restaurant for the first time. In our neighbourhood, it seemed that no one knew English and we hadn't at that point learned any Mandarin. We knew whatever place we chose there would be a definite communication barrier. But we were in Taiwan! One of the biggest things I was looking forward to in moving there was to eat all kinds of wonderfully strange Taiwanese foods. I had always been a big fan of foreign foods living in Canada, and, well, Chinese buffet tables were always the best!

Well, this was *the day* — the time to bust out of our early-twenties comfort zones and take a bold step forward in life. Steaming dishes of weird and wonderful and wacky Taiwanese food awaited us. Seafood and dumplings and noodles. All the good stuff. We've *got this*.

We walked up and down the main street in Nanztu, our "little" suburb in the greater endless mass of Kaohsiung, looking for the perfect place to test our new-found bravery. The smells of the streets were a sensory overload of all manners of cooked foods from the countless street stalls and restaurants mixed in with the sickly smell of raw sewage running directly and openly under the streets. Some places looked a little "too rustic" (we could see raw chicken sitting in air temperature buckets, curbside), while other places looked intimidating, with black glass and the impression that you might be accidentally walking into a mobster stronghold. We finally spotted the perfect place: bright red exterior and a clean, modern look. A quick glance through the menu outside gave us the final courage we needed: we couldn't read it, of course, but it had pictures — and not just words. We knew we would be able to point out our selections rather than embarrass ourselves trying to guess at a foreign language. We were sold, and we walked in, proudly. Our first Taiwanese restaurant!

We went in, sat down and the friendly, smiling waitress brought us our menu — the same one we saw outside. Aaah, this was so easy. "Why didn't we do this earlier, Erin?" "Well, Dave, that's a good question." Now, to find some great Taiwanese food. We scanned the menu and made our choices. The waitress came back and we pointed to four or five selections and her eyes got a little big, but she jotted down a few numbers in a pad and left. After first bringing us our drinks, 15 minutes later she returned with not just some plates of food, but some serious TRAYS of food. We, in our excitement, had ordered off a shareable menu. We now had

enough food in front of us for about six people. Facepalm. We laughed it off, though, and plowed into the delicious array of food put in front of us. *Wow, okay, this was easy.* Sort of.

Bring it on, Taiwan restaurants.

It was only after a gut-busting meal, when we went to pay our bill and said to our server, who knew some broken English, "This was our first Taiwanese restaurant and first real Taiwanese food — it was great! Thank you!"

She looked at us, and laughed. "Oh no, this is not Taiwan restaurant. This is a JAPANESE restaurant! Only one on street!"

This all made perfect sense, considering the sushi and sashimi and teriyaki dishes we'd just consumed. Oh well. Baby steps in Taiwan.

* * * * * *

As the months went on, our comfort level grew. Explorations of the streets of Nantzu led to explorations of downtown Kaohsiung and beyond. We even occasionally hopped on one of the national bus lines and headed to the deep south of the country to a resort town called Kenting, where beaches and hiking and a day or two of cold, frothy beers awaited.

While we were living in Taiwan, life wasn't all work, outdoor adventure or playing tourist. About once a month our interests turned to that of many a young couple the world over: socializing with friends over a drink or two (a.k.a. "a night out"). Our bar of choice in Kaohsiung was a place in the downtown core owned by three spunky local women. They would work the bar wearing short skirts and basically free-pouring tequila to the people they liked. Erin and I were in that category (well, Erin was...but I was her tagalong). As a result, a visit to their bar always resulted in a night of adventure, laughs, shenanigans, shots and a very real headache the next day. Harmless fun.

But there was that *one night* where it really went sideways.

It all started innocently enough (famous last words to anyone who's ever had a tequila night): a giddy bus ride from Nantzu with a couple of our fellow English teachers and teacher assistants, then a short walk and some loud greetings and hugs from the owners when we all walked into the bar. We tried ordering beers in an attempt to start with the *saner* choice, but Owner 1 (let's call her Candy) wasn't having any of it: "You. Tequila." This wasn't a question but a clear and concise statement. An order. It was *her* bar; who were we to argue?

One round of tequilas led to another round led to another. At one point we ended up in a nearby club on a dance floor in a techno wonderland surrounded by a hundred energetic and quite boisterous Taiwanese club goers armed with glow sticks and whistles, which were handed out at the door. Back in those days I danced like an un-oiled robot (it's only gotten worse since), but I can remember swishing and swaying under the strobe lights — the accompanying bass beat so intense you felt it in your spleen — and thinking, *this is what living is*. Pure elation.

Around 2:00 or 3:00 a.m. we knew we needed to get home — it was *time*. That point in the night when you inherently know that one more drink is asking for a level of trouble you know you don't need. Our evening food was still, at that point, safely in our stomachs. It didn't need to end up on the sidewalk as cockroach fodder.

In the night's journey our group had slowly drifted in different directions and we'd lost our fellow teachers; it was down to just us. The bus system had long stopped running (at least to Nantzu) and we had the choice of finding an expensive taxi or braving the night — either sleeping on a bench or stumbling through the empty streets until dawn. We were way too drunk and tired for the last option, and had no ambition to sleep on the streets (aforementioned

cockroaches and rats were a common sight), which left us, really, with the expensive cab ride. It was about a half-hour drive to our suburb from our downtown explorations. We knew it was going to be pricey, but this wasn't our first rodeo: we had been here before and knew roughly what an end-of-night cab would cost. That money was safely tucked away for the wee hours. Even in our tequila-soaked state, we knew this money wasn't to be touched as drinks and food and fun progressively emptied our wallets.

We flagged down a taxi and collapsed into the back seat. The driver gave us a quizzical look, as if to challenge us to communicate with him. We were, he knew, Westerners, and Chinese is not an easy language (except for the billion-plus people who speak it). But we had been here before. In taxis, that is, in Kaohsiung — and we had never *not* gotten home before. Usually we only needed to know one key word aside from the standard greeting of *nee hao ma?* (how are you?): *Nantzu.* Ah, yes, Nantzu. Our neighbourhood. All the taxi drivers knew the main areas of the city, and if they could get us to Nantzu, we could point, exclaim, dance and mime our way to the exact side street that our apartment was on.

"Nantzu!" I happily exclaimed. He stared at me.

"Nanztu! Nantzu!" He stared at me some more.

Hmm. He clearly he doesn't know Chinese, my inebriated brain pondered. Perhaps if I slowed down?

"Nant zooooooooooo." He raised an eyebrow and nodded. Success! I sat smug in my sense of linguistic accomplishment and turned to Erin. She shrugged, satisfied that we were on our way home, and we both fell into a trance as the blocks and the omnipresent night lights of a big, bustling city whizzed by. Beetle nut stands and stray dogs and endless neon became a buzzed blur. Our meditation was interrupted occasionally by the driver as he tested his knowledge of English on us, which amounted to lines that he learned from Eddie Murphy movies. He would raise an eyebrow in

the mirror to catch our attention and then exclaim with a big smile, "Fuck you?" followed by a bigger smile with an even louder "NO, FUCK YOUUUUU!" We laughed, and this only fuelled him. He laughed manically as he sped through the streets.

He finally quieted down, and although time was a fluid thing to the 3:00 a.m. tequila mind, after about 30 or 40 minutes we both sort of had the realization, at the same time, that something wasn't quite right. None of the buildings, blocks or stray dogs looked familiar. *Not at all.* Wherever he was taking us wasn't where we intended for him to go. This much was clear.

"Excuse me?" I said in English. He, of course, didn't understand. His English words were limited to the aforementioned civilities. He raised his eyebrow, again.

"Nantzu?" I asked, quizzically.

"Nantzu," he answered proudly and pointed out the window.

I frowned at him and repeated, "Nantzu," shaking my head.

"Nantzu!" he once again exclaimed and again pointed out the window as the blocks passed by.

I shook my head harder and again said, a little more firmly, "Nantzu."

He looked puzzled and frowned. "Nantzu?" he asked.

"Nantzu," I replied, fully aware that we had had an entire conversation in Chinese that consisted of one word and we still didn't seem to be any closer to a shared truth.

He pulled into a gas station and rolled down the window to talk to a bored old man sitting on a stool next to the pumps. They exchanged a flurry of words in Chinese and the old man raised an eyebrow at me.

I rolled down my window and said to him — no surprise here — "Nantzu."

"Aaaaah, *Nantzu!*" he smiled and said another flurry of words to our driver. Our driver rolled his window back up

and looked up, annoyed, in his rearview window at us.

"*Nantzu!!*" he said angrily, followed by an Eddie Murphy "FUCK YOU," and sped off again.

Twenty minutes later we recognized the buildings of our neighbourhood, Nantzu. Hallelujah! I woke Erin excitedly, and we started directing him, pointing down street after street, followed by a final couple of side streets. We came to a stop just down the street from our ten-storey apartment building. It's only then I noticed the cab's meter. My already lurching stomach dropped. It was about *triple* what we would normally pay for a cab ride from downtown to our neighbourhood — about triple what we had budgeted and carried on us as cash. These were the days before credit card machines and magical tap functionality. We were in a faraway country with a language barrier and we were in a situation and didn't have enough money to pay up.

Damn.

We tried to reason with him first, and held toward him the money that we would have normally paid a driver for that distance. He took it and then looked at us expectedly, waiting for the remainder. I explained to him, in very rational and eloquent language (English, mind you) that this was his fault and he took us on a wild goose chase and if he had just taken us to Nantzu, as we requested, the money we were passing over would have been more than enough, with a small tip added in.

He blinked and stared at me. The fact that his hand was still out toward me, looking for the balance, led me to believe that he hadn't quite understood what I was saying. *Oh boy.* I internally muttered some Eddie Murphy at him.

Erin and I did, then, what any normal person in our situation would do (at now close to 4:00 a.m.), still fuelled by godforsaken tequila running through our veins and obviously going nowhere in our conversational Mandarin skills. We followed logic and took necessary steps to end this night with dignity.

We ran.

We looked at each other and took off sprinting down the street as fast as our tequila legs would take us, dodging cockroaches and sleeping dogs, never looking over our shoulder or stopping to see if he had given chase. The street he had stopped on, thankfully, was just kitty-corner to the front door of our apartment, so we were pretty certain that if we could get inside our door before he rounded the corner, he would have no clue which of the dozens of ten-storey apartments we had disappeared into. We slammed the main building door shut and continued sprinting up our stairs, right up to our fourth-floor apartment door. Moments later we were inside, laughing hard and too breathless and buzzed to be scared or realize exactly what we had done. Within minutes, we were both asleep on the king-size bed in our small bachelor apartment. The night was done. Success.

* * * * * *

It's sometime the next morning. I see sunshine blast its way into the corner of my eye and I groan. My brain is flooded with a rush of ache and trauma. *Where am I?* I manage to pry one eye open, and then another. As my eyes slowly come into focus, I recognize our apartment and — looking around — Erin beside me. I don't know what time it is, and I feel like death. I stand on wobbly legs and make my way to the bathroom and splash water and life onto my face and try to piece together the night. The bar. The glow sticks and whistles. Dancing. Tequila. Stray dogs. *Shit, the taxi!!* I shake my head and smile to myself, and swear off any future tequila moments before emptying my stomach into the toilet. *Ugh*.

As I come back into the room, Erin is awake, sitting up in the bed and looking angry. "Oh man, what a night that was!" I exclaim, trying to muster up some false positivity.

My stomach and throat are all toxic bile and I just want to go back to bed. But I can tell something is wrong. *What's wrong?*

She looks at me and starts to say something but then stops. She breathes deep a couple of times and then starts again.

She recounts that after we both fell asleep — sometime in the next hour — there was loud banging on the door. "Oh shit, the driver!" was her first thought — that he had tracked us down after running from the taxi. My heart sank. She ignored the banging at first, but she could hear someone yelling. They wouldn't stop. Scared, she tried to wake me, but I was an unmovable force — a snoring, beached whale spewing alcoholic fumes.

As she tiptoed to the door, she called out, "Hello?" Silence greeted her back. For a few moments.

Finally, they responded. "We are priest men."

Erin: Huh? Priest men? The last thing she wanted to do was have a conversation about Jesus Christ our Lord and Saviour with one of the young, white Mormon missionaries we often saw walking our neighbourhood in their pressed pants and neat white shirts and ties. Especially at four in the morning. She began to suspect that we'd had something more than tequila spiking our drinks.

"Hello?" she repeated.

"We are priest men, please open."

Priest men? *Priest men??* She prayed. *Dave would you please wake up? I can't handle this.* I, of course, was having my own religious experience that involved a lot of snoring punctuated with mumbling to myself. The next morning I wouldn't feel nearly as blessed.

She quietly approached the door and looked through our spy hole, and her heart nearly exploded from nerves and fear when she saw not tidy-looking Mormons but four or five men in uniform with machine guns. Of course. Not priest men, but *police* men. Another one to chalk up to language

barriers, but that was the last thing on her mind. She was about to tiptoe back to try to wake me again when she heard BANGBANGBANG again. "OPEN UP!" Nervously, she opened the door.

A young white woman standing in her nightgown was clearly not what they were expecting to see. They seemed confused. Erin looked at them and all their guns, and then looked back at me, dead to the world, on the bed. Resigned to the fact that she was about to be arrested for skipping a taxi fare, handcuffed, taken away to some unmarked facility and held without bail, a lawyer or a cup of coffee, she looked back at them and just repeated, "Hello?"

One of the police officers knew limited English, and he shouted at her, "Where are they, where are they?!"

Where's who, she thought, confused. But she figured he had his English wrong and pointed toward me. The police officer looked into our apartment and looked at me snoring and looked around and then back to Erin once again. "Where ARE they?!"

"Who," Erin replied, confused. "*Who?*"

"Filipinos. Where ARE they?"

"Who??" Erin replied, with flashbacks of our Groundhog Day-esque Nantzu conversation from the night before.

They frowned, shrugged and left.

* * * * * *

POSTSCRIPT This heavily armed squad of police thought we were harbouring illegal Filipino workers in our apartment but quickly realized that they had the wrong apartment. They really just busted up some tequila dreams...at least for one of us.

If only they had clued in that they actually had the notorious Taxi Two in their sights at the same time, their

night's patrols wouldn't have been a bust. They let us slip away, unknowingly. As for us, I just hope we're still not on a Taiwan "wanted" poster for that $20 fare.

Tequila, kids...don't do it.

5

LOST IN −72°C

Nothing burns like the cold.

—GEORGE R.R. MARTIN

THE COLDEST DAY I HAVE EXPERIENCED ON THIS PLANET
is a day where it all went wrong in so many ways...and yet still
ended being *right*.

As a qualifier, I have lived many cold — even horrifically
cold (to "southern" sensibilities) — days in my life. I grew
up in the northern reaches of Alberta, where the icy grip
of −40°C would often spread its way across the land and
plunge our little remote community into deep freezes that
would last for days, even weeks, on end. Northern Alberta
was a land of extreme winter cold but not so much crazy
snowstorms — like the type I would encounter later in life
in eastern Canada — so we rarely had school cancelled. No
"snow days." However, if it hit that magical −40°C mark, our
world would change, at least a little, as −40°C meant the bus
drivers officially got the nod from the school division saying,
"Hey, it's kind of cold...take a day off." That was fine if you
were one of the lucky "bus kids." I wasn't and lived about
a 1.5 km walk to school. It didn't help that my father was a
teacher at the school — there was an added expectation that

teachers' kids should be there. I was bundled up with an extra layer and a thick hand-knit scarf and shown the door. Mom would exclaim, "Have fun, don't freeze!" while booting our asses outside. What she really meant was, *please, God, give me a few hours of peace and quiet. There's no way you're all staying at home with me today.*

Later in life, once I was in the working world, I decided northern Alberta wasn't quite *north* or *cold* enough. I would spend 12 more years of my life living in the Arctic and sub-Arctic of Canada, in both the Northwest Territories and Nunavut — pretty much the Canadian equivalents of Siberia. They were cold, icy, barren, beautiful and sparsely populated, but they were also wastelands. They were also ripe with culture, opportunity and geographic wonder. Both territories could swallow most countries of the world whole within their vast borders.

I can't count how many days I'd spend on the tundra in Nunavut, exploring its vastness by foot or by snow machine, camera always around my neck — or the countless nights I'd later spend under the stars on the frozen lakes outside Yellowknife, Northwest Territories, staring up at and photographing beautiful displays of aurora borealis. On pristine winter days, I would snowshoe the rolling Jack pine-covered hills. The moisture from my breath would quickly form to my face, creating beautiful snow chandeliers on my eyelashes or in my few-day-old beard growth. Pure frosty magic. In short, I'm an icy soul and literally a child of the north. Cold isn't usually anything that gives me a major reason to pause. It just is what it is.

* * * * * *

That day, however, was *different*.

Even if I wasn't *out there* and was instead wrapped in a blanket, tight, in the safety and security of a warm apartment

with a hot coffee, some DVDs (this was the early 2000s) and a pizza...this day would still be worth mentioning. "Hey, you're not going to believe how cold it is *out there!* Did you see the Environment Canada current temperature?" But, no — in my usual style — I somehow ended up *in the thick of it.* In another misadventure.

* * * * * *

In those days in Resolute Bay, Nunavut, I worked as an assistant operator at a power plant (another job I was vastly underqualified for but somehow managed to secure based on the fact that I showed up and generally did what I was told). When I wasn't working during the days at the power plant, I would either be relaxing at home, out following my new passion of photography or "working" (I'm not so sure I was ever paid) a side job for the part-time venture of Gary Guy, my co-worker at the power plant.

Just down the road from the power plant, Gary owned a building in the middle of the tundra that he used as a base for running a polar logistics operation, Polar Ice Expeditions. Why did he do it? I'm not even sure. Gary wasn't much of a business guy, and seemingly lost a lot of money at it. He was forever cursing the minutiae of his operation, including the fact that his furnace never seemed to work, his snow machines were always on their last legs, and to even get access into the building in a land where wind-driven snowdrifts continually overtake any open space often meant him begging or bribing a local snowplow operator to just "clear him a path." Polar logistics, though, excited Gary. You could tell being in the middle of the fascinating world of polar adventures, explorers, researchers — along with military, scientific and government types that set their eyes on the Arctic as their experiment, playground, battlefield and/or place of hopes

and dreams — just excited the guy. Gary loved being *in the thick of it*, and if Gary's wind-battered eyes weren't alternately scowling or twinkling at some story from his arctic past, some current headache or some future plan that he was neck deep into...well, life wasn't right in Gary's world.

My role in Gary's company wasn't really defined, nor did I really have a choice to be part of it or not, for that matter. Half our days on salary at the Power Corp were really spent down at his building, working on his furnace, gathering local gossip, playing cards or even, at times, sipping straight rum from coffee cups. Gary was about 40 years my senior and he was pretty much God to me in those days. I was a passenger in his beat-up red company truck, and when I wasn't doing oil changes on multi-million-dollar generators, I was putting on my coveralls, green parka and knitted toque and following Gary out the door of the power plant because, dammit, he *told me to*. I was just along for the ride.

March 2004. He announced to me one day that I had a job that he needed me for. "Dave, can you go to the airport and pick up this British guy named Simon Murray? He's rich, apparently, and training to go to the South Pole with Pen." Pen was Pen Hadow, another British guy who had successfully attempted the North Pole the year before, becoming the first Brit to ski to the North Pole "solo and unsupported" — a big deal, apparently (big enough that the Queen of England sent a fax to Gary's Base Camp upon Pen's successful completion, offering her congratulations). A year later, Pen was now helping Simon train in polar conditions for an attempt Simon would make himself on the South Pole the following year. Simon was a wealthy businessman, but he had his bona fides. At one time, he'd served in the French Foreign Legion, encountering all kinds of madness. He would later write a book about his experiences called *Legionnaire: An Englishman in the French Foreign Legion*.

All this didn't really matter to me on that particular day. All I knew was that Gary asked me to do something, and I'd better *do it, dammit,* lest I experience the wrath of his scowl. The airport run was made using Gary's ancient, barely-held-together pickup truck, and I sort of delighted in the fact that I was picking up this multi-multi-millionaire in basically the most rustic of modes of transportation. I did push Gary's cigarette packages and a couple of empty flasks into the back seat, first. For appearance's sake. The least I could do was to help him look like he was running a respectable operation.

After a day or so of getting situated and prepared at Base Camp, Simon headed off onto the Arctic Ocean with Pen. Their plan was to camp out on the ice — no matter what condition — to test gear, practise carrying their sledge loads, ski and for Pen to teach Simon basically all he could, in short order, about extreme-weather survival. All of this didn't really affect my life too much, other than getting the odd report from Gary over morning coffee at the power plant. "Tomorrow is going to be colder than today...and today was fucking COLD. Any bets they pack it in tomorrow?" he would say with a smirk. Gary loved working with the polar explorers, but he thought they were all nuts.

* * * * * *

It was a Sunday morning. I was at home, sitting on my couch in my underwear, pondering the day's plan, when the phone rang. It was Gary.

"Dave, you free?" I looked down at my underwear and then the couch and then thought for a second. I figured I didn't really have a readily available counter-argument to his question. *Yup, sure am.*

"Bundle up like you've never bundled up before — it's *cold* out there. Hope you don't mind, but can you come up

to the Base with your snow machine? I'm short one. We're going on an adventure. Don't worry if you haven't eaten yet — I've got sandwiches."

For Gary to say it was "cold" meant that it must really be cold, and immediately made me suspicious — but he hung up before I could do my due diligence. Gary had lived in the Arctic forever and routinely made fun of people for suggesting it was *ever* cold. "You live in the Arctic. Suck. It. Up." was his usual response — although his version would have a lot more curse words. I sighed (although secretly happy that Gary had phoned) and starting bundling up. As I put my long underwear on, I shouted out to Erin, "Hey, how cold is it out there today anyway?" She checked our tediously slow Arctic internet and about five minutes later yelled, "Holy shit...come here!" I went out and she was pointing to the screen, incredulous.

–72°C.

What? Serious? How can that even *be possible?*

By this time we were old Arctic hands. We had lived *up there* for the better part of two years and had been through countless days when the temperature dipped, with or without wind chill, to –40°C (fairly frequently), –50°C (wasn't unusual) and even, occasionally, –60°C (very rare). But –70°C? Two full winters and we hadn't come close — not even the high –60s. But, now, here it was: –45°C or so without the wind. Throw in a blistering, blizzardy, full-force wind...and according the Government of Canada, it said it felt like –72°C outside. *Sweet mother of mercy.* Or, as Gary would say: *That's fucking cold, boys.*

I phoned Gary back. It was as if he was expecting the call, and the reason why I was phoning back. He was probably smirking as he picked up the phone. "Before you can say anything, Dave...Well, we don't really have a choice."

"Oh?"

"Well, you see they're out there — Simon and Pen — on the ice and, well, this storm is supposed to get worse. Their

stove isn't working properly and some of their supplies are low. And, well, with these temperatures...if they can't work their stove, they can't melt snow for a hot brew, or stay warm. Let's just say it wouldn't *be good*. We got to pick them up." (He emphasized, strongly, the word "we.")

Gary had a way of convincing you that his problems, or other people's problems, were your own problems. And, as usual, he won. "Just come on up...and dress really, really warm. Make sure no skin is exposed. Oh, and maybe bring that thermos you have, full of something hot — like tea. It shouldn't take long to get out there — they're less than ten miles out. But, you know, just *in case*."

An hour later I was outside his Base Camp building with my Polaris 550 idling and kicking up a plume of visible fumes in the icy deep freeze. I was impressed that my machine had started without fuss down at my place in the hamlet, about 5 km across the tundra from his place — which was closer to the airport. Sitting beside my machine on the crunchy snow were two of Gary's machines. They were relics from an earlier era — probably 15 years older than my machine — but they "still worked just fine," per Gary. Even as he scowled at each of them individually, before scowling at both of them collectively, muttering under his breath and through his green Canada Goose parka. *I should have known right then and there.* He managed to get one running. The second took him a lot longer and was finally started, I think, mainly from the force of his profanities.

Standing by Gary, watching him with a mixture of amusement and fear, were two more Brits — Pen and Simon's accompanying photographer, Martin Hartley, and their logistics manager, Ian Wesley. Martin was heading out with us to do what he was tasked to do: photograph their preparations. Ian was to remain behind and be a point of contact at Base and do some other preparations. We looked each other over, and all of us with the exception of Gary had every single inch of our bodies covered with warmth-giving

material. Balaclavas on our faces, ski goggles, Canada Goose parkas with big fur-lined hoods. Snow pants. Thick gloves. Sorel −100°C boots. The brands differed from person to person, but it was a grand mixture of whatever we could find and layer on. Gary, of course, braved the cold with a similar ensemble minus the balaclava, at least during this prep time (it would come on once we were en route). For now, his chin — which I'm sure had been frozen too many times to count — remained jutted out and hardened against the wind, his only objective getting us prepped to go. Despite the bitter cold, you could tell he was in his element. An adventure was brewing and he was at the centre of it all. We all needed him, and he knew it.

As the winds whipped, Gary, Martin and I set off from Base Camp. We moved slowly at first as we navigated the first couple of kilometres across the windblown tundra, avoiding as much exposed rock as possible. Finally, we picked up a little speed as we went over the final section of shore out onto the ice, which was generally much smoother. As we drove, we all remained as low profile as possible, trying to stay behind the small plastic windshields. The thought crossed my mind as the icy wind tore through even the best of my winter gear (every Resolute Bay resident knows how to dress for winter, and I was no longer a rookie), "if it's −72°C wind chill standing completely still on land, what would the wind chill be if you added another 30–40 km/h to the mix? from the speed of the moving snowmobiles? −90°C? −100°C?" I'm sure someone smarter than me could figure it out. All I know was that even huddled, even having 99 per cent of my body covered, the cold *bit* through me like I've never felt. Every little gust of wind that made its way into my parka sliced an icy dagger through my core.

We stopped a couple of times early on to adjust outerwear and goggles and to work up the mental fortitude for what was to come. It was truly mad, we knew, but the mood was

jovial despite the extreme wind and cold; our surroundings were *incredibly beautiful*. The wind, whipping its fury across the ice, kicked up swirling masses of loose snow. The snow, combined with a low sun spilling golden rays, made us feel as if we were travelling through a portal into another planet. Martin photographed expertly as we went; I took a few snaps on my little pocket-sized digital camera (embarrassed to even pretend to make photographs next to this polar legend).

We slowly and surely weaved our way across the Arctic Ocean, slowing to avoid small pressure ridges, chunks of exposed ice and small icebergs as we went. Pen and Simon were somewhere out on the ice roughly parallel to a small mass of land called Griffin Island. Even as the winds whipped and kicked up icy snow from the frozen ocean, often blocking visibility, Gary was able to lead us to them through a combination of muscle memory (he had been out here on this section of the ice many times before), a handheld GPS he checked for reference a couple of times and good old-fashioned eyesight. Whenever the swirling snow clouds dissipated, we found that we could see a fair distance out on the ice. Something as bold and blatant as a colourful tent wasn't the hardest to see once you came within a general range of it, even from some distance away. After some time on the ice, but with slow, steady progress, we spotted the tent in the distance and steered toward it. *Thank God*, I thought. The wind was penetrating our thick parkas and my face was screaming — especially toward the edges of my ski goggles, which was the most exposed part of my face, as the mask would occasionally shift. Even with thick, overpriced gloves on, I could feel my fingers slowly going numb. Gary would later lend me his Inuit-made sealskin mitts to bring my fingers back to life. No store-bought brand could compare with thousands of years of traditional Inuit knowledge and skill.

As our snow machines pulled up to Pen and Simon's tent, we saw a head pop out and an arm extend, acknowledging

our presence, before both disappeared and the zipper closed again. As Gary chatted to them through the tent, Martin and I snapped a few images, and I couldn't help but marvel at the craziness of this all. Here we were, out snapping photographs on one of the coldest days — I'm sure — the Arctic had seen in quite some time...and it felt *normal*. It was *fun*, even. Bitterly cold, yes, but I still felt we were more okay than not. At least at that point. In that moment, it felt good to move around a little and get some blood flowing into my limbs as Pen and Simon bundled up and prepped themselves for the return journey to Resolute.

The sun was getting quite low by this point: even though it was now early afternoon, the sun had only "returned" to Resolute a few weeks previously after its long winter hiatus. That far north, every year the sun would disappear below the southern horizon sometime in late autumn and wouldn't peek back up (and only for a few moments) until February 4 — and then only fully break the horizon on February 10. It was an impossibly dark and cold period. We were now on "the other side" of dark season, but the period of daily light was still pretty short, and as beautiful as the long light was as we hopped around the ice in our winter, bundled-up, mummified state, I was groaning a little about the prospect of heading home in the dark. Dark just always felt colder and bleaker — words and feelings I didn't need more of at this particular moment.

Our first real sign of trouble came when we went to leave. My Polaris was fine, as was one of Gary's two machines. But the other one...trouble. No go. It wouldn't start. The wind whipped and chewed into us with sharpened fangs as Gary poked and prodded at it.

A shredded drive belt was the prognosis. *Fuck.* Luckily, Gary in his infinite Arctic wisdom had a spare with him. *Man, that was lucky.* Only it wasn't luck. This wasn't Gary's first time out on the land, and the mantra *out there* was to

expect anything and everything to go wrong, and to try to be prepared.

Having a spare drive belt was one thing. Trying to get it successfully manoeuvred into place on the machine in these temperatures was another. Even for Gary, whose hands were like rough leather and had been frozen countless times. You could tell he struggled, hard, with the cold as he tried to muscle the frozen rubber belt into the correct position. The belt just wasn't giving — it was too frozen. I suggested the hot tea from my thermos, and after pondering a moment, Gary asked for it. He poured the steaming, near-boiling liquid over the drive belt and let loose a shout: it worked! It softened the rubber just enough for him to be able to stretch, through brute force, the belt into place.

It was now getting critically cold and it was almost completely dark. The force of the wind increased further and it howled around us. *Time to motor.*

Our team set off back in the direction of Resolute, and all I can remember for the next hour was this slow, painful blur of tedious movement. With the onset of dark came loss of visibility, and our reasonably quick "out" trip to the tent became a slow crawl on the return. Our tracks had blown over — vanished without a trace — so it wasn't as easy as just following them home. The vicious winds had quickly erased any trace of our initial journey; to add to the slow crawl, the hidden land mines of quickly appearing exposed ice ridges were very real, and hitting one of them hard could damage your machine, or even worse: flip it if you had enough speed. We had to crawl on.

Gary led, I followed Gary and Martin followed behind me. Pen rode with me and Simon rode with Martin. All I could do was stay close enough to see Gary's red taillight — and Martin, mine. An endless red light beacon in a tunnel-vision chamber. *I'm so, so cold*, I thought. *This was an adventure... but let this be over.*

Time dragged on forever, and at one point something didn't feel right.

It felt, to me, as if we were headed in the wrong direction. I didn't know this for sure. It was all pitch black and there were no landmarks other than the endless expanse of ice. Somewhere *out there* the hamlet of Resolute Bay would inevitably be kicking off a little glow of light pollution and perhaps an indication of the way back home, but visibility was just too poor: we truly were swallowed by the darkness, with no indication of route, other than trusting Gary's lead. But right now I wasn't trusting Gary's lead. It felt as if he was going the wrong way, but there was no way to communicate this to him, being up ahead. As the youngest and least experienced polar person on the team, I wouldn't have had the stones to say anything to him anyway.

Our progression into the dark, bitter unknown continued on and on and on. I felt despair setting in, feeling we were moving farther and farther away from our goal. I pushed my face down as close to the handlebars as possible, trying desperately to cut the wind hitting my face. Behind me, I could feel Pen huddle as close to me as possible, trying hard, himself, to stay within my wind-cutting profile. There was no escaping the cold, however you tried. It was an omnipresent force, stabbing daggers through our bodies, and it found its way into every inch of our souls.

Ahead, I noticed Gary's red light stop moving. He had stopped. I pulled up behind him and hopped off my machine, grateful to stretch my legs and simply have a moment or two of lessened winds. I was careful to keep my snowmobile running — not wanting to leave to chance being able to get it started again. Martin eventually caught up to us, stopped and dismounted.

Gary was cursing. This, of course, was nothing new for Gary. As I walked toward him I could see him staring with anger at his GPS.

"Fucking thing is frozen. Useless piece of shit."

Now, one thing I have always been blessed with is a moderately decent sense of direction. As Gary fumbled with the GPS, I went over to Martin and told him what was going on and mused that Resolute was probably about 45 degrees to our current location if my internal compass was correct. Gary came back to us and pointed in the opposite direction: "I think it's over *there.*" *Okay, Gary, if you say so.* I bit my tongue, hard.

We hopped back on the machines and set off once again. We snaked another 30 minutes of twisting, tedious, frozen hell across seemingly endless light. I blindly followed Gary, and Martin blindly followed me. The cold punched and jabbed and it felt as if it was rappelling into your cavities to take up shelter against itself. The cold, trying to get out of the cold. I looked down at my gas gauge and noticed I was down to less than one-third of a tank. I pushed the thought out of my head of what would happen if any or all of us ran out of gas and we had to spend the night, exposed, in this.

Finally, Gary stopped again. Again, I hopped off and ran up to him. "Shit, sorry, I think we're going the wrong way." My heart sank, even as my suspicions were confirmed. He pointed into the blackness — in the direction where I had originally pointed. "I think it's *that* way." I was too cold to argue or agree or be exasperated or even nod. I just turned around and went back to my machine.

We backtracked along our fresh tracks for a while before Gary cut off in a different direction — the *right* direction, this time, I felt — and once again started a slow, snaking route through the small ice ridges and larger icebergs. Finally, improbably, I saw Gary go up a larger hump of snow and ice and instead of the usual pattern — him disappearing down momentarily as he returned to smoother sea ice — his lights kept going *upwards.*

Land!

If there was time for us to stop, I would have kissed the snowy, rocky tundra. I might have even gotten off my machine and made snowy love to the tundra (hey, cold makes you do weird things). Gary didn't stop, however, and for that I was grateful — he was now a man on a mission. Focused. The Gary I knew. Landmarks, however few and far between and almost indistinguishable to my relatively rookie eyes — well, this is where Gary *shined*. He knew every rock and crevice and canyon within miles of Resolute Bay, and I could tell he was on target. Fifteen minutes later, in the distance, a long row of lights. *The airport.* Tears, frozen, flowed.

We pulled into Base Camp and all hugged, briefly. Pure exhaustion and elation swept through all of us. Few words were spoken. Pen and Simon and Gary disappeared into the building to find Ian, the lone Brit we had left behind at Base Camp. He quickly bundled up and hopped on with Martin — the two of them were going to follow me back to my place in town on Gary's snowmobile and make sure I got there safely. Gary was going to pick them up some time later; right now, he needed to attend to his clients, Pen and Simon.

Thirty minutes later, we pulled up outside my apartment. After hours and hours outside in some of the most extreme conditions on the planet, we were *home*. My home. Safely.

Inside, Erin put on coffee, which she spiked with Baileys. A heavenly magic drink that remains — to this day — as probably the best hot drink that has ever touched my lips. Martin may have cried tears of joy. As we peeled off layers and sucked back coffee after coffee and came to life — even as we got more tipsy — we assessed the damage. I had a 1.5-inch section on the top of my cheek and outside my goggles that I didn't notice was exposed to the wind. It was badly frostbitten. In the week to follow it turned red first, and then black. I can still see evidence of it almost two decades later.

As we came to life, we started talking about the day that was. "Bloody hell, that was wild!" Martin, in his usual articulate way. Martin's a man who has seen the best and the worst of the Arctic and has spent more days, I'll bet, out on the ice in a multitude of conditions than almost any other human (he was later named one of *Time* magazine's Heroes of the Environment for his work documenting the planet's polar regions). To this day, Martin has a printout of the Environment Canada temperature reading from that day on his refrigerator back home in England.

−72°C.

There's cold and then there's *cold*.

That was *cold*.

*　*　*　*　*　*

POSTSCRIPT The day after this wild retrieval mission on the Arctic Ocean, Erin and I flew on a long pre-booked trip from Resolute Bay to the Mayan Rivera in Mexico. The temperature the day we landed? 42 degrees. The day before we left? −72°C with the wind chill.

A 114-degree difference. That's got to be some sort of 24-hour record.

When we returned to Resolute a week later, I went back into work at the power plant. Gary arrived about 20 minutes late and went and poured himself a coffee and then scowled at me, per usual, but then followed up with a quick smile. He sat and starting loading the dial-up internet weather report, ignoring me.

"Well," I asked.

"Well what?" he said.

"That was pretty crazy!"

"Huh? Oh, last weekend?" He shrugged and continued waiting for Internet Explorer to load.

"Um, yeah. I've never been lost at −72° Celsius before!" My face was a tanned, frostbitten mess. He stared at me with mock disgust and a twinkle.

"If you were lost, you wouldn't be standing there right now looking at me with your stupid face. Now, go *do something* and get to work, would you?"

Ten-four, boss.

* * * * * *

POSTSCRIPT #2 Gary Guy passed away in 2016 at the age of 70, a true Arctic legend. Martin, to this day, calls him the "John Wayne of the Arctic." Gary was a polarizing, loved and omnipresent figure in Resolute Bay. He was a huge influence on my life, and I miss him dearly.

6

SKUNKED #1

*It was almost funny, how even lying here
terrified and half-expecting to be dead
at any moment, his bureaucratic fear of
reprimand, of public embarrassment was
stronger than his physical fear of dying.*

—JAMES JONES, *THE THIN RED LINE*

I'M A MAN WHO HAS LIVED WITH A HEALTHY DOSE OF fear in his life. The "good kind" of fear, I like to believe. I have a cautious fear of things that can go wrong, or leave me maimed and/or lacking life. I've thought about it, and I don't really want to be lifeless — at least not anytime soon.

I travel to some of the crazier places on the planet, and find myself in all kinds of situations that, I suppose, the bulk of *normal* human beings don't find themselves in. Feeling a brisk –72°C wind while out on the arctic tundra, climbing a mountain at 5:00 a.m., lurching across the Sahara Desert on a camel, and drinking shots of vodka with military pilots at an American air force base in Greenland in one moment, and partying with Filipino sailors in the bowels of a ship in Antarctic waters another moment. Through all my adventures — and friends who travel with

me will attest to this, I'm sure — I'm the *cautious* one of the bunch. Sometimes overbearingly so. I've been given the nickname on some of the trips and adventures of *Safety Dad*. I've been called "bossy" out in the field when it comes to order and safety. I'll almost always back down from the edge of something insane if I find it crosses my own — rather broad — definition of crazy. In short, I feel I have lived an adventurous life, but overall a safe one. I'm not afraid of being afraid. It's served me well.

This is important to me. Being so afraid that you don't realize the joys the world has to offer doesn't sound to me like an appealing way to live. I don't want to live my life and learn about the world around me exclusively from an internet search engine or by watching cable news or Netflix: I want to live and breathe the world through a multitude of experiences. I *want* to be afraid and face those fears. I want to experience the beauty that exists on the other side of fear. After all, almost every great thing that has happened in my life has occurred after I've been scared shitless enough to take a leap, make a move. From leaping out of a plane to go skydiving for the first time (and realizing the most profound peace on the descent) to leaving a comfortable career to free-fall into a life as a creative freelancer (and realizing the joy that brought me), almost all my greatest life experiences have been born out of fear.

Fear has almost *always* led to beauty. But let's drop the poetry for a moment and be real: "almost always" isn't *always*.

* * * * * *

Sometime between my first and third years of university, God only knows which month or year, I was sitting alone at a place our family affectionately calls "The Cottage."

The Cottage is located in Bayfield, Nova Scotia. It's nestled on the shores of the Northumberland Strait, which separates Nova Scotia, my home at the time, from Prince Edward Island, which would become my future home. The Cottage has been in my family since before I was born, and will likely be in my family, spirits willing, long after I die. For decades it was really nothing more than a shack, held together by endless buckets of bright blue marine paint. Sand filled every crack in the floors, clamshells lined the open frame of its edges and bugs crawled through without restriction when it sat empty in the off-season, only to retreat — sort of — when someone in the family would open it up, each summer, for another season of singalongs, swimming, bonfires, hangovers and shenanigans.

Ever since I was two stumps high, I could remember going to Bayfield. We lived in northern Alberta, but our destination in the summer was often Bayfield: 5500 km of cross-country driving to a blue beacon of joy. *Mecca*. Dad was a camcorder addict, and when I sit down and watch the earliest recordings he made, it was of us, as kids, playing on the beach down in front of the cottage in Nova Scotia. After we moved to Nova Scotia when I was in my early teens, Bayfield became the place we went for family birthdays. Graduation ceremonies. Lobster feeds. Funeral celebrations. It's where I would sneak down to with high school and college girl-friends — a little oasis of aloneness.

The furniture down at The Cottage was a hodgepodge of things that probably should have been thrown out and replaced years before. A broken bench. A rusted couch with a pullout bed that smelled of mildew. A foam-cushion chair that looked as if a Great White had taken a chunk out of it during an ill-fated beach bonfire night; you had to sit on it *just so* to make sure your cheeks fit on it properly. This was all the *good* furniture. Otherwise, it was just a collection of folding wooden chairs — the type you'd find in a church

basement — or mesh lawn chairs that were a decade past their prime. What the place lacked in elegant details, however, it made up in the views it offered and the ambience it presented.

Oh God, the view.

This tiny little heaven couldn't have been situated closer to the water. So close, in fact, that we worried (and continue to worry) year after year about erosion taking the last of the tiny front lawn and plunging The Cottage down the small cliff to be swallowed by the ever-shifting tides. The flip side to literally living on the edge, though, is an unfettered view of St. Georges Bay and all the glory that that brings. Sunrises in Bayfield are magic, and on a clear day you can see mystical Cape Breton in the distance. During the right season, the bay is a flurry of lobster boats; during off-season it's eerily quiet, with the waters broken only by the odd kayak, pleasure craft or blue heron. Largely protected from the greater open seas, the waters are often calm. Occasionally, however, the wind shifts and finds its opening; the shores are hammered with fury and the deafening sound of pounding surf. This provides its own comfort, and there is no better place to be in the rain, or a storm, than down at The Cottage. No matter what the season, no matter what the weather...I love it. My happy place. My favourite place on Earth (except for all the other ones).

* * * * * *

It was early summer. I sat alone one early evening, waiting for friends to arrive for a night of alcohol-laden beverages and inevitably a few laughs. This was in the days before smart phones, Facebook and the constant compulsion to live on our phones in all our free moments, and I was doing something that I should do more of today: reading a book.

I devoured books in those days, before my brain turned to mush as the electronic addiction set in. Kudos to you, then, for reading these words. You're a wiser person than me now. My flavour of book of the moment was *The Thin Red Line*, a James Jones masterpiece about the Second World War. Today, I don't have any time for war, but in those days, yes. I was brought up obsessed with G.I. Joes, and later *Full Metal Jacket*, *Platoon* and *Saving Private Ryan*. Then I discovered *The Thin Red Line*. This book! — this book swallowed me whole. It flew me to Guadalcanal, it horrified me and it made me appreciate my own rather benign existence. A life lived without bullets. Or real fear for my safety. I sat back on a broken chair and put my legs up on a broken bench. I gripped and sipped a Molson Canadian, occasionally wiping the beads of condensation sweat from the bottle on my shorts so I wouldn't dampen the pages. I listened to the gentle sound of waves through open windows. I was happy and content.

The summer light extended long into the evening, but even summer light has its limits. As the world slowly darkened around me, I glanced at my watch. As usual, my friends were late, but it didn't really matter. This place, this refuge, didn't concern itself with time — only relaxation — and the pushing away of the "normal" world. I, for my part, just kept turning pages and devouring words.

The outside screen door in those days was ripped, sort of off its hinges and in drastic need of repair. Before the first "permanent" neighbour moved in across the street to eventually set up a bed and breakfast, the entire row of cottages in our neck of Bayfield was a summer-only, seasonal affair. All winter the cottages would be locked up and sitting idle, rarely visited. Except that ours, that winter, was visited by a small pack of local teens (we guessed) who broke in and used it as a place for their own socializing. Later that spring my father would find the shredded screen, the inside wooden

door ajar and, inside, bottles and cigarettes strewn across the floor. "They must have frozen their asses off," he mused. And, then, dryly, "I hope they did."

The bottles and butts were easy to clean up. Per the apparent *norm* down in Bayfield, however, larger repairs didn't happen quickly. There was always something to repair or fix, and the list was long. I, for my part, just shrugged my shoulders when I arrived. I propped open the inside wooden door to let the breeze in, as air conditioning was a luxury we never had down there. The screen was ripped, but it was a night with almost no bugs and the breeze felt so nice.

I read on.

"When compared to the fact that he might very well be dead by this time tomorrow, whether he was courageous or not today was pointless, empty. When compared to the fact that he might be dead tomorrow, everything was pointless. It just didn't make any difference. It was pointless to the tree, it was pointless to every man in his outfit, pointless to everybody in the whole world. Who cared?"

It all started with some scratching. Not me scratching my head (or my ass), but somewhere *out there*. Outside. A sound I didn't discern at first, because I was busy listening to the sound of mortar fire and sniper rifles in my other world. I buried my nose deeper in the dry pages I was turning and continued.

Tap. Tap. Tap. Scratch.

Distracted, I looked up and around the cottage. This sound wasn't the sound of the wind or the birds or the hum of the ancient refrigerator, which always seemed to have a leaky freezer and contain a hodgepodge of cooked hot dogs from a gathering the week before. I didn't notice anything and returned to my chapter.

Scratch. Tap. Tap. Tap. Scratch.

Again, I ignored this unplaced sound.

Rustle. Rustle. Tap.

I slowly peered up from my book. My heart...
Fucking.
Stopped.
I peered deeper and deeper into the heart of darkness, and what I saw, in that moment...broke me.
A flash of black and white. A blur. A ghost. An enigma.
A skunk!
It was halfway through the ripped screen door. Its demonic front paws were up and over the lower frame of the door, lying on the kitchen floor. It stared at me with proud *Here's Johnnnnnny* eyes. An avalanche of terror struck me. *The horror!*

Why the fear of getting sprayed by a skunk is so profound in me — to this day I don't know. Almost every east coast kid has either been sprayed by a skunk or knows someone who has. If not your sister, your cousin Bob, or your friend from homeroom, it's likely happened to your dog — your damn dog who just *had* to try to prove who's boss, only to be shamed and humbled. It'll come cowering back to you, seeking solace, protection and redemption.

To that point, I had somehow escaped a skunk's wrath: that noxious, pungent shower of disgust that would inevitably lead to social ostracism and consequent lack of romantic opportunities.

"Go on a date with Dave? Gross. I heard he got skunked."

Maybe it was the caffeine from the two Diet Pepsis I'd had earlier that day, maybe it was the bravado and the lack of clear-headedness that a second or a third beer injects into your psyche, or maybe it was the soldierly mentality that I was imbibing from the words I was consuming, but I have never moved so fast, or with as much fright.

The Thin Red Line flew into the air like exploding shrapnel, and I leapt to my feet like a gazelle springing to action to avoid a cheetah. Pure, unadulterated poetry, to be honest. The shark-chewed chair went tumbling backwards and

would have busted a hole through the drywall...if The Cottage had ever had something as fancy as drywall. It knocked down a couple of cobwebs, though, as a bonus. Ants and centipedes ducked for cover.

It was a race — a test of speed. The skunk, be damned his poisonous, stinky ass, *knew* it. His beady eyes locked on my eyes, which were attached to my bouncing head, lunging toward the kitchen — directly *into* the danger zone and bravely toward the enemy. He coldly communicated, "It's ON, bastard." *Fuck you,* I poetically responded.

He blinked first, put his head down and, with determination that I'll even give him credit for, pushed hard to get his striped arse up and over the wood frame and solidly into the kitchen. Up and over the established borders of my sovereign space. Into the cottage. My domain. My refuge and my solace.

If only Dad's camcorder had been set up on a tripod in the corner of the kitchen, it would have recorded an unhinged young man. His eyes would have been wild with the primal fear of the power of the universe and the heavens and hell beyond. It would have recorded that chair go flying, and the fastest three-metre sprint of his life. Donovan Bailey, the Canadian sprinter who had won the Olympic gold medal in the 100-metre just a few years prior, would have undoubtedly backed off in a head-to-head showdown, and if there was any degree of wind in that cottage that evening, it would have rippled across my cheeks and into my mouth, which would have flapped furiously as I floated across that open space.

The skunk, the intruder, looked up at me from the floor with violence in his eyes just as I extended my arm up and over his head, reaching for the open wooden door. My only mission was to close it. If I failed, I failed. I was prepared to go down trying, a proper soldier to the end.

When I look back, I picture him wearing camouflage paint on his face and a black bandana wrapped around his head.

"You're not going to stop THIS!" he screamed. He spun around, lifted his tail and readied his automatic machine gun. His cannon. His anus and the musky ammunition within.

"FIRE IN THE HOOOOOOOLE!!!!!"

These were the last words I heard him scream, just as I countered with a deafening BOOOOOOOOOM. The door, closing tight.

Silence.

.

.

.

.

.

.

It's so still.

.

.

.

.

The silence was broken by the sound of my heart exploding and blood gushing through my head. It pounded like an angry jackhammer.

All I could see was darkness.

Oh God, this is it.

The end.

A life lived, only to end like this. *Everything was pointless.*

* * * * * *

On the edges of the darkness, some light! And wait, *what's that*? Over there...through the haze...what?

Are those eyelashes?

My eyes. They were pressed closed. My eyeballs cowered as I slowly pried them open. Light flooded in, blinding me.

I was still holding my breath from the time of that final leap. I opened my mouth and my nose and tentatively sucked in some air, expecting the worst. My life flashed in front of me, and I whispered *I love you* to no one in particular. *I'm sorry I wasn't a better person.* In response, I heard "go forth in peace."

I breathed in...pure, sweet, delicious mildewy air. I cringed, expecting a delayed reaction. A split-second gap between anus explosion and the registering of senses. But, no...nothing. *Could it be?*

Heart crashing against my innards, I slowly slid down the door and collapsed on the floor. Right about the spot where his little demon feet had rested only seconds before. Sucking in air, tears ran down my cheeks. Sweat dripped out of every pore. Adrenaline surged through my body, and I lay down on the floor. *I'll do better*, I mumbled to the swaying light bulb hanging down from the ceiling.

I closed my eyes and let the darkness swallow me...

7

THE PINNACLE OF MY CAREER

It wasn't fair, but what is? Life is a crap carnival with shit prizes.

—STEPHEN KING

THE WAY SOME NATURE PHOTOGRAPHERS GO ON, YOU would think they talk to leaves, meditate with armadillos and exist on the same spiritual plane as rays of golden light rising over the perfect leading line in a misty beam at daybreak. As a writer for several photography magazines over the years, I've been guilty of a few of those "essays" myself. I've waxed poetic about the art of photography — and sometimes catch myself assigning it way more importance than it really has. Don't get me wrong, I love a good ideological rant on the nature of art and beauty and how I feel it's important for photographers to pay attention and capture it — I do believe in what we do having a *purpose* — but not at the risk of sounding too pompous or elevating ourselves to the status of saviours of humankind in the pursuit of our craft. Rather, from time to time, I like a good dose of self-deprecation. I like keeping our collective ego in

check (and when I say collective, I'm really looking in the mirror first and foremost).

I've noticed, over time, that what photographers don't often share is the honest "the struggle is real"-type stories of what goes into *getting* some of the shots: the challenges and embarrassments — the failures. Why not? Well, maybe that will upset the karmic nature of things. Or maybe it will make people think we're less professional than we let on? Too much fodder for the next beer night with photog buddies? In any case, I'm going to break down some barriers here. Full disclosure from the outset: any notion you may have had of me being a classy person may go into the sewer.

* * * * * *

Before I head out on a typical photography excursion I don't generally go overboard in preparation, but I usually give it some forethought. I'll go through a quick mental checklist of what I'll need for my location, and I'll try to think through what might happen, condition-wise. It helps me avoid getting to a prized photographic spot and forgetting something critical. If I'm going to be doing night photography, for instance, a headlamp and a tripod are necessities. If I'm going to be doing some higher-altitude work, bringing layers to be adequately prepped for a variety of (possibly quickly changing) weather conditions is paramount. If I know I'm going to be working a four-hour event without a break, properly eating and hydrating ahead of time is critical. And so on.

One afternoon I found myself in Cervantes, in Western Australia — hired and flown from Canada to shoot the wedding of a young couple. The Pinnacles are these incredible limestone formations in a small desert in the middle of coastal lushness that seems — like so many places in Australia — randomly dropped in by aliens from some

distant planet. Months earlier, when I knew I was to be travelling to Perth, I did my Google homework. This was one of the places that immediately jumped out at me — a landscape photographer's dream.

After landing and overnighting in Perth, my grand plan was to make my way the next morning, first, to Cervantes — a sleepy little fishing village — check into my hotel, do some scouting and then leave in early evening for the Pinnacles, which was only about a 15–20 minute drive. If my timing was right, it would get me there an hour before sunset. This, of course, I would try to photograph expertly. After sundown, I would shoot the post-dusk period known as the "blue hour" and then wait until dark to make some astrophotography images. The Pinnacle area, with its absence of light pollution, had a reputation of being a prime place to see and photograph the Milky Way. After I checked into my hotel in Cervantes and made an quick initial run to the Pinnacles to scout it out, I sat in the outdoor pub, sipping an afternoon brew, and went through my mental checklist for the evening:

Tripod: check.

Camera + lenses: check.

Intervalometer: check.

Book: check.

Headlamp: check.

Massive bean burrito: consumed.

Smug sense of self-assurance: check.

All set. Time to nail this sunset.

I made the short drive to Nambung National Park, protective home of the Pinnacles, feeling surprisingly fresh considering the non-stop travel. There wasn't a cloud in the sky and the light was already turning a light shade of golden. As I drove past the park gates, within metres a flash of brown whizzed to my left. A kangaroo to greet me. *Ha, of course.* Because, like, it's Australia. I can't even make this shit up. The only thing missing was Colin Hay singing on the side

of the road about a land down under; for now, I played it on my car stereo.

The kangaroo stopped hopping and simply stared at me. In response, I pointed my smart phone at it and snapped two or three quick photographs. Proof that I was there — and yes, I was greeted by a kangaroo. Not that anyone would ever ask, or care. Right now, the Aussies reading this are rolling their eyes. Kangaroo lifted his nose up into the air with arrogance and then hopped down the road. *Whatever. I have perfect sunrises to catch, Kangaroo. Piss off.*

When I made my initial afternoon scouting run into the park, I pinpointed exactly where I wanted to be for the perfect sunset. It involved a lot of slow driving on the dusty, bumpy roads of the park, but the beauty around me was staggering. *This truly is a place out of a movie.* I parked my car in the midday heat and hiked a short distance, where I found and pondered a few distinctly beautiful limestone arrangements among the multitude of Pinnacles; it looked ideal.

When I got there on this return trip, I was all business. My afternoon "hike" to my sacred location was only about a ten-minute walk from the main parking area, I noted with amusement. Even at this late hour of the day the park was busy with tourists with stretched-out selfie sticks with various Pinnacle formations in the background. Everyone, whether professional or amateur out with their family, wanted to capture a memory — a little piece of magic. So did I.

The sun was about 10–15 minutes away from its slow dip to the horizon when I arrived at my spot. *Oh, sweet Jesus, the light* — all sweet and special and glowy and fantastic. Photographers have so many words for beautiful light and right now my brain was bursting with descriptors. I had a sudden urge to meditate with an armadillo. Thankfully, it passed. I set up my tripod, carefully put my camera on it and set up for the composition I had scouted out earlier in the

day. Through my lens, the composition looked *divine* — even better than it had in the afternoon, as the light was now sensual rather than harsh. Looking at my watch, I estimated I only needed to wait about five more minutes for the sun to be in the perfect spot, and then my perfect shot of a perfect moment in a perfect, unique, one-of-a-kind place like the Pinnacles would be complete. *This is how it's done!*

* * * * * *

But, wait...*oh shit.*

Huh?

No, like, *literally.*

A bullet of pain rips through my stomach, followed (like thunder booming across the land after a strike of lightning) by a gurgle loud enough to turn an emu's head.

Well, that's annoying, I think. But, whatever. *This, too, shall pass.* This pain in my stomach. And lower.

Only it doesn't. It intensifies.

Ugh.

I start doing the dance. The "Clench," I think it's officially named.

The dance goes something like this: first, a slow hop. And then a freeze! (Where every muscle in your body stiffens in hopes that you push the pain away.) And then the cold sweats. And then another hop. And then a booty shake. Then you swivel your head around from side to side, anxious that someone might be watching. Repeat. It's a dance that's been perfected by humans throughout history. I can't claim ownership of it. Cleopatra, at one time, did this dance under the heat of the Egyptian sun. So did Gandhi. Even Julia Roberts undoubtedly did it (at least once) on the set of *Pretty Woman.* You can sit there and pretend you haven't done it. You *have.* Many times. I'm just owning it — for better or

worse publicly.

Nope, this pain isn't going anywhere. I consider my predicament.

Dave, run behind a bush...

Terrible plan. You're in a desert, dummy. There aren't really a lot of bushes, if you hadn't noticed.

Come on, work with me here.

Dave, even if there was the perfect bush, you're in a *national park.*

So? I really, really have to go.

Dave, if you were ever disrespectful enough to, you know, do your business behind a bush in a desert in a national park, karma would dictate that all your future images will be out of focus.

Okay, Mr. Morals. The bush is off limits. Oh, and this is the last time you come on one of these outings.

What about just holding it?

But, but the sun...the sun is...dammit!...it's almost the perfect time for the shot!

Another sharp pain rips through me. Holding it isn't an option.

But...my image!

Okay, this is getting critical. I've got to get out of here, now, image be damned. Either that or stay, and become a future spokesperson for Depends.

My tripod, camera and backpack are hastily packed up and I start running, kicking up desert dust and ants. I blaze a hasty retreat. I see the car. *Thank God.* Darn it...keys? *Keyskeyskeys.* I can't find keys. Okay, there's the keys. I'm now sweating like I've run a desert marathon. As I open the door, my stomach twists again and I double over.

Inside, the car starts and I hastily put it into drive. It's not far, distance-wise...but it's not a quick drive. Damn National Parks and their twisty desert "oh, don't you knock over a Pinnacle!" speed limits.

I narrowly avoid a selfie-stick tourist. I look to my rear-view mirror and see him squinting at me with a look on his face that says he knows I'm about to desecrate my rental. I picture him screaming, "I hope you can't clench any longer!" *Rude.*

Somewhere around the park entrance, I see relief. A big brick building that looks like a palace: a literal oasis in this desert. I made off like Mario Andretti across the parking lot and slide into a parking space with a slam of the brakes. A huge cloud of dust billows around the car. I take off running — a quick 50-metre dash — and crash through the public washroom doors. *This is almost over.* The evening janitor dives out of my way as he sees me barrelling in: he's been down this road before. I can see it in his eyes as our retinas briefly lock. He wants *nothing* to do with me, or this situation. I'm sure he'll report to his superior the next day: "Hey boss, it was clean when I did my pass around seven p.m....No, I don't know what manner of beast was in after that. It did *what*? People are disgusting!"

I find a stall and don't remember locking the door. Pity the person who might accidentally walk in after me. I don't remember unbuckling my belt or getting my pants down, but I do remember sweet tears of relief streaming down my face.

* * * * * *

POSTSCRIPT I missed my sunset photo. It happens. You can't win them all.

I did, however, acquire a little more respect for "the nature of things" after that evening, and modified my pre-shoot mental checklist permanently: no bean burritos.

8

ALL BARK, NO BITE

*I may be crazy, but it keeps
me from going insane.*

—WAYLON JENNINGS

I PEERED AT THE TROUBLE TICKET AND QUICKLY TOOK
note of the key details. Name, address and a description of
what was wrong. I stacked that trouble ticket atop the other
three trouble tickets I had in my metal-encased clipboard
and said goodbye to the crew, who were still milling about
the shop getting ready for their own days. I headed out the
front door toward my service van.

It was just another −35°C in Yellowknife, and today it
was my turn to drive outside the city, down the highway
about 100 km, and take care of whatever telephone issues
were happening in some of the smaller communities that
were serviced by Yellowknife, the bigger centre. About once
a week one of the service technicians in our crew would be
assigned to the community detail, and this week's rotation
was assigned to me. I never minded it. It was a chance to
blast my brand new iPod — a relatively new invention at the
time — sing some songs at the top of my lungs and watch the
dramatic long morning light kiss the land, lighting it up in

shades of pastel purple and pink as I floated down the road. This was meditation time. Talking to myself time. Open highway time.

After filling up at Gastown, I found Coldplay's *Parachutes* album on my iPod and turned the volume as high as it would go. I turned onto the highway and accelerated. Yellowknife, a city surrounded by countless kilometres of wilderness, lakes and overall vastness, could sometimes feel remote and restrictive. A little escape every now and then felt really nice.

Four trouble tickets. Really not a bad day, I mused, as I sang along to "Don't Panic." Some days were more intense than others, but a four-ticket day was average. Light, even. Which was good. I had a combined total of two hours of driving in the there-and-back, so if I could get through the tickets efficiently, without too many curveballs thrown at me, I should be able to make it back home by 6:00 p.m. In time to meet up with the crew at the Forty Below pub for a beer to recount the week that was and laugh at some of the madness. *Man, I need that right now.*

Heading to the smaller communities in the Northwest Territories was always an adventure, mainly because you never knew what you were going to get. Your technical support was largely back in Yellowknife, and if you forgot a key piece of material, like a spare telephone jack or a tool, it was a long, embarrassing drive back to the city with an incomplete trouble ticket — not to mention the wrath of the service manager, Wes. Before I headed down the highway — each time it was my turn — I usually spent extra time going through my van to ensure it was properly stocked, and analyzed the trouble tickets carefully to try to envision what issues I might encounter. Some of the telephone poles were crappy in that area too, and harder to climb. I also made sure I had my climbing gear and my ladder and my test equipment. Again, better to be ready for anything than encounter a big headache. I'd never hear the end of it at the Forty Below if I did.

After an hour of driving, weaving around the potholes and frost heaves that marked the highway "south" from Yellowknife, I finally saw the sight I was waiting for...the turnoff sign to my first community. Showtime. *Let's figure out where these customers are...and let's tackle them in order of difficulty,* I thought. Some technicians do the harder ones first; I always chose the perceived easier ones, with the reasoning that I needed a small victory or two — a quick win — rather than go completely off the rails on a problematic trouble ticket right from the onset. I've been down that road before, and it throws me off. You never know when one ticket is going to suck up an entire morning, or bring on a massive headache.

First stop, a breeze. "Customer complaining about crackling on the line," the ticket read. After knocking on the door and introducing myself, I went to the side of the house and checked the Network Interface Device, commonly known as the NID. The NID is the demarcation point between the telephone company's wires and a customer's own home or business wiring. Modern NID boxes make it easy for telephone service technicians to troubleshoot. You can "unplug" one side easily and test to see if there's a problem on either the customer or the company's side, which narrows down your troubleshooting time tremendously. Is the problem *up the pole*, or is the problem inside? That's the question I wanted to answer first most of the times when troubleshooting.

My quick test at the NID revealed a problem on the customer's side. I knocked on the door again, explained that the problem was inside, removed my steel-toed workboots and started looking for the trouble. Sometimes that hunt could be time-consuming; the problem could be any one of the various telephone wires that run through a residence or the jacks they are attached to. On this day, I found the problem almost immediately: a telephone jack that looked like it had got yanked from the wall. One of the two wires

needed to make a connection was barely attached, and it looked like something had been spilled on the jack too. Apple juice. *Mmmmm.*

Within minutes I had the jack replaced, a good, clear, strong dial tone, and my trouble ticket signed off by the customer. I phoned my progress back to dispatch and closed off the trouble ticket; repair times are monitored closely not only by my company but by the Canadian Radio-television and Telecommunications Commission (the CRTC), who mandate set repair time limits nationally. "Great job, Dave... That was speedy!" That was Julie, my friendly dispatcher.

With a quick win under my belt, I sat in my van, chewing on an apple and plotting my next move. I leafed through the three remaining tickets and picked my winner. "Telephone set doesn't seem to be working; no dial tone in the bedroom." *Easy-peasy.* This usually meant another jack problem — like the ticket before — or possibly a problem with the actual telephone, or the line going specifically into the bedroom. All fairly quick problems to diagnose and solve. Most times. Julie's going to be mighty impressed with me, I thought, if I can clear two trouble tickets in less than an hour. Wes might even give me a "Good job!" if I make it back to the shop an hour early.

I navigated down one snow-covered road, and then another, scanning the house numbers as I drove slowly. I eventually saw my target: a small, brown, wooden-sided bungalow. Pulling into the driveway, I noted that there was no vehicle in the driveway. *Man, I hope they're home.* I could fix any problem outside a person's house if they were not there. Inside, of course, is different. Company policy dictated that a customer must be home to fix anything inside, even if they've given you permission to enter without them. *Makes sense, I guess.*

* * * * * *

Knock knock knock.

I stand outside, glancing over the clipboard at the customers' names. Edna and Johnny. I commit this to memory and knock again. I can see my breath in the cold, crisp northern air, and can feel the crunch of snow under my workboots. I love the north with a passion. Right now I'm getting chilly, however. The faster this day goes, the better.

Still no answer. I silently groan and start to contemplate my next move. Maybe I'll go to the third stop of the day and then beeline back here after I fix that; it's possible they'll return home by the time I'm done that. If worse comes to worst, I'll have to report it as a no-show. Their bedroom telephone will have to wait until next week.

I decide to knock one more time, this time listening intently after I knock for any signs of movement. Footsteps, or signs someone might just possibly be in a shower.

Success! I can hear a thumping sound, followed by what seems to be a muffled voice. I can't really tell for sure, but I know someone is home. Feeling relieved. I should now be able to solve this ticket quickly. I gently knock again.

Still, no one shows up at the door.

I decide to do something I really shouldn't do, but I know everyone does...especially in the north. I decide to try the door to see if it's open. Turning the handle, I find it unlocked. I slowly open the door, and again can hear a thumping down the hall followed by footsteps.

"Hellllloooo! This is Dave from Northwestel. Anyone home?? I'm here to fix your telephone."

The noise coming from down the hall stops. I hear nothing except the hum of the furnace. Silence.

"Hellllllloooo! Northwestel! Are you there?"

After a couple of moments of silence, I hear footsteps, possibly in a bedroom. Good, I thought. They're coming. But still they don't answer, and I'm beginning to wonder what the hell is going on. Have I stumbled upon an intruder? Is

Edna a mass murderer? Is Johnny growing something illicit in the bedroom and he's going to retrieve his firearm to protect it at all costs?

The footsteps continue then stop once again. I hear the door creak open and I take a deep breath. Whoever is there is now in the hallway, but I can't see the hallway from my angle. I'm standing outside still, with my head poked into the open doorway.

"Hello?"

I say this timidly.

Shuffle shuffle shuffle. Whoever is in the hallway is moving toward me at a snail's pace. This is getting seriously creepy. My heart starts racing.

I see a hand grip around the edge of the wall. Just a hand. *What the fuck?* It doesn't appear to be bloody, or be holding a weapon.

"Hello? Northwestel, here!"

I see a mop of hair slowly reveal itself from around the corner, but still I don't see a full face. Just wild hair...and then a forehead. A head appears, sideways. Eyes. They're wide, and wild. *Jesus.*

A woman's face surrounds the eyes, and she's looking at me — no, looking *through* me — and I wonder what she's looking at.

"Excuse me, ma'am, I'm from Northwestel. I understand your phone is not working? We have a trouble ticket that was phoned in. Are you Edna?"

She looks at me, then down to the metal clipboard I'm holding, and then back at me again.

She opens her mouth...

I wait. Anxious.

...and lets loose "RUFFFFFF!"

I jump. *What the fuck.* Did she just bark at me?

I look at her, trying to discern if I heard her right. I don't think there's anything in my employee handbook about

ruffing, or the appropriate professional response. Her eyes widen even further.

"Excuse me," I start to say, but she cuts me off.

"RUFF!"

Ruff?

"RUFF!. RUFFRUFFRUFFRUFFRUFFRUFFRUFF!!!!!!!"

She's gone full-on German shepherd on me. WTF.

"Um, ma'am," I say nervously. I start to back out of her doorway.

"RUFF! RUFF! RUFFRUFFRUFF! RUFF! Grrrrrrrrrrrr... ...RUFFF!"

Whatever portal to another universe I have opened, I want no part of this sorcery. Where's my van? Where's my ham sandwich and Coldplay? Where are my keys? How did I choose this life? Is it too late to make a change?

I gingerly close the door and turn around to get out of Dodge. I get to the bottom of the steps when I hear the door open. I turn around and see she's taken a step onto the front step, her bare feet standing directly on the hard-packed snow.

"Are you okay, ma'am?"

"BARK BARK BARK BARK RUFF RUFF RUFF!!!!!!"

I break into a trot and head toward my van. I look to see if she's running behind me, nipping at my heels, or peeing on a bush with one leg raised. Luckily, she isn't. Instead, she's gone back inside, and I see her in the window, still barking through the glass pane.

My heart is beating and I'm disturbed. Big time. After getting safely away from the doghouse and onto the next block, I pull over. I phone Julie.

"Um, Julie. I'm not really sure how the CRTC wants this one classified..."

9

SHAKE, RATTLE
AND ROLL

*Nothing in life is to be feared, it is only to
be understood. Now is the time to under-
stand more, so that we may fear less.*

— MARIE CURIE

1:47 A.M. ON THE 21ST OF SEPTEMBER, 1999 — A TUESDAY
— is not a singular moment that will likely stand out in most
people's lives. It's not practical, like 5:00 p.m., or sexy like
12:12 a.m. It's a time of day when most normal humans are
sleeping. If they're not sleeping, they're cursing the perils
of insomnia, trying to stay awake at yet another nightshift
or trying to make their way home, with wobbly legs, from
the after-club pizza shop. 1:47 a.m. on the 21st of September,
1999, however, will always be a date entrenched in my mind.
It's a moment that led to more than 2,400 people dying.
Essentially all at once — in one country. The country I was
living in.

* * * * * *

Farller that year, Erin and I were walking through a job fair for recent university and college graduates. A job was something we desperately needed: after close to four years of higher education, endless student loans and minimal income, our collective debt had grown to something resembling that of a small nation. I'm pretty sure we were on par with Estonia or Namibia. Or, at the very least, Liechtenstein. Times were exciting but bleak — job prospects in Atlantic Canada in those days were far from abundant or lucrative. I can't remember which of us spotted it first, but out of the many booths filled with smartly dressed people preaching the virtues of coming to work for their company or organization, one booth grabbed our attention. The banner read simply, CITO. The Canadian Institute for Teaching Overseas. Curious, we found ourselves drawn to it, and the man who was standing behind the booth smiling.

A couple of short months later, we found ourselves tearfully and excitedly hugging our families goodbye before heading into the departures lounge of the Halifax International Airport. In the whirlwind time since we approached CITO's booth, we had secured jobs in Kaohsiung, Taiwan, as ESL (English as Second Language) teachers. After all manner of red tape, scrambling and excited preparation, it was now time to leave on our grand adventure to the other side of the world: Taiwan, where we both had one-year teaching contracts that promised to pay a good deal more than anything we hoped to make back home. The thought of being able to afford to eat for a year was kind of nice.

* * * * * *

1:46 a.m. on the 21st of September, 1999.

I woke up immediately, as did Erin. What was to come wouldn't come, officially, for another minute or so — but

it was the dogs that first woke us. A chorus of howls had sparked up and spread through the neighbourhood in seconds. Every stray dog wandering or sleeping on the streets quickly joined in. As we slowly came to and made sense of what was happening, the howls hit us. The howls haven't left our brains since. We had been living here, in this apartment, for over six months and had yet to experience anything like it. Over the din of the dogs, we heard it: a low groan — seemingly from the bowels of the earth. I wasn't sure if I was awake or still sleeping...but if I was still sleeping, I didn't want any part of this dream.

Our hard bamboo bed, which we initially cursed but had grown to love, was normally so rock-solid that if either of us were to jump up and down on one side while the other was sleeping, the other wouldn't feel it. But now it was moving... and that was different. Unusual. Not just gently moving — it felt as if we were in the middle of the ocean, riding the heaving sea waves up and down during a winter swell. Immediately, Erin's arm reached out for me and mine, her. *Earthquake,* I whispered. Not that it needed being said; we both *knew.* In the dim light of the room, our eyes locked — wide-eyed and fearful.

"Come — to the door frame." I jumped out of bed and pulled Erin along with me in the darkness. The floor was like Jell-O. We swayed and stumbled. The floor pitched and heaved and rolled as we lurched forward toward the door frame. The walls rocked back and forth at impossible angles. This was *really happening,* and whatever notions I had in my head previously about what it might be like to be in an earthquake quickly went out the window. I remember saying to Erin, naively, before we went, "Hey, Taiwan is in an active earth-quake zone. Think we'll experience one while we're there?"

On shaky legs, we reached the door frame. We held each other, fearful, and watched as the small apartment around us rocked and rolled but somehow defied gravity. The walls

swayed violently and the floor continued to buckle up and down. It was as if we were living in the Upside Down, from *Stranger Things*. At any second, we expected the concrete floor above us to come crashing down, instantly crushing us.

Fuck.

We briefly entertained the thought of running for the stairs, but we were on the fourth floor of a ten-storey apartment building. It didn't seem practical at the moment — but then again, nothing seemed real. All we could do was wait. And pray.

It's hard to describe the sound an earthquake makes. "Rumble" seems too gentle a word — but that's what it was. A deep, demonic, guttural orchestra that resonated off buildings, pavement, storefronts and seemingly off the sky itself, growing in strength as more and more buildings around us groaned and swayed and screamed. For impossibly long moments, all we could do was hug each other tight and listen to perhaps the soundtrack of our deaths. We had no clue what exactly we were experiencing. An earthquake, of course, but we had no point of reference, no indicator whether this was big or small or commonplace or rare or something of little worry or if these were to be the last breaths we took. We had never experienced an earthquake before. Not once in my 22 years leading up to this moment had I ever felt the ground shake unnaturally like this. Only it *was* natural, and one of nature's most powerful actions. All we knew was these moments were pure, unbridled hell.

In the context of an overall life lived, this earthquake was but a blink. It felt, in the moment, endless. It rumbled and twisted and buckled for almost two whole minutes before finally, improbably, the walls stopped swaying and the floor stopped buckling. We opened our eyes and let go of each other — each in a death grip that would later leave bruises. We looked at each other and finally allowed ourselves to breathe, first, and then speak.

"Holy shit...that was crazy. Are you okay?"

"Yes. You??"

Our apartment was still standing. We weren't buried. Our overhead light fixture still swayed back and forth from the earlier momentum, and we could see a layer of stirred-up dust visible in a small beam of light from the outside streetlights. *The power is still on. That's a good sign.*

I ran over and opened the window, looking outside. The buildings opposite us seemed fine. I stuck my head farther out the window and looked left and right. Everything seemed to be standing — nothing seemed to be collapsed. Looking down to the street below, I saw dogs everywhere, still howling — still scared and pissed off from being wakened from their street slumber.

I turned back to Erin and shrugged. Having never been through an earthquake before, we just didn't know. "Maybe that wasn't so bad," I said unconvincingly. "Everything seems okay. I don't see anyone in the streets. Maybe this is sort of commonplace here?" We both had a bad feeling.

We were too shaken (literally) to sleep right away, and were still lying wide-eyed, staring at each other and the ceiling when the first aftershock hit. Once again, our little apartment shook, and once again we ran to the door frame wondering if "this was it." This aftershock was almost as strong as the initial quake, and over the course of the next hour we would experience several more aftershocks and repeated leaps out of bed. Exhausted, frightened, huddling, each time wondering if our game of Russian Roulette with nature was going to end the wrong way. Finally, Earth seemed to relax, tired from this little display of her power. The aftershocks quieted, at least for the time being. Our apartment became still enough for us to drift back off into a panicky, restless sleep.

I can't remember exactly how long we slept — maybe a half-hour, or an hour, tops. Around 4:00 a.m. our telephone

rang, sending us both shooting straight up from our slumber. Erin slipped out of bed and answered.

"Hello? Oh, hi! Yes, no, we're okay. We're fine, seriously. What's up?" After a pause she exclaimed, simply, "Oh noooo!"

"Dave, turn on the TV. Turn on CNN. It's Joann...She's watching Taiwan from back home. The earthquake. It's all over the news."

Joann was Erin's sister, and she was in Quebec. With time zone differences, it was way later in the day in Canada. She was watching breaking news back home about the mass devastation in Taiwan. The earthquake registered a 7.7 magnitude — and was reported to be the worst to have hit Taiwan since 1935. As we watched CNN, our eyes widened. Scenes flashed across our television showed building after building reduced to piles of rubble. Ambulances and rescue teams and bloodied faces. Terror and confusion. Here we were, safe in our apartment — which had escaped unscathed, as had most of our city. A little farther north, people weren't so lucky, and the devastation was pretty widespread. In total, more than 2,400 people lost their lives and another 11,000 people were injured. Those exact numbers wouldn't become known for some time after the quake, in the weeks and months to follow. At the moment, we were just thankful to be alive, safe and together.

Sleep didn't come for the rest of that night, and the next 24 hours were a daze. As reports came from across the country, a bigger picture of the extent of the devastation became clearer. This wasn't an everyday quake, and was one of the most serious earthquakes in the world that year. Only the 7.6-magnitude İzmit earthquake in Turkey would claim more lives, taking over 17,000 souls.

School continued on as normal that afternoon, and as our young schoolchildren came into our classrooms, looking tired and sad, we realized that almost everyone we talked to

had a relative, a friend or knew of an acquaintance who had died, been injured or had their home destroyed in the quake. Taiwan is a fairly small island, and this quake affected people throughout the country. We offered empathy, but really there wasn't much we could say or do. It was a national tragedy.

One of the toughest parts of the next few days was living in constant fear of the aftershocks. In the month following the main quake, Taiwan would be hit by over 12,900 more measurable aftershocks, some of them almost as large as the initial quake. A full five days later, on September 26, an aftershock hit while Erin and I were walking around our neighbourhood on the hunt for some groceries and a pay phone for a quick call back to Canada. While Erin was on the phone, the ground started heaving up and down once again and we both lost our balance. We were next to a parked car, and it angrily rolled back and forth and looked as if it was going to charge us — a scene from *Maximum Overdrive*, a horror movie about machines coming to life — before the tremor finally broke and settled down once again. That after-shock measured 6.8 – a powerful earthquake in itself — and would cause the collapse of some more already-weakened buildings. I looked to Erin and she looked to me. The phone was dangling by its cord, swaying back and forth. We were beat. Done. *Finished*.

We had been in Taiwan about six months at that point. We technically had about six months left in our contracts, but we both knew that was *it* for us. Our hearts cried out for being back home with our own families. To be in a place where the ground didn't shake. We put in notices with our employers with heavy hearts and within a couple of weeks were on a flight back home — disappointed that our Taiwan year hadn't ended in the same spirit of optimism as it started, but also feeling a little wiser (maybe for the first real time in our young lives) with the reminder of just how short and precious life is.

10

NAMIBIAN NIGHTS

Never let your ego get in the way of
asking for help when in desperate need.
We have all been helped at a point
in our lives. — Edmond Mbiaka

HELLO, AND GREETINGS FROM NAMIBIA. I HOPE YOU receive this letter well. Sorry I haven't written more, but it's been the usual mayhem.

I hope that all is well and beautiful back "home," despite the bitter cold and the onset of winter winds that are probably cutting right through you. Sometimes I don't fully appreciate the beauty of the cold. I will now, forevermore.

I'd like to say things are going perfectly here, but it's been a bit of a trying couple days. An understatement, as you'll learn. I had a bit of a life-and-death situation play out over the last 48 hours — one of the hardest experiences of my life. Let me back up.

When we last talked, I was heading way inland with Aaron and Paul, my travel mates. Away from roads and humanity. Our route was going to take us, via off-road 4x4 trucks, deep into the backcountry: driving across plains and valleys first before eventually hitting dune country. Dune

country is beautiful but sort of harrowing to drive through. It's an endless series of massive dunes...to navigate and "make miles" in this territory requires driving up apartment building-high faces of dunes... and then, once cresting, eventually plunging down the other side. It's scary as fuck, yet weirdly fun (when you're with a driver you trust). We're with a great team, and with fantastic guides — Michelle and Paul (not to be confused with my travelling companion, Paul Zizka). We trust them implicitly.

The initial travel through the dunes was fine, to be honest, and kind of exciting. As we got deeper into no man's land, however, the temperature started climbing higher than anything I've experienced in my life, including all the times I've spend in the various deserts around the world: the Sahara, Death Valley, Western Australia, Dubai and, of course, Namibia the last time I travelled here. First, in mid-morning it hit 43 degrees Celsius — which even at 11:00 a.m. was a degree higher than the day before. We thought *that* day was deathly hot. It didn't stop at 43°c. Impossibly, it kept climbing as the morning stretched to noon, and then noon turned into an endless mirage of an afternoon. 44 degrees. 46 degrees. 49 degrees. Jesus. Once it hit 49°c, we couldn't keep our eyes off the dashboard temperature gauge. Now that we had come this far, we were weirdly rooting for it to hit 50°c. You know, for bragging rights. And you know what? It DID! When the reading changed from 49°c to 50°c we all let out a whoop and started cheering. After that little moment of joy, I think it hit us all just how crazy that really was. 50 degrees? So fucked. Seriously hot. Dangerously hot.

Our problems started when we crested one particularly big dune and then drove down the other side into a little dip. The truck bogged down and got stuck in some softer sand. This is not all that unusual in the dunes, to be honest — usually you just work your way out through a series of forwarding and reversing, or the second vehicle pulls you out. Paul, the driver,

couldn't work his way out of this one, though, and by weird happenstance and poor timing, at that exact moment the second truck — driven by Michelle — died. Like *dead* dead.

It took about 30 minutes for Paul and Michelle to dig us out, but they managed, even in that crazy heat. We tried to help, but by that time it was so hot that if your feet touched the sand for even seconds you felt them blister. We were all wearing flip-flops, and it was tough to keep the sand from touching your feet. So painful. Bottom line, we were useless as helpers. They just rolled their eyes at us and went about digging the truck out; we just assumed this was an every-day occurrence for them (we later learned it wasn't). They ultimately freed the stuck truck, but now we were down a vehicle. There was no bringing the dead one back to life — not out there.

They took out and connected the tow rope, and our truck (which had the two Pauls and me in it) towed their vehicle (which had Michelle and Aaron in it) the next 30 km through endless dunes and valleys. This made for incredibly slow progress, and the driving truly felt endless. Many of the dunes required multiple attempts up as the one truck strug-gled to pull the other.

At least our vehicle had air conditioning. At 50°c the effects of it were nominal, but at least we had air blowing, cooling the cabin slightly. Their truck? Well, it was dead. A dead truck meant no possibility of A/C. Michelle was simply steering it as our truck towed it along, and the only relief they got was with open windows. Man, I felt for Michelle and Aaron. Anyway, back to the plot. Wow, it was slow going! As a result of the breakdown, being stuck and towing, when we finally got to our destination it was much later in the day than originally anticipated. As a result, we had to find a spot for camp that was a little less than ideal.

Paul and Michelle set up camp, but the winds were intense and howling so hard that sand permeated everything. We

would sit in what we thought was shelter from the elements and within seconds our arms, hair, lips and everything else would be completely coated with a layer of grimy sand. Pretty wild. It all felt so hot and grungy and dirty. We poured sweat, endlessly, and just got caked.

I'm not sure if I told you ahead of time, but the reason we were there, photographically, was to attempt to shoot this place called Deadvlei — at night. Deadvlei is this incredible dried-out white clay pan that is pretty famous because it also has this collection of dead 600-year-old camel thorn trees in its centre. They're not petrified — they're just dried out — but they're strikingly beautiful. I really hope you have the chance to travel there and see them with your own eyes someday.

Shooting Deadvlei at night is almost never done — despite it being one of the most beautiful places on Earth — because the Namibian government doesn't allow access after dark from the normal, sane, "easy" way in — a roughly 2 km hike through reasonably packed sand after driving from a nearby community for about 30 km. I'm just making estimates on the distances here. Someday I'll narrow it all down a little more precisely, but at the moment I don't have access to Google Maps.

So we had no access from the "easy" side, and, to be honest, before we left Canada and were in the planning stages, we didn't think we were even going to find a way in after dark. It didn't look possible. Everything we read online said basically that it was impossible to access Deadvlei at night.

Our fortunes changed, however, when we contacted Paul and Michelle. We've used them as guides in Namibia before, and they're top-notch. They went to work researching a legitimate way into the park, and they ultimately succeeded, coming up with this plan. We knew it wasn't going to be easy and we were right: the plan they presented called for this crazy 14-hour drive south first, and then back up north

to let us come in from the lands on the "opposite side" of Deadvlei. Apparently, no company but the guys we hired has access to — or permits to operate in — this side of Deadvlei. The problem, though — aside from the long drive across wild uninhabited country and the aforementioned massive dunes — is that there's no easy access from this opposite side down to the dried floor of Deadvlei. Not from our camp, and not from anywhere, really, along that side of the pan. It's surrounded by steep, difficult terrain.

Let me back up a little. The location where Paul and Michelle set up our camp was on the backside of this monstrous son of a bitch of a dune known as Big Daddy — one of the biggest sand dunes in Namibia. I think I remember Michelle saying it's about 325 metres. Over 1,000 feet of sand...think about that!

Going down Big Daddy down to the pan below isn't an issue, nor any great physical feat: you basically slide/surf your way down on a sharp angle and end up on the Deadvlei floor. Seriously, it's a lot of fun on the way down — like how I envision snowboarding to be, if I ever was brave enough to try it. You pick up a lot of speed and in no time flat you've gone from the top to the bottom of this insanely steep sand face. I really wish someone had been at the bottom of it recording us as we whooped and yelped our way down. Three men acting like kids and loving every minute of it!

Paul and Aaron and I made our way down the edges of Big Daddy right around sunset, 7:30 p.m., with an abundance of camera gear and the intention to basically stay out all night. We had come this far on this impossible route, and we planned on soaking up every minute of the night. Most likely we'll never be back here again, at least not at night. Our goal was to capture and create something memorable — something *unique*. After a big night out, our plan was to head back up the dune in the early morning when first light hit, get back to camp and crash.

* * * * * *

Almost as soon as we slid down the dune and got organized on the pan floor, I started feeling *off.*

I had a slight headache and just felt a bit weak. As you know, I don't really get headaches. Rarely, anyway. Although I'm not a model of fitness, in these situations I'm usually the "go guy." On these trips I don't generally feel weak and normally have good endurance. I just want to keep going. Making hay while the sun shines, as the saying goes. The previous two nights I'd had only three or four hours of sleep per night, so also wasn't feeling too hot from that. I love these trips, but man, oh man, I sometimes suffer from lack of sleep on them! I remember thinking at the time that it was most likely just a mild case of heat exhaustion from the crazy day. It was still about 38–40 degrees when we slid down the dune, post-sunset. Despite all that, it was no time to complain. *Suck it up.* This is why we're here and have spent a lot of money to get here.

Standing on the floor of the pan, I looked across to the far end where the famous old trees were. Despite the headache, I just thought, *wow, we're here.* The three of us started across the lake bed. On a normal day, it would be just an easy little scenic jaunt: about a kilometre across on entirely flat ground, surrounded by glowing dunes and not a soul in sight. Even with my aching brain, I was able to appreciate what we were about to do. *Fuck, this place is beautiful.*

It took us maybe 15 minutes to cross the pan. Once we reached the trees on the far end, I took off my heavy camera bag and rubbed my shoulders. I had taken pretty much all my camera lenses with me, my tripod and a 1.5-litre bottle of water. So, yes, a fair amount of weight. Not multi-day backcountry hiking kind of weight, but a solid 30 pounds, if I had to estimate. You know how I talked before the trip about getting a lighter carbon-fibre tripod? Yeah, well, I forgot. Hindsight, eh?

The golden evening light was still pretty great. Aaron and Paul went off in different directions to scope out compositions and create. We knew we had a couple of hours, at least, until the stars really came out. *Plenty of time to take it all in.* I just sat down, trying to shake the headache. It wasn't budging, though. Every movement I made, it dug in deeper. It throbbed, and a weight overcame me. I tried to take a little nap, lying flat-out on the floor of the pan — my head against my camera bag — but the wind was howling too hard and sand was finding its way into my eyes no matter what angle I positioned myself in. *Brutal.* Not only was it the hottest day I had ever experienced in Namibia, but it was also the windiest. What an inferno; Dante would have been proud.

I was feeling terrible, but I decided to just suck it up and shoot. I thought that maybe moving and concentrating on something would be good for my head. Surprisingly, I lasted a while, even feeling like shit. Between 8:30 and 9:00 p.m., I shot the majestic trees, which were getting blasted by the dust storm. The dust was brutal to experience, but the photographs were pure joy: such incredibly unique conditions! I got some of my favourite images of the trip in that 30-minute blast.

Sunset turned to blue hour, and blue hour to night. The winds finally died down and stars started peeking out — the magic we were really waiting for. I moved on to shooting the stars, capturing a star-trail image that I was proud of. I even took a nude self-portrait, something I've never done before...I must have been out of my bloody mind! It was just so hot on the floor of the pan and clothes felt like a weight. It felt so good to get them off.

Around 10:00 p.m. we all realized that we were all getting a bit dehydrated and our (well, mainly my) water supplies were getting low. I was more dehydrated than Aaron and Paul, and they were kind enough to share some of their water

with me. The night was still long in front of us, and despite the water break, I felt myself getting more and more thirsty.

Now, of course we had brought water down from camp, but we failed to realize that it would still be so incredibly hot at night. Deserts are often known for being on the chillier side in the evening. That's what I had in my head: that we'd be operating and returning to camp in the wee hours in the chill of a clear night sky. I had even brought my puffy down jacket for the colder temperatures — temperatures that were never realized. What water we had brought down with us was quickly used up over the first three or four hours. We realized that we would need more if we were going to last the entire evening.

We radioed up to Paul and Michelle, who were sitting perched alongside Big Daddy overlooking Deadvlei below, enjoying a fire, an evening meal and the stars. They rolled four 1.5-litre bottles down to us at the far end of the pan, bless their hearts. Thankfully, Aaron and Paul volunteered to go retrieve them. They knew I was feeling really crappy; I wasn't sure I had the energy to walk across the pan and back to retrieve them. With this replenished supply of water, I thought *all good*. That was premature.

Even with more water in me, shortly after they returned — about midnight — I made the hard choice that I was going to have to bail early. I communicated this to the guys, who were a little incredulous that I was going to skip my chance to shoot this place at night, but they understood; my stubborn headache was worsening. The thought of climbing that dune in the morning sun when it was probably going to be well over 40 degrees again didn't appeal to me. At all. I wanted to tackle the dune and get back to camp when it was still cool enough to sleep a little. I took one of the water bottles, leaving the other three for Aaron and Paul, and packed all my gear up. I started back across the pan toward the base of the dune, stopping occasionally to snap a few final images.

As I trudged across the dried floor and got closer and closer to the base of the dune, visually it towered higher and higher above me. Reaching its bottom delineation, I looked up... and gulped. This really was a beast. I readjusted the heavy camera bag around my shoulders, tightening the strap, and started up.

I can't really describe how big the slipcase of this dune was or how much sheer physical effort it took to take even one solid step up. It was as steep as sand can be without falling in on itself. These were details we'd failed to note as we gleefully slid down this monster hours before. Even the first ten steps felt like a killer — especially with the weight of the bag on my shoulders. For every two steps I would take up, I would slide about the equivalent of one step back down. I peered up at the never-ending wall of sand, which disappeared into the starry night sky. *What the hell did I get myself into*, I thought.

* * * * * *

It was 30 minutes later, and I'd been making almost no progress. I was inching upwards like the slow spread of sticky molasses. I was sweating buckets and panting. Looking up again, I estimated that at my current pace I probably still had — at minimum — two more hours of climbing left. A sense of dread was building in me. I realized that I had a major problem. *Water*.

To get through that first 30 minutes I'd gone through almost my entire 1.5-litre bottle of water. Our route up Big Daddy to the camp consisted of two near-vertical climbs. You start with one steep climb up an initial slipcase from the bottom of the dune at the floor of the pan; once you finish this first huge vertical, you hit a ridgeline and then a plateau and then start up another giant wall.

By the time I finally got up and over the first vertical, hitting the first plateau, I was more exhausted than I'd ever been in my life. For me, that's saying something. You remember my experience on Baffin Island? The time I got the kidney stones during the two-week hike? To be honest, I was even more shattered than on that hellish day.

As I walked a few steps along the ridgeline, my body was shaking and I couldn't catch my breath. I was sucking hot, impossible air into my lungs, but it was as if it wasn't recognized by my body. It was foreign and it had no impact. No matter how hard I sucked air, I felt I was suffocating. I lifted my water bottle to my lips and realized — with horror — I was on my last drops of water. These last precious drops gave no relief. My body literally started giving out. I let my camera bag fall from my shoulders and I just collapsed into the sand, straddling the spine of the ridgeline.

I couldn't move. My body spasmed as I gasped for air and pain shot through me. I lay there in the sand with burning, parched lungs. All I could do was close my eyes and try to bring my breathing under control.

* * * * * *

I don't know how long my eyes were closed — probably 30 minutes or so — but my breathing finally stabilized to some degree. My deep, heavy gasps turned into short, ragged, shallow breaths that filled my lungs with heat. My head was still pounding, but I eventually managed to open my eyes, and when I did, I realized I was staring at the infinity of space. Countless bursts of starlight twinkled above me, bathing me in their beauty. If death was a vessel to bring me to this perfect portal, so be it. *I'm ready.*

The scene was so perfect, and I could have just remained there, perched precariously on this knife edge for hours, if

my body could hold on. Everything felt warm and peaceful and still. I forgot about my breathing. I forgot about everything. It was so peaceful and beautiful looking at the stars, yet I knew instinctually I was in trouble. I've often heard of people freezing to death in cold climates feeling warm and peaceful right before hypothermia closed its grip. I had no baseline knowledge on what dying of heat exhaustion and dehydration could or should feel like, but I knew what I was feeling in this moment wasn't, despite appearances, *good*.

I had to keep moving. Period. I wanted to stay there forever, but I knew I needed to keep putting one foot in front of the other. To find water and to replenish my body, which was now shutting down. The moon was creeping lower in the sky, setting above the dune on the opposite side of the pan; in about an hour it would be gone — taking away whatever "natural" light I had left. I didn't want to be stuck halfway up this massive dune, all alone and without water, where no one knew exactly where I was in the pitch black. Aaron and Paul weren't due to climb up themselves for likely at least six hours, maybe more; our guides atop the dune also weren't expecting us until morning and had no reason to believe anything was wrong.

I don't know how, but I lifted myself up from my prone position and stood on shaky legs. I looked down to my heavy camera bag and tripod and near-empty water bottle, dreading the weight of all three. The thought of hauling the camera bag or the tripod was defeating. But I simply had to. I couldn't leave them there. Way too expensive. I grimaced in expectation and heaved the bag up onto my back. For a split second all seemed well but, then, AAAAAAAAAGGGGH. My back started spasming. Hard. Every nerve ending in my body exploded. I yelped and my bag dropped hard to the ridge. Waves of blinding pain swept through my body and tears streamed down my face. I felt like just giving up.

Plain and simple, I couldn't go on with my gear. I made the decision to abandon it. It was just too much. Every step

would have been impossible and pure agony with it. $11,000 worth of camera equipment left to dust on the ridgeline of a dune in Namibia. At least I'd have a dramatic departure story out of it, eh? Better than it getting stolen out of the back of my car in a Walmart parking lot in Moncton, right? After letting my spasms pass, I gingerly continued on the edge of the ridgeline, each step agony, toward the base of the next massive vertical climb. I looked back to my gear and prayed Aaron and Paul would find it upon their return, even though I knew it would be impossible for them to carry it along with their own gear.

* * * * * *

I started up the next vertical slipface. Within ten hard, impossible steps upwards I knew I was screwed. I had no more water — my empty water bottle was tucked into the camera bag I'd left behind — and my mouth was more parched than it's ever been in my life. It was destroyed and blistering. It screamed for moisture, and as far as I could tell that was an elusive dream for at least another hour. That was assuming I could even climb the next wall.

I felt my throat closing, as if someone was tightening a noose around my neck. I dripped sweat — precious moisture I couldn't spare — and my heart was pounding so hard I felt as if I was standing under a bridge, listening to the boom and echo of trucks careening across. My gasps were now desperate, futile, empty. Every single breath of air fought its way through a constricted throat, and what little air actually hit my lungs had minimal impact. Even if I was stopped on the side of the dune, in a resting state, attempts at breathing would be fleeting — I wasn't at rest but was still trying to inch my way upwards against an ominous, omnipresent wall of sand. Two impossible steps up, one slide back. On

top of it, I started continuously throwing up, losing to even a greater extent what little water I had inside. Every five or six steps I would feel my stomach lurch and come up. Bursts of light popped through my vision and my brain and the world started spinning. I dropped to my knees and hugged the side of the dune wall. *I can't go on. I can't do this.*

As you know, I'm an experienced outdoorsperson. I've hiked the world over, and spent time in glaciers, mountains, forests, tundra and plains. I've climbed mountains. I've successfully led hundreds of other people on trips on almost every continent. I'm not saying this to brag. You know me better than that.

I've never, ever, had to call out "help" on one of these trips (and have always wondered how drastic a situation one would need to find oneself in to do so), but it felt like things were getting drastic. That I was within touching distance of *the end*. I felt I was beyond the point of being able to carry on and live to type this out. I probably still had 60 minutes of hard climbing left (for a healthy hydrated person with no gear) and felt I would literally drift away permanently if I couldn't find water. I needed moisture and soon. Everything was spinning.

I was still far, far away from Paul and Michelle, above, and I didn't have a radio. (I'd thought it wiser to leave it with the two guys down below...big mistake. So many mistakes.) But I starting croaking out their names as best as I could with my throat in such bad shape. "Paul! Michelle!" I looked up toward the top of the dune expectantly but was met with silence. No answer again and again and again. I mustered up a louder *HELP! Nothing.* I estimate I yelled and called 20 times between gasps and puking. At this point I had nothing left in my system to puke; not even fluid. Just dry heaves in this dry, barren, hellhole.

For 15 minutes, I was met with nothing in response and was seriously getting scared — like *I didn't know what the fuck I was going to do* scared. I've been on so many outdoor

adventures, and although many of them have been challeng-
ing, you sort of live for the challenge, you rise to the occasion.
It's part of the joy of an outdoor adventure: testing yourself
against the elements and the situations that arise and then
walking away at the end of the day with the satisfaction of
knowing you had the spirit and the smarts — *the chops* — to
overcome and persevere. Here, my confidence was shattered.
I was so far out of my element. Something seriously wrong
was about to happen. Dread overcame me and I fought my
way through infrequent breaths. I just wanted it all to end.

Still hugging the side of wall, I closed my eyes. *This was
it.* I couldn't go on.

* * * * * *

I don't know how long I was there. I drifted in and out of
consciousness. I saw the kids swimming through my head
— their loving, smiling, impossibly beautiful faces. I felt
their hugs and their intense love. I remember smiling. *Dad,
we love you.*

* * * * * *

I open my eyes with a start. A flash of light!

Way up the dune, I see another flash — a headlamp! I can
barely hear him, but Paul — our guide — is calling down to
me. I don't know what he's saying, but I hear his deep voice.
I would later find out that Aaron and Paul — down the dune
and a kilometre across the pan — somehow heard my voice
echoing across the lake bed and radioed up to Namibia Paul
to see what I was yelling about. My throat feels like it's bleed-
ing and words feel like sharp daggers, but I manage to croak
out words. "I need water, Paul. Bad."

Ten minutes later, he's returned with water. I pop off the cap and devour the entire 1.5 litres, gulping it down. Crying. Paul is still unaware of what exactly I've been through, other than I'm drinking water and seem okay. I can't communicate further — not yet. He asks me where my gear is, and all I can do is point down to the ridge below. He sets off to retrieve it as I puke up some of the water that I too quickly consumed. I'm alone once again.

The water is beautiful. Fuck, complete *salvation*. Without it, I'd be done. Still, I have to get up this second massive face with literally nothing left in my bank. But I also know that Paul can't carry me. Or pull me along. Not up *this* face. Not up an avalanche of sand that wants nothing more than to keep sliding down. So I have to continue on. All I can do is break it into the tiniest of challenges: five steps at a time. It's all my brain, my will and the last of my energy can handle. Five steps. One foot in front of each other with a little vertical progression, fighting against the weight of gravity. Five steps and rest. Five more steps and then collapse. Five more steps and throw up. Wait 15 minutes for the tiniest of sparks of energy to return. Stand up and continue for five more steps. Throw up. Repeat.

This goes on for 60 more minutes and there's nothing anyone else can do. Paul is somewhere in the darkness and occasionally I see his headlamp flash toward me, or hear him yelling a word of encouragement. There's no way to carry me up a hill this steep and I just have to *get there*. Myself. Or not.

Finally — I don't know exactly when – 2:30 a.m.? 3:00 a.m.? — I complete yet another sequence in my endless series of five steps and I see that the endless wall is no more. I crest the final ridge. Vertical turns to horizontal, and I lie down on flat ground, crying some more. I can see the truck 30–40 yards away, waiting. Somehow I get up, stumble to it and collapse in the back seat.

I don't remember what happened next, but I would later learn that Paul and Michelle brought me directly to our

camp and pumped hydration fluids/electrolytes into me and a hodgepodge of pills. They finally got my heart rate down. I drifted off to sleep.

* * * * * *

Fuck, what an ordeal.

I'm typing this to you the next morning — it's probably 10:00 a.m. and everyone else is still sleeping. I can only assume that Paul and Aaron also made it back. Fuck, I hope they did. You probably won't read this for another two days, when I get back to civilization. I still feel so weak and exhausted, but much better, and still, somehow, I'm happy. Life is precious and I've been given another shot.

I've been thinking a lot since I woke up about life and love and what's important. How fortunate I am to have so much life and love and people who care about me. How stupid it is to get hung up on the little shit that we humans get hung up on (I'm so guilty) when we truly have one life to live. All you should strive for is peace in your heart and to give and receive love. Any of us could go any moment. Can we live like this going forward? *Please?*

11

ON TOP OF
THE GLOBE

We're all just making it up as we go along.
No one really knows what they're doing.

— A.S. KING

AS A FREELANCE PHOTOGRAPHER, I JUST FREELANCE
and photograph. I do my thing. Sometimes I take photographs
on commission for other people: think weddings and family
photographs and commercial projects and headshots. My job is
basically to not fuck up. To make people look good and to capture
a little snippet of their essence. I love this part of my job — this
challenge of taking a vague description of a client *want* and to
try to output a *successful reality* for them. The process is a puzzle
where you're considering a multitude of inputs, including envi-
ronmental conditions, light, setting, wardrobe, the mood of the
client, happenstance, composition and creative interjections,
and you're trying to piece together all the parts to make some-
thing shiny and impactful for the client. That's my job.

When I'm not photographing for clients, my photography
takes on the form of what I call Creative Time (CT). CT is
everything. A drug I crave. An itch I must scratch.

I'm a photographer who ignored the advice over 20 years ago to "pick one genre in photography and learn to do it well." I'm the proverbial squirrel, and I love bouncing from genre to genre and going from project to project. I just love getting creative: sometimes it takes on the form of wandering through the woods wondering where a side trail might take me, or edging along a cliff for the chance I might be offered up some unseen angle on potential magic below. When I'm not out shooting nature in my CT, I'm often scheming up portraits with the incredible array of people I come across both in my travels and in my home province of Prince Edward Island.

The client work...well, it pays the bills. I love it, to be certain, but it ultimately exists as a means to an end — the relief you feel when you pay the mortgage or can buy your next shopping bag full of groceries and rest in the comfort that your children are fed, secure and safe. I've had some incredible clients over the years, and hope to meet many more (and output some work they're very happy with), but if I had the choice I'd be out wandering with the winds, chasing light, getting into trouble, peering over edges and photographing people and places on my terms, or in various creative collaborations.

CT has led to, well, my most creative work. The photographs in my portfolio I am most proud of — the ones that stand the test of time? They're invariably 99.9 per cent born out of that craved Creative Time. And what's the point of these images? If no one's paying me for them directly, *why do them*? Primarily, because I *have to*. I simply have to. If I don't create for a couple of weeks, I first get twitchy...and after a while, this twitchiness turns into full-blown anxiety. I'm sure any creative mind can empathize: whether photographer, musician, painter, sculptor — or even the athlete who has been kept away from their physical pursuit of choice due to injury or weather — when you don't do what you love

doing, it *gets to you*. Even if you're the happy sort, which I am, you find yourself getting cranky. Sour. You know you're not a treat to be around. Simply, you have to *do* if you're meant to do something.

A huge bonus that comes out of this creative urge is that when you do actually go out and act on the urge, great things often happen. This creative output is the work that occasionally makes people straighten up and take notice, and turns some heads. It's the true, artistic *you*, and when you stay true to that pursuit and don't give up on that thing that makes you tick, eventually others pay attention. You don't do it for the accolades, of course, but let's be real: a little recognition here and there feels pretty damn good.

<p style="text-align:center">* * * * * *</p>

The year is 2013. It's been roughly five years since I took the ultimate deep breath, looked out into the unknown and took the plunge. I left my good-paying, secure, pension-building career with the telephone company to face the great unknown. In that five years I've built my client base, my reputation and my portfolio. I've gone from being a fairly mediocre photographer with good people skills to a photographer who — through a lot of hard work (and even more naïveté) — can actually pull off a creative vision fairly consistently. I can create a strong photograph, here and there. People started paying attention to my work — first in my city of Yellowknife — and then, through a slow-spreading trickle, elsewhere. Cool opportunities started popping up, and my work started appearing regularly in publications the country (and world) over.

One day, an email came in. It was from someone at *The Globe and Mail*, Canada's largest newspaper. I read it; my heart skipped a beat. They wanted me to come out to Toronto

in a month's time to give a talk to a crowd of subscribers about my aurora borealis photographs from the Northwest Territories, in partnership with Northwest Territories Tourism. The bloody *Globe and Mail*! Whoooooboy. The big time. Jesus, I thought, I might have to get a haircut (this was when I still had hair) and buy a suit.

I can't remember what exactly I replied with, but after checking my calendar and confirming it would work — I was to be in St. Louis teaching a couple days before and could fly directly there afterward — I'm sure I wrote back with measured enthusiasm. Inside, I was bursting. As a failed aspiring writer who'd idolized the words from *The Globe and Mail* back in college — my favourite thing to do on a Sunday was head to a coffee shop with a newspaper and read it front-to-back — to be able to head to Toronto to do a talk for them, well...it's funny where life takes you. My photography was going to take me places where my words never could. I phoned my mom.

"Hey Ma...wanna come to Toronto? Your boy is giving a talk for *The Globe and Mail*."

"What boy?"

Facepalm.

"For Christ's sake, Ma, ME."

"Oh. Well, that's nice."

"Nice? Mom, can I get a little enthusiasm?"

"Do I have to dress up?"

Despite the initial conversation, Mom was, in fact, excited and proud and even asked if her mother — my grandmother — "Nan" could come with her. Their plan was to fly from Nova Scotia to Toronto to take in the evening. Geesh, man, this was big...Even Nan was coming!

"Whoa, buddy! Don't fuck this up!" This is my buddy, Pablo.

Thanks, Pablo.

Gulp.

* * * * * *

Speech day. I woke up on a sunny day in St. Louis, groaned and rolled over to hit my alarm. Two realizations hit me: one, that it was speech day. And two, that I felt like complete and utter death.

It felt as if the bubonic plague had crawled into my gaping, snoring mouth sometime during the night and slithered its way into every single nerve ending and artery in my body. My head ached, chills rippled through my entirety and a wave of nausea swept through my stomach and pushed up my throat. *Noooooooooo.*

After a shower and a quick pack-up — in which I tried to wake up my shattered brain — I found a taxi and collapsed into the back seat. Twenty minutes until the airport, four hours' flight time to Toronto and about nine hours until the speech. I closed my eyes and prayed.

* * * * * *

I'm in Toronto. I'm in the hotel and it's about an hour before I'm due to head over to the venue for the speech. I've been a mess for eight hours, and have thrown up more times than I can remember. My skin is grey and my eyes look as if I've met Mike Tyson in a dark alley and said the wrong thing. They're obscene, puffy bags of pain. This would be a good time to cancel, of course. It would be the wise and thoughtful thing to do. By showing up, I could spread whatever disease I have to everyone else, and I know this...but this is pre-pandemic, and all I can think of is that I've got to find a way. I've got to push it down and show some good old-fashioned *pluck*. If there's one thing my lineage has taught me, it is that, one, if you complain *no one will listen* and, two, sometimes you have

to just *suck it up*. Oh, and work hard and brush your teeth and be good to your mother.

<p style="text-align:center">* * * * * *</p>

The event is due to start at 8:00 p.m. and I'm instructed to arrive about 6:30 p.m. for a venue walk-through, an audio test and introductions. I'll be sharing the stage with Manitoba-born, successful Hollywood actor Adam Beach. I'm both excited and terrified about the thought of being co-billed with Adam — I've never really met a Hollywood actor before. The *Globe* is expecting a full house tonight — I carry no pretensions about who people are really here to see.

I'm not a dress-up sort of guy, but I get to the venue wearing a sharp suit. Despite the sickness, I look good. Armour, to hide what lies beneath. As I take the elevator up to the designated floor, I fidget with my tie. Maybe if I tighten it enough it will hold in my sickness. I feel weak and like I could puke — or explode in other ways. I'll spare you the details. For now.

<p style="text-align:center">* * * * * *</p>

I manage to keep it together for the walk-through, and through meeting Adam. He's gracious and funny and encouraging and wonderful. The plan is that I'll be going on after so-and-so introduces me, I'll hold a mic and then I'll give about a 30-minute talk in a question-and-answer format with a host from the *Globe*, along with a slideshow. It's a small venue but will feature some of the *Globe*'s long-standing subscribers as guests. This is part of a speakers series they've been doing as a perk for their subscribers, and my only job is to not trip over my tongue and screw it up.

While my coordinator is going over final details, I'm leaning against the wall. I'm weak and doing my best to hide it. The room is spinning and I swallow furiously to keep my stomach down. I can feel the acidic burn slowly chug its way up my throat. I close my eyes and try to will it back down. Incredibly, it does. For now.

It's 20 minutes until go time and the doors have just opened. The coordinator is continuing with the last of her rundown when she leans in close to me, excited: "Oh, wow, know who just walked in? John Stackhouse. He *never* comes to these things. Come, I'll introduce you, this is BIG."

John Stackhouse is, in 2013, still editor-in-chief of *The Globe and Mail* — a legend in journalistic circles. At the moment, he's got one of the most high-profile gigs in Canada: editor of the biggest newspaper in the country. I, of course, have never heard of him and know none of this other than he has nice hair and that I shouldn't puke on him. I shake his hand after we're introduced, and as his hand tightens around mine (sidebar: in retrospect, I probably passed on The Plague to him...Sorry, Mr. Stackhouse, if you were sick that entire next week), I could feel the contents of my stomach quickly rising once again. Jesus. I can just imagine the headlines: FAILED PHOTOGRAPHER EXPLODES ON HELM OF *GLOBE*.

John finishes offering up a polite "good luck tonight" and turns to talk to someone else. I look at my coordinator but can't even talk. I'm about to throw up, and I need to get out of there. The room is spinning, hard, and vertigo has swallowed me. I look around for a rock to crawl under, but there's none to be found. I see my mom and my grandmother walking in on the other side of the room. I have to escape before they see me. *I can't do this.*

I stumble out through the nearest door and down the hallway. Luckily, I have chosen the right doorway and the right hallway. I can see a bathroom sign above a doorway

at the end of the hall. It's the most beautiful thing I've ever seen. I could cry.

A couple is walking toward me as I weave through the arriving crowd toward the bathroom. I don't recognize them, but I can tell they recognize me. They exclaim, "Dave!" I push past them and head toward the light. I'll explain my rudeness later. My body is about to implode; I'm pretty sure I have Ebola.

I crash into the bathroom and thankfully it's empty. Stall door: open, close, lock. I think. Having done its job for so long, my throat can no longer hold anything back. Before I can even raise the toilet seat, the dam bursts — there's no stopping it now. A burning hot stream of poison gushes out. I don't know how there's anything left, to be honest, because I've sung this sad song back at the hotel already, numerous times. As I wretch, doubled over, it seems endless. *Is that last week's lasagna?* Someone walks in, hears me and slowly backs out. *Good choice*, I think.

At the risk of TMI (too much information), my body is not content with exploding from one outlet. That would be too easy. I fumble for my belt, wishing I was safely in a coffin...

* * * * * *

Five minutes before the evening officially starts, I walk back into the room. My mom and grandmother are waving, with ear-to-ear smiles. They're beaming, and I love them so much. I see my former boss from the telephone days, Susan, also sporting a huge smile and a wave. She's heard about the event and bought a ticket, bless her soul. I catch the coordinator's eye and she looks panicked. She flashes me a "wherethefuckwereyou" expression and I can only give her a pained smile and a thumbs-up. I stand off to the side of the crowd and hear the host say, "And now, let's

welcome your speakers for this evening, Dave Brosha..."
I straighten up, adjust my tie and walk to the front of
the crowd...

* * * * * *

The host asks great questions, and I duly respond. I have
no clue what, exactly, I say, but I know I'm articulate and
concise. Eloquent. Funny, even. I hear laughter and can see
faces nodding and listening intently. My slideshow is met
with ooohs and aaaahs, and loud applause as the final image
disappears. I see my family bursting with pride. The hour
is a blur, and somehow I make it through to the other side.

Afterward, a stream of people come up to me to ask
further questions about the north, about aurora borealis or
to congratulate me. The couple I pushed past in the hallway
come up and loudly congratulate me. I feel as if I'm out-of-
body and floating somewhere near the ceiling. Adam comes
up to me and punches me lightly on the arm, and says, "That
was GREAT, man!" I muster a weak smile.

Somehow, it was one of the best talks of my career.
Impossibly. Just as I start to allow myself to feel a little
proud, my stomach rumbles again...

DESERT STORM

RE: ONE MAN'S EPIC

*The difference between the difficult
and the impossible is that the impos-
sible takes a little longer time.*

—LADY ABERDEEN

SPRING 2010.

I'm somewhere above the top of the world, the place where trees are a distant memory and you're fooled into thinking there's a thousand different shades of white. My world is snow and ice and wind; I'm embedded with about a hundred Canadian Forces members, scattered in and around Alert, the most northern military base in Canada. As I'm a freelance photographer and writer, my travels have taken me many places; none of these travels quite matches the quirkiness and isolation of Alert, which is truly located at the edge of the accessible world.

My assigned story for this trip is something military related: Arctic sovereignty has been the buzzword of the decade and I've been assigned to showcase Canada's efforts

in a land where people don't normally live: not even the Inuit, who were smart enough to make their home in lands much farther to the south. The closest Inuit community of Grise Fiord is 700 km south, and even then it was only settled because the Canadian government forced the Inuit to relocate there from even farther south. Alert is located, quite simply, in a place where humans aren't meant to live.

A couple of days into this assignment, there's a second story brewing. A buzz has spread quickly through the outpost: an Australian adventurer has put out a distress signal 50 days into his goal of reaching the geographic North Pole. A rescue team from the Canadian Forces has been dispatched in response from the Alert base. It's both coincidence and extremely good fortune for the troubled Australian that the rescue team is currently here at Alert for the very same operations that I've been assigned to cover; normally they are stationed thousands of kilometres to the south. It's also happenstance and good fortune for me that I happen to be there, right in the middle of an honest-to-goodness international news story.

The rescue team pulls off a textbook operation and the Australian is brought back to the base. This is where I first lay eyes on, and meet, Tom Smitheringale. Turns out he's a six-foot, seven-inch giant with a broad smile, a month-long beard, a bit of a limp and the appetite of a bear having recently awoken from hibernation.

An hour later I'm photographing him, stripped half-naked to his skivvies in a base washroom, documenting a moderate-to-severe case of frostbite that has blackened the ends of his fingers and toes after a journey that has left him scrawny and shaken but still smiling. All I can think is *shit, did he really just fall into the Arctic Ocean, halfway to the North Pole...and survive? And he's got the strength to smile?* I eventually write a story for the magazine about Tom's ordeal. Tom and I stay in touch.

* * * * * *

Fast-forward 18 months.

I'm bombing down a deserted highway in post-Revolution Egypt with three locals I've just met earlier that day, our destination the shores of Lake Nasser near the Sudanese border to the south. Our tiny car has almost sunk to its axles from the weight of the gear we carry, and every bump feels like a kick in the ass with steel-toed workboots. Despite the discomfort, I just smile as we roll down the broken pavement at the weird and wonderful turns of life that somehow, improbably, have brought me to this country. *I'm here.*

We turn off the deserted highway onto roads even more deserted; we are so off the beaten track it feels, to me, like the beaten track may never be found again. We stop to stretch our legs at an ancient temple — a splendour rising from the sand — that looks long abandoned. It's the sort of thing that would be a major tourist draw in Canada. Or anywhere else in the world. Gates and entry booths and plastic souvenirs and ice cream and lineups. Here, a lazy, mangy-looking dog is the only visitor, lying against the wall of the temple. He raises an eye as we get out of our car to poke around and play tourist for a few minutes. The dog goes back to sleep, curled into his little slice of shade and heaven, surrounded otherwise by the relentless sun.

After we snap a few photos, we head down a nearby dusty road — really two barely visible ruts through the rock and sand — and the shores of Lake Nasser finally come into sight. As does a silhouette, against the sun, of a giant. He's standing on the deck of a decrepit barge, waving to us as we approach. I open my car door, stretch my legs and smile. *There he is!* I climb aboard the vessel and am welcomed by the ear-to-ear smile of Tom Smitheringale, Australian adventurer, whose change in appearance from when I last saw him up in the Arctic couldn't be more dramatic: his

"snow-and-ice" woolliness has been trimmed to military precision (he formerly served with the British Army), and where I once saw the scrawny aftermath of a month on the Arctic Ocean with limited food, he's now a glistening, sweaty mass. He's not only recovered his depleted body; post-Arctic, he's bulked up. It's the next round of adventure for Smitheringale, in temperatures that couldn't be more opposite to the first major expedition he undertook. Tom has invited me to document his Egypt adventure from the get-go.

"Why Egypt?" I asked Tom in the lead-up to me joining him. Everything I knew about Tom in the months following my introduction spoke of a person drawn to colder lands. It's something Tom and I talked at length about before, during and after the journey.

"It doesn't take a great leap of logic to understand when you're freezing your bits off in the Arctic that you want to go thaw out somewhere hot. Of all the insane ideas in the world, I acknowledge that crossing the Sahara alone, with four camels, in a world beyond guidebooks, with no support system, no hope of rescue, armed with just the clothes you're wearing, $20,000 in cash and a small pack of essentials, has to qualify as instantly certifiable. Few undertakings hold more allure — and more potential for misery, but that's what I decided to do. Risks that pay off are bold moves. Those that don't pay off are stupid. Part of my job included taking risks. It's a measured life."

His plan this time around, for Expedition #2 – eventually titled by his support team as One Man Epic: Mission Sahara — was no small feat, on paper. He planned to cross the bulk of Egypt under human power, starting with a five-day paddle down 550 km-long Lake Nasser, one of the world's largest man-made lakes (created with the construction of the Aswan Dam across the Nile about 40 years prior) in some of the hottest conditions imaginable before pulling out and setting in on the other side of the dam in Aswan. From there,

he would continue a further 20-or-so days and an additional 1250 km down the historic Nile to the Great Pyramids near the capital city of Cairo, where he would finally leave water behind. I thought he was nuts, but of course I kept that to myself.

Tom believed, per his research, that if he was successful, he would be the first person in history to complete that specific route. It would be a kayaking feat of that magnitude. The kayaking stage alone would be adventure enough for most normal people, but then again "normal" isn't really Tom's style. His pre-trip description to me of one set of accommodations he booked me into upon my arrival in Egypt: "Mate...you're staying in a hotel that has the best prostitutes in Luxor. If you can't make good photos out of that then give me the camera and you go out on the boat." He made sure to copy my wife on the email exchange. For the record, I kept both my camera and myself in my own room, jet-lagged once I arrived. Thanks but no thanks, Tom.

After ending the water stage, Tom's next goal would be to continue the expedition, only now switching to the "dry" portion of his journey in the historic city of Luxor with a small team of camels he had procured months before, along with a Bedouin guide. The plan was to set out into the Western Desert (an area of the larger Sahara Desert) to cross some 1300 more kilometres to the tiny, ancient Siwa Oasis near the Libyan border. This, at least, was the initial plan. The plan would ultimately change.

It all started smoothly. When I arrived he was one full day into his kayaking stage, and after the endless months of preparation, his face was pure elation that he was finally in the water. Lake Nasser was "like sex" for him, he explained.

"The boat (an Expedition Epic 18X — a sort of sea kayak on steroids that was manufactured in China and then shipped to Egypt) cut through the water like the singing blade of a sharp knife. I liked the silence. I liked the feel of

motion, one paddle stroke then the next. The sky empty — I liked this. Paddling away, it was something fine to think about. Even if it had to end, there was still the pleasure of pretending it might go on forever. I had opened the door to a small part of the world filled with unforgettable characters, humorous interactions and starkly beautiful scenery."

My job was clear to me. I was simply to document his journey through photography and video footage from the relative safety and comfort of the barge (described to me before I left Canada as "a boat that looks like a floating double-decker London bus from the '50s. I'd give it 1.5 stars. A bonus half because it has a working toilet"). Tom personally wanted nothing to do with the barge, and it came at great expense — but he was ordered to use it as an official safety escort by the ever-fickle Egyptian government in the lead-up to his expedition start. I liked the barge; it gave me room to wander and spread out my gear safely. The thought of sleeping in tents along the shore wasn't nearly as appealing as sleeping on the glassy waters of Lake Nasser in a comfortable bed each night. That working toilet would come in handy too.

Tom's initial plan was to do the entire kayaking stage completely solo without any support team. However, after months of red tape and bureaucratic frustrations that almost resulted in the trip being called off more than once, he relented to the government decree that — due to the potential crocodile and bandit threat he would inevitably face — he would also take along with him, at his own expense, an armed police escort. He faced no other choice short of calling the expedition off. The recurring talk was that Lake Nasser was infested by crocodiles — talk that we found held a grain of truth but wasn't entirely accurate (we saw two small crocs the entire week). The threat of lawlessness was definitely higher, however. It was a threat that proved quite real to Tom later, after I departed. I only stayed about a week during

that stint documenting him; I would also cover some of the time he spent in the Sahara too, in another trip to Egypt. Somewhere along the Nile stage he came face to face with his first *real* threat while paddling.

"Passing through some wild country, on the high bank assembled a crew of tough customers holding their AK-47s like cricket bats. They looked like scarecrows. The shabby look was not the tailors fault; their bodies are not designed for clothes requiring posture and discipline. I gave the 'hi' sign and got a couple of ounces of lead in response. The rounds came in, *fast-fast-fast*. I could feel the hair rise on the back of my neck and my body turn into a single force of concentrated muscle. I couldn't believe these dickheads had the fucking audacity to shoot at me. Fearing the scene could go sour mighty quick, I made evasive manoeuvres and put the boat into cover. At the same time I could hear the twin engines of the police boat rev high into the red. Here comes a ton of rapidly approaching ass-kickery. When I spun around for a better look, The Law was in full throttle retreat. We caught up downriver and I made no effort to hide my displeasure. Not much was said."

Despite the risk, and the government decree that he only kayak with his escort, "for more than half the trip, they never turned up or I succeeded in giving them the slip." Undeterred, he carried on. The three and a half weeks Tom spent on the Nile had its challenges, but the rewards were many too. Adventure travel is almost unheard of in Egypt, and it drew the curiosity of many along the route. "Regular Joes in their day-to-day lives would never have seen a kayak before and I was a compulsive curiosity. Imagine a Martian from outer space landing in your backyard. Some people ran away screaming while others rubbed their heads as if they wanted to hurt themselves. Most people I met were down-right chatty, hospitable, gracious and tons of fun." The Nile itself was a thing of constantly shifting beauty and intrigue,

with something different to observe at every bend in the famous river, unlike the wide-open monotony of his earlier lake stage.

He succeeded on his kayaking stage, completing the 1800 km combined Lake-Nasser-and-Nile stage in 31 days total in "murder hot" conditions. He later completed, too, his even longer crossing of the Egyptian Sahara in 75 days, a brutal day-to-day slog with unpredictable camels in a landscape suited for migraines and mirages, bringing his total distance covered in 106 days to approximately 3100 km. This was really, truly, an amazing feat.

That, then, should be the end of this story — a story that isn't really mine. I'm just a person who played a role in documenting some of the pieces, a role I really enjoyed. I spent about 30 days in Egypt between the two trips I made, and made countless photographs; to this day, I think they're some of the finest documentary work of my career.

Tom, for his part, did what he set out to do. A goal was met — not without its challenges — but was successful in that he had navigated Egyptian bureaucracy, delays, being shot at, the elements, his own physical limits, the enormity of the Revolution during his initial planning stages and his own motivation to complete the goal he set out to accomplish, despite the fact he "hadn't put a boat in the water for up to two years" in the lead-up to Egypt. He persevered and he succeeded. When he reached the edge of the Egyptian Sahara, his fans and supporters around the world lit up in support. *Well done, mate.*

But simply doing what he set out to do and quitting while he was ahead was not enough for Tom; he made a decision that would dramatically change the tone of his adventure's final chapter. And, I suppose, that is why a story not my own makes its way into my collection of misadventures. This is where this tale takes on an aura of intrigue, adventure and danger that is the stuff of Hollywood.

* * * * * *

By the time Tom reached Siwa, I had long since returned to Canada. Life had to carry on, and I had to continue making a living, doing a series of commercial and personal photography assignments. Like many people from around the world, I followed his continued progress across the Sahara through Facebook, his blog and emails with his support team. Tom had become a friend, and his story was enthralling. He had a talent for writing; following his progress was a source of humour and pleasure whenever the updates would trickle in. Case in point, this — a blog post he posted from the field while assessing the varying strengths and weaknesses of his camels, one of whom was not-so-affectionately nicknamed "Joe Lazy":

> Joe Lazy is not of sound mind. He is not approachable and is difficult to work with. This camel suffers from 'draggin' ass' disease; I believe it is incurable and irreversible. Any constructive criticism devastates Joe. We cannot walk on eggshells around him if we want the team to get better. Joe has a tendency to instigate problems between his co-camels. Displays violent outbursts. Joe Lazy is not a team player. This camel should not be allowed to breed.

Perhaps it was one too many days in the sun, perhaps it was just the notion of doing something *different*. Tom had larger plans than "simply" crossing Egypt. He decided he wasn't done in Siwa. He wanted *more*. And more, in this case, meant carrying on and crossing into Libya first, with the intent of crossing all of the Sahara in North Africa right through to Morocco. This, shortly after a time when Libya was in the headlines of newspapers the world over with the hunt for a certain deposed despot named Gadhafi. In the words of Tom, "[it was] all shaping up to be the single most stupidest move of my life, but then again, Forrest Gump ran across America and he was pretty stupid."

The tale of Tom in Libya will someday be someone's full book (if not his own). The super-condensed *Reader's Digest* version is that he crossed into Libya and made about eight days of good initial progress before arriving in the border town of Al-Jaghbub. There he fell out of communication with his support team, got arrested "at the business end of an AK-47 by trigger-happy militia, accused of having a false passport and being a spy," and thrown into a prison in solitary confinement for 28 days without access to his embassy.

I didn't know this, however. I, and everyone else following him, only knew silence. His contact with the outside world was cut off, and days stretched into weeks; his supporters held their breath. I was devastated, thinking he was dead somewhere *out there.* In the endless desert, in the blowing sand. Ashes to ashes, and dust to dust.

Finally, word came in the form of a Facebook post from Smitheringale on March 7, 2012, stating that he had been released but with few other details. The post read, "It would be inappropriate of me to elaborate on the details of my capture and extraction as I'm still in country." *Wow, he's alive! What happened?* Relief washed through me, even as I was desperately curious about the details.

What I — and the world — didn't know was that a British special operations team had extracted Tom and relocated him to a safe house. There, he spent the next four days being "debriefed" by several different agencies working in the country. Liberated in the most dramatic of manners, he was to return home on the "advice of British authorities." The expedition was *over*. That meant nothing, though, to everyone else. Tom was safe. That was all that mattered.

Despite the sudden and dramatic end to his months-long adventure, he encountered a relieved following — perhaps no one more so than his naturally caring and upset mother, Jackie. I talked to her after : "I [wish] he would settle down, have babies and the dog he talks of. At seventy I can do

without the adrenalin rush." I don't blame her. *Fucking Tom*, was all I could think. The cat who was now down two of his nine lives, and maybe more. I've yet to really ask him about his previous military career in special operations. I'm sure a few of his lives were used up in those chapters too.

Tom returned to Australia and has, for now, taken a bit of a break from the world of swashbuckling adventure that took him on a tour of the planet's harshest climates and the absolute challenges they pose in the matter of two short years. He has pretty much dropped from the public eye. He has never been one for the media world, and little has been mentioned by or about Tom other than a few stories at the time of his expedition's immediate end. His former website is now offline, and the last post on his *One Man Epic* Facebook page is a note from his support team dated March 11, 2012, stating that he "is currently experiencing a excessive overdose of civilisation 20 clicks off the WA coastline at Rottnest Island before returning home to the mainland to get his backside tanned by his mother." Online, that's where his story seemingly ends.

For something that consumed the better part of a year of his life and didn't ultimately end the way he may have envisioned, the question remains: Was his quest admirable? That's open for debate, of course, and depends who is asking. He didn't raise millions for charity (although he did raise thousands), and he didn't finish his "extended" expedition, although the conditions around his ill-fated end were extreme. Ultimately, both expeditions (the Arctic and the Sahara) were adventures in the purest sense and without pretension, and I think that's what attracted him more than anything — more than the hype that always seems to go along with an adventurer's big ideas. Richard Sullivan, who formerly served with Tom in the British Army, agrees: "He has no ego or bullshit about him." For Tom, it was all about the journey. Or maybe, without realizing it, he was seeking a misadventure.

While many look to the adventuring world for specific accomplishment, I think inspiration, rather than accomplishment, is an underappreciated attribute. There is no doubt that he has inspired others. I saw it in the faces of the Egyptian children of Siwa who flocked to his side in delight as he would drop what he was working on to challenge them to a push-up contest. I saw it in the surprised faces of the fishermen on the calm waters of Lake Nasser as he approached their ancient, brightly painted boats in his space-age kayak to take a small break and make small talk. It was also evident in the comments and reactions from the social media crowd as they collectively held their breath to hear of positive news following his capture in the dusty and dangerous Libyan frontier. If inspiration was the hard currency of the expedition, Tom traded in riches.

And that, I suppose, *was the point*. When I asked him about what he had set out to accomplish, Tom revealed to me what perhaps was his main goal in setting out on this journey — an expedition that required a lot of good luck and an uncanny sense of survival.

"The true test [of living] is not in the talking but in the *doing*. Things worth having are not easy to obtain. Commitment to a goal requires living, breathing, eating and sleeping your goal every day. Literally. Kids need to know there are still badasses out there pushing the limits of what's possible, and if I can inspire them to get off the couch and into the great outdoors...then I've done my job."

Tom Smitheringale, my misadventure guru.

DEAD IN GREENLAND

AUTHOR'S NOTE: A VERSION OF
THIS CHAPTER APPEARED AS A
FULL-LENGTH COVER STORY FOR
ADVENTURE KAYAK MAGAZINE.

Not all those who wander are lost.

—J.R.R. TOLKIEN

THE FIRST PROTOCOL IN ADVENTURE TRAVEL IS TO HAVE
a protocol.

Every adventurer knows this: the set of semi-official
"rules" you play by when you're doing anything with even
a small dollop of risk associated with it. You know, the "if
this happens we agree to do this" kind of stuff. The world can
go incredibly wrong doing even the simplest of things, like
crossing the street in your hometown while your distracted
neighbour blows through a red light, texting. When you're
a hundred kilometres from the closest person and facing
elements like towering, often-calving glaciers, towering
seracs, cliffs and rocky and unpredictable terrain, after being
dropped off by a boat that only promises to try to come back

sometime in the future "if conditions allow"...well, it's good to have a plan. You know, the kind you agree to beforehand. This would be wise planning.

I'm a pretty diligent fellow and take safety seriously. I am not only "Safety Dad" on these tours. I'm sure I've also been lovingly called "Overbearing." You know what? I'm good with it. No photo, to me, is worth unnecessary risk to acquire. No adventure is truly worth hurting yourself for, or risking life or limb for. I'm a father of three beautiful children and I kind of like returning home to them at the end of the day. It's just my thing.

<p style="text-align:center">* * * * * *</p>

Eqi, Greenland.

Eqi is home to one of the most active glaciers in Greenland — if not the world — and its 5 km-wide face constantly spits out and sheds massive towers and blocks of ice from the famous Greenland ice cap. It's a very impressive place to visit, but it's a very remote place in an even more remote country. Getting there involves a chartered boat drop-off with an arranged pickup time. The time of year we planned on visiting was just after the small number of yearly tourists stopped going to Eqi and the quaint lodge on-site closed for the season. This meant that once we were dropped off we'd be the only humans in this sparse and beautiful and otherworldly landscape. This was hugely appealing, per our photographic desires, and we relished the opportunity for *aloneness*. To have one of the world's most impressive glaciers entirely to ourselves, without a soul around for countless miles — well, let's just say that was way more appealing than foreboding to us.

<p style="text-align:center">* * * * * *</p>

"Us" is myself, along with friend and fellow Prince Edward Island photographer Stephen DesRoches. We're being dropped off at Eqi a couple of days after my photo workshop business partner, Paul Zizka, has also been dropped off; he's in the process of being filmed as the star subject of a documentary on night photography. He arrived early in Greenland to have some footage filmed of him; we've agreed to meet up with him at Eqi and spend a (hopefully) incredible night collectively shooting together, after which the boat will come back and pick us up the following day. At least that is the agreed-upon plan, established through countless messages and emails in the months and weeks leading up to the trip.

The plan, or protocol, is pretty clear, or at least we think it is: Stephen and I will get dropped off in the early afternoon and start hiking up toward the glacier, stopping for photography en route. As we go, we will radio Paul and establish an exact meet-up location and time (around dinnertime), when we'll then collectively set up a camp for the night. Reunited, we will all spend the evening shooting our hearts out before crashing hard. If the aurora borealis is playing ball, sleep might possibly go by the wayside. We're all good with that, a bunch of wayward night junkies looking for a fix. In the morning, we'll pack up camp and go down to wait for the boat, which has been arranged to arrive for Ilulissat about 10 a.m. It'll bring us back, then, with plenty of time to prep for our upcoming workshop, which will see 12 photographers from across Canada join us for nine days of photography magic.

Stephen and I arrive feeling good about the plan, the shooting conditions (it's a glorious, clear September day) and having one of the most incredible locations on Earth to ourselves. The boat ride out is stunning: ethereal icebergs, massive cliffs and golden and auburn autumn colours lining the passing shore. Our cameras get a workout even before we arrive in Eqi.

Once we pull up to the dock, we offload our gear from the boat and wave goodbye to Anders, our captain. We promise to show him some pretty pictures the following day when he's due to return. Anders is an experienced Greenland captain, having navigated the channels, ice-fjords and bays of this stretch of coastline for years.

After getting oriented and taking a moment to simply sit on a rock, have a snack and appreciate the wonder of the place, Stephen and I start hiking the few kilometres up toward the face of the Eqi glacier. We wear wide perma-grins on our faces as we walk and talk. *This place is staggering.* As we hike, every 20 minutes or so we hear a mass thundering in the distance: it's the glacier, shedding tonnes and tonnes of ice down into the bay below, where it splinters and pushes forward a giant wave of water that dissipates in all directions. This is what Eqi is known for: being a very active calving glacier. We've been sternly warned ahead of time to not set up camp anywhere near the shore, and to avoid going anywhere near the water, period, if at all possible. *You got it — I'm not messing with that risk,* I think, as I watch building-sized blocks of ice drop from the massive glacier pushing up massive walls of water. The fury of the water is intense as it crashes against the shore a minute or two later. Deadly violent at times, depending on the size of the block of ice that drops into the bay.

As we hike up the moraine ridge, which will eventually lead to an overlooking parallel view of the top of the edge of the shedding face of the glacier — the edge that is spitting out ice and icebergs — I fish out my two-way radio. We've pre-determined established channels with Paul in the planning stages, and I switch my radio to that channel. Happily, I send out a "Zizka, Zizka, Brosha here! Can you hear me, Zizka?"

I don't really expect to hear from him yet. We're still a few hours away from our designated meet-up time, but hey, *you never know.* I don't hear from him, shrug, and go back to the walk.

Over the next couple of hours, Stephen and I shoot count-less frames and shout and smile in excitement over the magic of this place. We wander to and fro. At one point, I put down my camera and sit on a boulder, taking my pocket harmonica out of my pack. I wail out a little tune. I mean, I really, really wail it. Stephen's somewhere out of sight and really, I'm just trying to ensure he doesn't enjoy *too much* peace and quiet in this incredibly powerful place. Neil Young's "Heart of Gold" seems like a perfect match for Eqi. I eventually get bored of my own bad playing. I take out my radio again. "Zizka, Zizka, Brosha here! Can you hear me, Zizka?"

Again, no response. Again, I shrug.

Over the next couple of hours, every 30 minutes or so I take my radio out and call out to Paul. Each time I hear nothing back. I'm still not worried, but I do start looking at my watch as the meet-up time gets closer and closer. *He's probably just saving his batteries.* We go back to shooting but occasionally scan the horizon, looking for any sign of one of Paul's bright Mountain Hardwear jackets standing out against the ice around us. He's a stickler for wearing bright orange or bright blue out in adventure situations — "looks better in photos," he claims. He would know — he's one of the best adventure photographers I've ever met, and is known widely in the photography world for his epic compositions.

As the agreed-upon time arrives, I radio Paul again. Nothing. Again and again and again, I try. Each attempt is met by silence. Over the next 30 minutes I radio him every five minutes, thinking he's just in a pocket of poor signal but reason that if he's walking and he's close he'll hear us soon. The radios we use aren't the best — it's been a problem far too long — and we keep talking about getting more powerful radios. *In the future...before the next adventure.* I think we've said this on our last five trips.

Stephen and I have now stopped shooting, getting a little concerned. We've returned to camp to focus our efforts on

making contact with Paul. "Zizka, Zizka...do you copy? Paul, please answer. Dave and Stephen here!" Our radio banter is, at first, lighthearted.

"Paul, I know you're an addict, but put the camera down and answer your damn radio!"

"Seriously, Paul, answer...we have chocolate bars...and gummy bears!"

We joke about how much Paul loves chocolate and gummy bears; about how the guy somehow stays looking like a chiselled Greek statue despite the fact that his penchant for junk food while shooting is legendary. Oh, to have a metabolism on warp-speed.

As 30 minutes turns to 60 minutes turns to 90 minutes, our language becomes peppered with more concern and, eventually, to full-on worry. Ninety minutes is no longer a laughing matter, easy to brush aside — it's starting to get in the territory of *seriously late*.

I don't like this one bit. I'm a "show up 30 minutes early rather than arrive five minutes late" kind of guy, and although few things seriously bug me in life...lateness does. Thirty minutes late bugs me. Ninety minutes? I'm a ball of anxiety. I tense up. Seriously, *where the hell is Paul?*

To be honest, we haven't really thought this part through. The "what to do in event of a no-show?" Paul's an experienced adventurer and mountain climber — one of the most hardened I know. He has immense backcountry experience, including ice and glacier travel and safety. He is also with his filmmaker friend, Matthieu, and we know they have a satellite phone. We, however, do not. We have radios. Radios are our link to Paul; Paul is our link to the outside world. We have no way of trying to contact Paul, and therefore no way to alert the world (if rescue is needed, or worse).

As evening turns to dusk and then dusk transforms to near-darkness, both Stephen and I also turn dark. I feel sick to my stomach, and even though we're still surrounded by

incredible beauty — the stars sparkle and dazzle and kiss the glacier and hills below with their gentle glow and the world is silent save for the occasional crackling of ice — we have officially presumed the worse at this point. We have lost a friend...either in the literal sense of "lost" (he's fallen into a crevice and needs rescuing), or in the darker, more morbid sense. The *incomprehensible* sense. Our thoughts go back and forth between the need to mount a rescue as soon as the boat arrives the next day and the thought of the impossible phone call to Paul's wife, Meghan. How do you tell someone *that* — whatever *that* is. I know Meg quite well, and she's used to Paul's adventurous ways, but still — she's not ready for that call. Not from me, or anyone. Not now, and not ever.

That night, sleep is impossible. Every 20 minutes through the night we wearily take turns radioing Paul, mustering up a little glimmer of hope with each call out into the void. This hope is met by silence, and then the feeling of defeat. These radio calls are wasted breath, maybe but so needed,mentally. To at least feel like you're trying is...something, right? And maybe, just maybe, this attempt will get something, *any-thing*, in response. We close our eyes and make an effort at sleep, but we know it won't come. Anyone suffering from insomnia knows the crushing weight of exhaustion: sleep-lessness feels like a hazy 600-pound boulder on your body and brain. It's a bullet tearing a hole through your stomach. Add to sleeplessness this additional stress: the weight of feeling your friend — one of your best friends — is possibly injured, lost or dead. *How did we get here?*

At dawn Stephen and I, fighting tears, slowly pack up camp. We don't say anything. We're pretty much wordless; we've talked through every situation during the night and our capacity for words is depleted. Securing our tents to our backpacks, we head down the boulder-lined path toward the dock. At about 9:00 a.m. we see Anders's boat — our connec-tion to the outside world and the tragic news we must share

— off in the distance. It takes almost an hour for it to reach us as it weaves its way through an endless puzzle of brash ice — an hour Stephen and I spend making a last-ditch effort to reach Paul. Radio calls and frantic scanning of the horizon. Nothing. Our hearts are heavy. Stephen looks at me and I look at Stephen. We are shattered.

The boat pulls into dock, and the warm smile of Anders fades as he sees the looks on our faces. Something's not right and he knows it. His face twists with concern.

"Where's Paul and Mathieu?" he asks quietly.

I've practised this first talk to Anders in my head for the last hour. Still, it sticks in my throat and I struggle to get the words out.

"We have bad news, Anders."

I start, choking back tears. I am about to spit it out — tell him the terrible news — when he looks away from me. He's looking up to the top of a rocky overhang about ten metres up from us. Anders breaks out into a huge smile and starts waving. Stephen and I turn around. Our jaws drop.

"Hi guys!!"

It's Paul. And Matthieu. Bouncing down the path leading to the dock, wearing giant grins and looking ruddy. Stephen and I can't speak. We've seen ghosts — we're literally speechless. Before we can say anything — before I can spit out words and questions and relief and anger and perhaps choke and maim them — Paul's all excitement and smiles. "Oh, MAN...what a PLACE! Can you BELIEVE this place? It's so, so incredible. Out of this WORLD!! How did you guys make out last night?"

But, but, but...

"Oh, man. Seriously. How was YOUR night? Did you get some great shots? There's no way you couldn't have. Wow, this place is so great!"

But, but, stop...how? What? Where? WHY? Stephen and I just look at each other, still in shock — unable to form

proper words. Or say anything at all. Anders pushes off from the dock as the brash ice is starting to close in around his small boat; we start our return journey.

Our immediate relief turns to anger and eventually to acceptance as our boat returns to Ilulissat. Paul and Matthieu faced no issues, no problems other than they got caught up in their shooting. And apparently forgetting to turn their radios on? They simply forgot there was a plan. A protocol.

Forgiveness is the beating heart of humanity, and I'm not one to hold hard feelings. Really, I was just happy he was safe. The one thing about Paul is that his absolute enthusiasm for life, for his creativity and his craft softened the blow quickly. But there were lessons all around on that excursion. I really, really need to find a sat phone and be clearer about protocols. Paul, for his part...well, let's just say he knows where he went wrong. *Protocol* is now a word probably burned into Paul's brain like none other. Somehow we still like each other through it all.

* * * * * *

POSTSCRIPT Paul, of course, remembers this all differently. But I have Stephen solidly on my side. About the plan — the protocol — and what transpired. *We're right.* This, I know.

14

THE SEAS AND ME

When heard someone's boasting,
I could smell shit of bull from afar.

—TOBA BETA

THE PROBLEM WITH BRAVADO IS THAT IT *ALWAYS* catches up to you.

You see, the sea and I have always had a pretty kind and caring relationship. I'm a salt-air-and-seaweed-loving Atlantic Canadian boy with the Celtic music of my ancestors running through my veins, and have been on my share of boats of varying sizes over the years and never had issue with the ocean. From hulking ferries to tour boats to cruise ships to even smaller lobster-fishing boats setting out at pre-dawn on choppy water, boats and I — well, let's just say we get along just fine. Our dates — the sea and I — are firmly in the category of *nice:* not overly dramatic and quite pleasant. We'd often finish one date with plans for a follow-up. Possibly with candles and wine the following time, and anticipation of deeper conversation.

Over the years, I have spent almost 20 weeks total living the boat life as a photographer-in-residence aboard expedition vessels crossing to and sailing around South Georgia,

the Falkland Islands and the famed Antarctic Peninsula. In order to reach the Antarctic from Chile or Argentina you have to cross the notorious Drake Passage — an 800 km passage between Cape Horn and Antarctica. When it's calm, it's known as the "Drake Lake." When it's feisty, it's known as the "Drake Shake." Many of my crossings were fairly calm — I experienced the Drake Lake and kicked back and relaxed for the voyage. However, I have also experienced the Drake Shake more times than I care to remember: wave swells that have reached upwards of 30 feet and the constant feeling of riding an endless roller coaster from hell. There's nothing quite like the feeling of going to bed at night and then waking up every second minute all night because the force of the waves is sliding you up and down your bed, your head hitting the headboard one second (now I know why it's called a *headboard*), your feet rammed up against the footboard the next. Puke bags would line the walls of the vessels, tucked into railings and on every staircase, at the ready, and I've seen way too many of these filled by people with far more sea experience than me.

Still, I not only survived but *thrived* in those conditions. It would always take me several hours, and maybe sometimes even a day or so to find my sea legs — and I don't want to pretend for a second that I didn't feel it at all — but compared with the hangover you'd feel after a night of sambuca shots at the local pub? Pfffft, *child's play*. For me, it would amount to some minor seasickness of the "I'm tired and feel like sleeping it off" variety, but nothing serious. *I've got this.* The sea and me? Well, we're friends.

Then Greenland happened.

* * * * * *

Ah, Greenland — truly one of the most remotely beautiful places on Earth. By no means green (at least any time I've

been there), but definitely full of land. Endless, dramatic, adventurous, soul-fulfilling lands. It's a place with few roads and one of the smallest population densities on the planet, and it has geographical features that would leave anyone speechless: fjords and massive ice sheets, canyons and valleys, icebergs and towering cliffs. A photographer's paradise, sure, but really a paradise for anyone who simply appreciates the beauty of nature and of our planet's wild places. I can remember the very first time I laid eyes on Greenland, on a flight from Halifax to Scotland on a trip during university, with a stopover in Iceland (more green than Greenland, by the way). I slid open my window shade at some point during the earlier part of the flight and looked down upon a seemingly endless mass of ice, mountains and beauty. *Wow.*

It was 2018. I arrived in Greenland for what was now the fourth time in my life with a group of eager and excited photographers for a ten-day photographic tour I was co-leading. Unfortunately, I also landed with all kinds of endless sea ego. I had *been to Antarctica*, after all. I had rounded Cape Horn many times, for crying out loud. And boy, did I talk the talk. I told all these water rookies *how it was*, and what they should and shouldn't do. I nodded at a few people patronizingly when they said they were prone to seasickness. *Oh, you poor person...that's rough. I don't get seasick, but let me tell you what you should do.* I droned on about watching the horizon in rough seas, fresh air and pre-emptively talked about anti-nausea medications. *Use your scopolamine, people! No, no, I don't need any. See these legs? They are a couple of sea stumps. I'm good.*

A week into the trip, we found ourselves in the tiny Greenland village of Qeqertarsuaq on the remote, dramatic and spectacular Disko Island coastline. After we'd spent a few days exploring some of the most spectacular northern country imaginable with our cameras, hearts and souls, the

time had come for us to travel back across Disko Bay to the larger community of Ilulissat, where our photography tour would come to an end the following morning.

In Qeqertarsuaq, the waters were reasonably calm; such is the deceiving power of protected harbours. We got aboard the small passenger ferry feeling good about the day and about life. Our tour was coming to an end, and great memories had been forged and the photographs everyone had created bordered on the spectacular. The previous night we were blessed with a spectacular display of aurora borealis that danced artfully across the sky and shimmered in the waters below, and we were all tired the morning of departure but happy, and were looking forward to a planned (roughly six-hour) crossing of happy banter and napping — much like the crossing we'd initially had to get to Qeqertarsuaq.

It wasn't to be. As soon as we pulled out of the harbour, the sea let us know that she was there. A big hug, let's say. A tight, gripping embrace of the type that makes you bob back and forth on your feet with your partner, as if you haven't seen each other for a while and you don't want to let each other go. A slow dance. Our eyes all got a little larger, a few "whoas" were exclaimed and we sat down on the benches, settling in for the journey. It was rocky but nothing alarming.

That quickly changed. As we hit the vastness of the unprotected open sea, over the next hour the waves went from rocky to choppy to lurchy to gravity-defying. Our eyes went from big to buggy to nervous to wild. Our plans for a quiet crossing filled with some napping, lighthearted banter and possibly some image editing went out the window. Rather, it was simply close-your-eyes-and-survive mode.

I started out fine enough, even as other passengers got up suddenly to run to the bathroom or outside to empty the contents of their stomachs overboard. I *may* have even possibly been a little amused, and proud of myself once again for having such a great sea stomach.

174

That is, until I didn't.

It started innocently enough. I was sitting on a bench across from my two co-leaders, Stephen and Curtis, and one of our tour participants...let's call him Perez. As the boat lurched and dove and rose and skipped across the waves, my head bobbed up and down to the flow of the water. I tried closing my eyes, but sleep was impossible. I felt a little off, but nothing dramatic. That all changed, however, when I made the mistake of opening my eyes and looked up at Perez, who was wedged in between Stephen and Curtis.

Perez was the colour of summer grass — and was about to become Patient Zero in the oncoming zombie apocalypse. Just as I opened my eyes, his eyelids opened and his eyes rolled back into his head, exposing the whites of his eyeballs. I looked around for a bulb of garlic before I remembered that was for vampire protection, not zombies. *Get me off this boat.* I didn't know for sure what was coming, but I had the sense that I was screwed.

Without seeing, without opening his eyes, without any awareness of his surroundings, Perez casually and impossibly reached out in front of him and grabbed the brown bag his lunch was wrapped in...and unleashed the contents of his stomach into it, filling it almost to the brim. The smell of pure nasty filled the air and I gagged. Perez knew not what he was doing — I still don't think he truly woke up from whatever state of destroyed confusion he was in. He only had enough energy to put the bag on the table in front of him — between him and me — and go right back to his comatose slumber. His head dropped and he looked like he was out for the count. Kind of a pathetic Patient Zero, but at least he hadn't bitten Stephen or Curtis. Yet.

I stared at the brown bag of puke on the table, processing what I had just seen. The bag had already started soaking through, and I pictured it eventually exploding, splattering across our entire end of the ferry. I could hear it swish and

swash with every wave. I looked from the bag to Perez, back to the bag, back to Stephen. I saw Stephen's eyes start to roll back. Shit, the Zombie infection was spreading! I had to get out of there, but I was trapped. *Noooo.* I felt the gurgle and the green spread through me almost like a gunshot, immediate and effective in its fury.

I was a leader, though. Leaders don't get sick. There's no way anyone else needed to know about this — this breakdown in their fearless leader. I kept my lips pursed and walked back to the bathroom, avoiding eye contact with everyone. I couldn't possibly let them know that *I'm* sick. Not *me*, no way. As I rounded the corner to the tiny bathroom stall, I felt a hot heat climbing up my throat. It burned like lava. In the bathroom, my insides quickly emptied themselves. I saw bursts of light flash in my eyes as my stomach made its way unceremoniously *up and out,* and I quickly exhausted myself heaving.

Whew. Okay, that was unusual and terrible — but I survived. *So what?* I got sick. Nobody needs to know. *Right?* It's a one-off. An anomaly. It'll never happen again. It was probably the cheese-and-mayonnaise sandwich I'd wolfed down earlier. I knew I shouldn't have eaten the mayo.

I made my way back and sat down again, settling in. A minute later I was back on my feet, running back to the bathroom once again. *Damn, this is serious.* Again, my stomach heaved and retched and boiled. My legs became more unsteady, and this second trip to the bathroom lasted twice as long as the one before. There was no more hiding it from everyone upon my eventual return: I was full-on *sick.* Only there was no judgment, no mocking eyes…as I looked around the boat almost 90 per cent of passengers were in the same unfortunate state as me. The sea had kicked all our collective asses. It was to be the Passage of Misery, and as the minutes ticked by — each feeling like an hour — a constant flood of passengers bolted and elbowed their way

176

to the bathroom, seeking short-lived relief. The entire boat reeked of puke.

All told, in that endless crossing, I vomited almost ten times. A constant state of never-ending, relentless seasickness that was arguably one of the worst six hours of my life. The thing about seasickness is that there's almost no relief once it starts: if you haven't taken your seasickness meds *before* its onslaught, you're pretty much stuck. Fresh air and looking at the horizon can help, sure, but our deck was a dangerous roller coaster, and standing outside meant getting drenched, knocked off-balance and head first into something steel, or risking falling overboard. Eventually, the captain insisted we stay inside out of concern about losing someone overboard. It was buckle-up-and-suffer territory, and... suffer I did. I don't know what dehydrated me more: losing my stomach countless times or the tears that streamed down my face from the unbearable shame of it all.

The sea. I'll respect you forevermore.

* * * * * *

POSTSCRIPT Hours (many terrible hours) later we finally pulled into the comparatively calm waters of Ilulissat harbour. As we approached the dock — that sweet, beautiful end to the misery — co-leader Curtis opened his eyes, rubbed them for a second and said, innocently, "Oh, we're here?" Blinking, looking around and generally looking smug.

He'd slept the entire journey and didn't wake once, unaware of not only the passage of doom but the collective body of death-stares he was getting from all of us...led by me.

15

TWO PUNCHES TO GLORY

He who hesitates, meditates
in a horizontal position.

— ED PARKER

I'LL BE THE VERY FIRST PERSON TO SAY: A FIGHTER I am not.

Now, in my mind, that's not true, of course. In my mind I am Muhammad Ali, William Wallace, Rowdy Roddy Piper, Joan of Arc, Dave Semenko and Mike Tyson all piled into one. As a child, our weekends were often spent pleading with Mom and Dad to let us pop the latest WWF WrestleMania tape into the VCR; we'd watch the latest exploits of André the Giant and Hulk Hogan and The Ultimate Warrior and then we would transform our entire basement playroom into a giant wrestling set. We'd line the edges of the "ring" with oversized cushions, set up a timer and designate someone — usually my little sister Tricia — as referee. Then we would gently and elegantly knock the living snot out of each other until, invariably, someone would be sent flying into a wall or into the couch head first and end up in tears.

The only rule in our fight club was that you couldn't cry loud enough for Mom and Dad to hear you, otherwise they'd shut us down — break up our little underground ring of pain and glory. Bruises would be hidden and sobs muffled. We just wanted to keep the tournament going.

Aside from drawing attention, everything else was pretty much acceptable — there were no rules. Half nelsons, piledrivers and backbreakers were all fair game. If it had a name, and you saw it on TV, it was acceptable. If it didn't have a name, and you made it up on the spot: also acceptable. Creative moves would draw impressed nods and pats on the back. Drawing blood was generally frowned upon, as was biting, pinching and pulling hair. "Just have fun" was our motto.

This ongoing wrestling match wasn't just a thing of our basement; it was basically the official sport of northern Alberta. Weekends wrestling in my basement with my friends and siblings evolved to trying to avoid wrestling at all costs once Monday mornings came and I went begrudgingly back to school. It was one thing feeling like the World Champion Belt Holder when your opponent was your little 6-year-old brother — who was about 100 pounds lighter than you — and you were able to make up the rules in your favour. It was another thing facing kids in your Grade 7 class who had been held back four or five times and had full-grown moustaches, social insurance numbers and a rap sheet. *Fuck that.*

Ricky Smith, in particular, thought he was a wrestling God — anointed by Mean Gene Okerlund himself. He'd walk through the halls of Fort Vermilion Public School and dare anyone to look his way. No one did, much to his dismay. He stank of meanness and a serious lack of deodorant. If I was at my locker, I'd usually smell him before I saw him, and it would be my cue to pack my binders up quickly and get moving. No one wanted to find themselves the target of his

attention, but occasionally someone would get caught up in his web.

I once saw Ricky walk up behind a kid at school who didn't see him coming — he was busy doing an Arsenio Hall impression he'd seen the night before. He forgot the cardinal rule of Fort Vermilion Public School: always know where Ricky Smith was in proximity to you. He walked its halls with violence in his eyes, and he could strike anytime, anywhere. You always had to keep your wits about you. School was a *battlefield*, dammit, at least when he was in it.

Ricky slithered up behind him like a snake, and just as the kid started laughing hard at his own antics, Ricky wrapped his big, oversized, hairy arm around the kid's neck and started choking him — some move he had undoubtedly watched in *WrestleMania 7*. Ricky wasn't smart enough to realize that wrestling, as everyone knows, is *fake*. Well, *that kind* of wrestling. Seeing wrestlers collapse and pass out on TV was all a giant game of theatrics; we all knew this. Except Ricky. To him, these moves were real, and if someone collapsed, were seriously hurt, or even died from his moves... well, I don't think he really cared.

We all watched in horror as the kid struggled — Ricky's bristly, gross moustache pressed against the back of his neck — and then slowly went limp. He blacked out, and Ricky let him slide to the ground and sneered his toothless smile...and then walked away with his arms raised in victory. The kid eventually woke up.

I, for the best part of my childhood, managed to avoid people like Ricky. Although I was weak and uncool (no one told me that you shouldn't wear leather ties to school as a kid if you wanted to be part of the "cool" crowd), I was too valuable to some of the goons to have serious damage done to me on a regular basis. What I lacked in street-fighting skills, I gained in school smarts and an entrepreneurial spirit: one of the only times in my life I got hauled into "The Office" at

school — a.k.a. "The Principal" — was when I got caught selling completed math homework to other kids. I was lucky that my father was vice-principal in those days: he conferred with the principal and let me go with a warning as long as I stopped, rather than any serious punishment. On the drive home, he just laughed and said he was proud of me. "You should have charged them more."

As good as I was at staying somewhat invisible and restricting my slick wrestling prowess to the confines of our basement, time and fate eventually caught up. I was walking out of class one day and made the mistake of not paying attention to where I was going. As I left the classroom, I was looking back, talking to a friend. Just as I turned my gaze forward, I felt it. A big tree-trunk leg shooting across the doorway. My forward momentum met this solid mass and I went flying out into the hall, books and binders shooting up into the air, and me coming down hard on my knees and chin. I held back tears, barely, and felt my knees bloodied and scraped and my pride burning hot. Even before I looked, I knew: *Ricky*. Sure enough, as I looked over my shoulder past all the other kids looking at me — a mixture of shock, fight anticipation and laughter on their faces — I saw his big, hairy goon face smirking at me with an expression that said, "Try me, tie-boy."

I knew I was outmatched, but all I felt was rage. I knew deep down that it was wise not to do anything that would aggravate the situation further and invite a lifetime of future torment. I, for my own part, would only gain such wisdom much later in life. I stood slowly, shaking, and felt the hot sting of tears in the corners of my eyes. I walked up to him, looked up, drew back and with everything I had...punched him on the shoulder. Well, I say *punch*, but really I mean I may have tapped him. A mosquito might have had greater impact sinking its proboscis into his arm than the impact of my "blow." In my mind, I was Mike Tysoning his smirking

jaw, shattering it into a million pieces. The reality was that my punch went way off target and barely glanced him. I may have actually hurt my knuckles with rug-burn as they brushed against his jean jacket. *Whatever*. I stood up to him, showed him I wasn't a pushover and did what I had to do. I turned away from him and started walking away. Not a wise choice.

I ended up head first into a locker. The world went dark.

A fighter I am not. And really I should have remembered this episode later in life, when my rowdy, ass-kicking ways would catch up to me once again.

*　*　*　*　*　*

University. As with many people (note: not the *smart* ones) who enter the realm of university, I really had not much clue as to direction or desired outcome. When I moved as a teenager from northern Alberta to Antigonish, Nova Scotia, I was moving to a university town — home of St. Francis Xavier University (known affectionately to one and all as St. FX, Xavier, or simply "X"). Living in a university town you would think you should — more than most high school graduates across Canada — have a set plan on your life and direction before setting foot in that institution of higher learning, but I found for me the opposite rang true: I hadn't the faintest about what I wanted to do with my life or what direction I should take in my education. So I started with what I thought was pretty much the surefire path to a successful life: Celtic Studies.

I was fresh off watching one of the greatest movies of all time, *Braveheart*, and thought, "Hey, if I can actually get a degree learning about William Wallace and listening to Celtic Music, well...*why not*?" Very quickly, I found out the hard way that university was a lot of work and Celtic Studies was no fluff

program, and let's just say I struggled. In my first few years I would bounce from my Celtic dreams to Political Science to a year in the Business program, back to Arts and, finally, improbably, ended up with a Bachelor of Arts with a major in English Literature and a minor in History. Remarkably, it only took me a year longer than it should have.

A big part of my early struggles in university (I would later turn it all around and in my final two years actually did quite well) was that for me — as with many of my fellow university freshmen — school was a big social experiment where "partying" was more of a predominant word in the vocabulary than "studying."

It was on a Wednesday night of social experimenting that I came to a quick return to my former not-so-glorious days of fisticuffs. Only it wasn't my fault. Seriously, it wasn't.

Piper's Pub is an iconic institution in downtown Antigonish that's been there pretty much as long as I can remember and still operates to this day. A sprawling space, it sometimes gave off a true "pub" vibe, other times a nightclub vibe, and even other times, a sports bar vibe. It all depended on the night of the week, what time of year and what the owners thought, in the moment, would bring the most people through their doors on a given evening. Whatever it was on a particular night of the week, it was almost always a go-to of the university crowd at least half the days of the week. If you were going out in Antigonish, there's a good chance you'd end up at Piper's Pub.

It was on Wednesday night that I found myself in the middle of some drama. The very fact that I was out on a Wednesday night — which was traditionally a quiet night in the overall university social life calendar — should have been my first sign that I should have just stayed at home.

But no. I ended up shotgunning beers with a few friends on campus before we decided to "go for a wander," and ended up, of course, at Piper's Pub.

It all only really took about three minutes total.

I walked in, ordered a beer. I took a big gulp of the cheap draft — and smiled to myself. A coy smile. I should have been studying, but here I was, sipping a draft beer and about to share some laughs with some friends. University was fun.

I turned around to go find what table my crew had sat at... and that's when it happened. A flash. Some blinding pain. And then the lights went out.

* * * * * *

The beer-soaked floorboards were cool against my head. All I could smell was draft — Keith's, I think. It didn't smell very good, and I could feel wetness all over me. I blinked open my eyes and stared up at a bunch of people staring down at me. They looked at me oddly and with concern, so I looked back at them — equally oddly and confused. My hand still gripped the glass beer mug, which was now empty — its contents dispersed across my body and intermixed with a million other spilled beers slowly seeping into the floorboards. A future archeologist might dig up these floorboards under a hundred metres of dirt and discern a lot about the social history of Antigonish.

As I blinked, my head screamed with pain. My eye exploded with light and I vaguely caught in my peripheral vision a commotion near the exit: the bouncers struggling with a guy in a plaid shirt and a ball cap. I sat up and put my hand to my eye and wiped away a drop of blood. *What just happened?*

Chris O'Neill is what happened. And Chris O'Neill was in the process of getting tossed out of the pub while I was left to put together the pieces.

I knew I'd been hit — "smoked," to be certain. I just didn't know *why*. I wasn't a lippy fellow, or a wannabe tough

guy. My Wrestling Superstar days were in my past and my Boxing Glory days only ever lived in my head: they never saw the light of day. MMA hadn't yet got popular and wasn't on my radar. As far as I knew, I hadn't bumped into this guy, made him spill his beer, kissed his girlfriend or looked sideways at his grandmother. I hadn't stared him down, cut him off in traffic or made an off-colour remark about his choice of plaid.

"Man, did Chris ever smoke you! What a sucker punch THAT was!" My helpful friends. "What did you do to him?"

"Nothing. Seriously, nothing."

"Well, you're going to have a hell of a black eye...It's already looking so bad."

I did. A black eye. It followed me home that night and only got worse as the week went on. By my classes on Monday morning, I looked like one of Tony Soprano's henchmen. Professors looked at me oddly — they weren't really used to people wearing sunglasses in their lecture halls. *Hey, if Bono could do it, so can I.* Plus, it made it easier to fall asleep in class undetected.

My mother was a little horrified when I went home the next weekend to visit, but my father was impressed. All he wanted to know was whether I'd "got in a good shot too." Sadly, I hadn't. I was on the losing end of a wild punch and it was the shortest match in history. I walked around in shame. I didn't even get in a punch.

People would say things like "Sure, you got hit...but I bet you the other guy got it worse!" "No, no he didn't. I fell down, and he was gone by the time I got up."

"Oh."

The disappointment was evident.

About two weeks later, my shiner had almost disappeared. It had been reduced to the size of a quarter, hanging on — barely — but enough that I was still getting the odd funny look. I would scowl at them. *I'm a brawler...What's it to*

you? I didn't have to say those words; one look was enough and people would scatter from the sidewalk in front of me. I was clearly a tough guy.

Somehow, I found myself down at the pub on another Wednesday night. Same group of friends, same bouncer, same weather outside. The bar wasn't too busy and I walked up and ordered a draft beer. Keith's. The bartender slid it across to me, I paid him and I held it up to my lips and took a big gulp. Froth spread on my lips, which I wiped away. I smiled. Life was good again, despite my lingering injury. Despite the affront to my pride — the ongoing jokes among my friends that I was now a "fighter who had never even thrown a punch" — I was here, being social, back at the scene of the crime. *Damn, this beer is good.*

But then it happened. I turned around and once again my lights went out. Only this time I wasn't struck physically: instead, something came into my vision that exploded my brain a little bit. Chris O'Neill. Standing about ten metres from me. Standing in profile, talking to his friends. He didn't see me.

A better man would have undoubtedly walked away. I'm just stating that here for the record. If you're reading this, always be the better person. Future self, when you reread this chapter: *be the better person.*

I put my glass mug down on the counter and walked slowly toward him. It felt like slow motion — one of those out-of-body scenes where you feel like you're watching yourself. I could see my friends slowly look up toward me with their eyebrows raised, as if to say, "Where are you going?" I could see the wait staff walk by with trays laden with countless bottles of beer, dodging semi-intoxicated customers. I could see Chris's friends laughing at some joke he was telling. *Laugh, you assholes. Laugh.*

The slow motion dissipated and the world returned to full speed. I tapped him on the shoulder and he turned around

— his eyebrow raised questioningly, wondering who was disturbing his story.

Mid-turn, his expression turned from being halfway through a laugh to a look of worry. A split second later my fist connected with his eye with a satisfying splat, and the shock wave reverberated up my arm. He fell down onto the ground, spilling his beer all over himself.

Before I could look down and smile, or worry about his friends responding, the bouncers were on me. Two of them: big, burly, muscled giants. They grabbed my arms and violently pushed me away from Chris's crew and toward the exit. Before they fully kicked me out, one of them turned to me and said, "I kicked the other guy out two weeks ago...He had that coming. Nice shot!"

"Since he had it coming, can I stay?"

"Not a chance. Get out."

I found myself in the night cool, the smell of hot dogs and grilled sausages permeating the air. The hot dog guy waved from his stand across the street. I went over and bought one, shaking out my fist, which was split open and bleeding. Much later in life, I would buy his whole hot dog stand and operate it as my business — but that's another story.

As I stood on the street, eating my hot dog and rubbing my bloodied fist with satisfaction, I saw the main door to the pub open. Chris O'Neill came running out, and I immediately tensed up. He spotted me and jogged across the street. I assumed what I thought to be a fighter's stance but probably looked like I had severe constipation, and got ready for battle. I was prepared to put him down...or more likely get my ass kicked.

"Chris, I don't want..."

He cut me off.

"Brosha. Brosha! Jesus, man..."

I had my fists clenched and tensed up, ready for his first punch. In my head, I would duck it elegantly, jab him in

the gut and knock the wind out of him. I'd Bruce Lee his ass. Victory would be mine, and glory would follow me for time immemorial.

"Put your fists down, I'm not looking to fight you."

"You're not?" I eyed him suspiciously. His eye was swollen and blackening, and he had a drop of blood running down his cheek. I was sure this was a trap and another suck punch awaited me.

"Seriously, I mean it." I relaxed.

"Did you really just wait two weeks to punch me back?"

No shit, Sherlock.

"Well, I deserved that, didn't I? And sorry about last time...I thought you were someone else. Nice shot, by the way. I'm going to have a hell of a black eye."

He shook my hand and left. I went back to my hot dog.

16

THE ROYALS

Keep calm and carry on.

— BRITISH SECOND WORLD WAR POSTER

ONE OF THE MOST MEMORABLE ASSIGNMENTS IN MY career occurred in 2011 when I was asked to be the official photographer for the three-day visit to northern Canada of His Royal Highness The Duke of Cambridge, Prince William, and Her Royal Highness The Duchess of Cambridge, Kate Middleton.

This was a pretty high-profile task, and one that I was excited to shoot. It's not every week that you get to spend documenting two of the most famous people in the world.

I handle stress pretty well and never really let the pressure of any assignment get to me, but this assignment started out with one of the most stressful moments in my entire career in photography.

The evening the royal couple was due to arrive, my first task in my role as official photographer was to take a formal portrait of William and Kate, along with a number of dignitaries. It would be done in a secure hotel meeting room, and would be their first order of business when they arrived in Yellowknife from the airport. The royal couple would meet all

the dignitaries and then sit down, with me directing, while the entire group posed for a short group portrait session.

Normally when I shoot large group portraits for businesses or families I give myself, at minimum, 30 minutes to work through everything that might arise, in order to get the best possible photograph. So much can happen in a portrait session, and as a photographer you're juggling not only the people you're tasked to capture and, with that, the posing, the expressions and the expectations — but also numerous technical considerations like ambient and introduced lighting, environment, lens choice and ensuring all your gear works as advertised.

Thirty minutes was my normal time frame for a big group shot; for this portrait I was allocated about 90 seconds.

Ninety seconds. Ninety seconds that could make or break my career.

"Can you pull it off?" This was my government contact — the contact who had hired me for the project.

"I suppose so. What could go wrong?"

"Good. We're counting on you."

* * * * * *

Earlier that day, I had spent the better part of the morning and afternoon setting up for this 90 seconds. If I was going to nail this photograph in 90 seconds, I sure as hell needed to be prepared. As a professional, I prided myself on my preparation, which was often the bigger component to a successful photograph than anything that actually happened in the field shooting.

That morning, I brought in all my equipment, including studio lights, light stands, modifiers, cameras and lenses, to the hotel. Aside from some stacking chairs, at that point the room was a blank slate, and I was free to set up the group

portrait however I wanted. After sketching out some possible set-ups, I carefully set my equipment up and then did what any photographer worth his salt would do: I tested, tested some more, and then once I thought I was done testing, I tested even more.

I tested everything multiple times. The angle of light. My camera settings. I even had 14 hotel workers take ten minutes out of their day to come and sit in the seats that would later be filled by the royal couple and the dignitaries. I tried to imagine every consideration and mentally walked through the 90 seconds. I pictured myself directing the royal couple with confidence. I envisioned holding my camera up to my eyes and capturing the perfect photograph — a photograph that would later impress my client and impress William and Kate. Maybe they would invite me along on the rest of their tour and to just give up my Canadian life to be their official photographer permanently. I would live in a modest flat along the River Thames and serve tea to visiting celebrities in my down time. I'd become chummy with Kate Beckinsale and Colin Firth and Sir David Attenborough.

Back in reality, everything was perfect. I exhaled deeply and felt ready. Ready for this portrait; ready for my royal moment.

* * * * * *

It's 20 minutes before the royal couple are due to arrive. About an hour ago I arrived back at the hotel and went through the various security protocols. I'm patted down, my gear is checked by the RCMP and my camera bag sniffed by explosive-seeking dogs. I've been given the all-clear, and I'm left in the room by myself to look everything over one last time.

Turning on my camera, my studio lighting and my radio light triggers, I test everything once again.

Once again, everything tests perfect.

The door opens and various government types start streaming into the small conference room I'm situated in. I smile and nod to a couple of people I recognize, but everyone pretty much ignores me. Even the dignitaries are filled with nervous excitement. Today is not a normal photo op, even for people who are used to many photo ops.

I know the exact moment that Prince William and Kate Middleton enter the hotel. Outside the room and down the hallway, a loud cheer explodes in the lobby. I've been instructed ahead of time to go down the hallway once I know they've arrived and take a few frames of them greeting hotel guests as they make their way through the lobby. I scurry down the short hall and catch my first glimpse of royalty. Prince William and Kate Middleton! They're there; they're real. *How is this happening?* I've only quit my full-time job three years ago, with a great deal of hesitation as to whether I could make "a go" as a professional photographer. Now I'm photographing royalty. I fire off 40 or 50 frames and then quickly return to the meeting room ahead of them.

Prince William and Kate Middleton arrive about 30 seconds after I do, and the door is closed behind them. They make their way through a small line of people, shaking hands with the small crowd of dignitaries and exchanging pleasantries. I wait at the very end of the line, the final person they're to interact with. I've been told I'm to direct them to their assigned chairs and then — *gulp* — tell them what will happen during the photo shoot. They've been briefed before — every second of their public appearances is scripted and reviewed, I'm sure — but I've still been tasked with the responsibility of informing them about the plan for the group portrait. *My plan.*

My voice cracks, I feel the back of my neck grow hot and flushed, but I get it out. I tell their Royal Highnesses — along

with the entire group of dignitaries — that I will take approximately ten images total. I've been given 90 seconds, but I am aiming for efficiency. I want to keep it way less than my allocated time; I figure I can have the photograph I need in less than 30 seconds. I've tested everything down and I know exactly how my lighting and exposure will look, having practised with the stand-ins previously. Nothing has changed, and there's no point holding everyone up further.

"If everyone will kindly look right into the camera, and smile nicely. This is a happy portrait opposed to serious. This shouldn't take long at all."

I put my camera up to my eye, compose and press my shutter button. At this point in my career, I've photographed close to a million frames and a camera feels like an extension of my body. My soul. I can literally photograph in the pitch black (countless images shot under the stars), and I don't have to look at my camera to adjust any exposure settings. I am to the point, from a skill set perspective, where I simply *react*. React and *do*.

As I press the shutter, I see a peripheral flash of light triggered by my radio controller atop my camera. As the first frame completes, I feel happy. Satisfied. In the 1/160th of a second that it takes for the shutter to open and close, all the anxiety that has built up through the day dissipates almost immediately. It feels good. Great, even. I am where I am supposed to be.

I adjust my stance a few centimetres and press the shutter once again. And then again and again.

My gut flares. Something's wrong.

I feel sick.

By frame four, I realize what's off: I'm not seeing the telltale flash of light out of the corner of my eye.

My studio lights are not going off; they're not triggering.

My heart stops.

What do I do? Think, dammit.

The very last thing I want to be doing now — now, of all times — is to troubleshoot. Excuse me, your Highnesses. Mind if I take five minutes to figure out what's going on with my lights? Yes...why yes, I am incompetent. I really am. Don't worry, just enjoy that stackable chair while I press random buttons and check trigger batteries. Thanks for your patience!

I just can't do that. I have been given 90 seconds – 90 seconds that I agreed to and assured my client that I could "absolutely nail" the shot within. This is one of the biggest moments of my career to date. I feel absolutely ill.

Somehow, I keep it cool. This is just a hiccup. Nothing. My best approach, I reckon, is to simply shoot some more: my radio wireless triggers are bound to kick in eventually, and the studio lights will fire as normal. They'll be okay. This is just a blip.

I press the shutter. No light fires. I press it again and again and again. With each shutter click my soul shrinks further and further. There's still no light spilling into the corner of my eye. The studio lights are not firing.

Heart pounding, I've got to make a decision — even if that decision is to lie through my teeth. Maybe I'll tell them it's all perfect and then claim that my memory card, which holds the images, became corrupted later. Or I got mugged by spies, who made off with my camera and all the images. I just know I have to do something. My ten frames are up and there's a room full of people looking at me. All the portrait subjects — including William and Kate — are probably ready to give their smiles a rest. I can't keep them posing forever.

"If you'll excuse me, I'm just going to take a look at the images and make sure I captured at least one with no one blinking."

This is what I tell the group, who are waiting patiently. They have no clue anything is wrong. William and Kate turn to each other and exchange small talk as I turn my back slightly to them and look at the LCD screen on my camera.

I hit the play button with dread. I know I'm doomed. My nausea is getting stronger. I know what to expect: without my lights firing, my exposure will be way off. I'm counting on the light from the studio strobes to fill the scene. With no light, the exposure will be horribly underexposed, if it renders any impression at all.

I look at the last image I took. Black. The exposure is completely black. I hit the play button again, just to make sure I've hit it. The displayed image looks exactly like the LCD screen would without hitting play: dark.

I flip back to the image before, and again my heart tightens. It's black. Again.

Flip, black.

Flip, black.

Flip, black.

I'm dying.

I'm already making excuses in my brain. I'm plotting escape.

Career, it's been a nice ride.

Flip, black.

Flip, black.

Flip, light.

Wait, what?

The brightness of the frame blinds me after all the dark.

As my eyes adjust, I see an image appear on my screen. It's the group. The group in front of me.

What?

My heart beats a little faster. I look at it, trying not to get excited. On the first frame I took, the studio lights went off! But that doesn't really mean anything. The lights may have fired, but what are the chances that 14 people will have given me perfect expressions, with no one blinking, in a singular frame? Next to impossible.

I zoom into the image, quickly and furiously scanning all the faces.

Prince William's look is perfect. As is Kate's. *Of course, they would pull this off perfectly — It's what they do!* But what about the others? I look at each and every face, all 14 of them. Perfect, all.

I nailed it. *I fucking nailed it.*

I let the camera hang limp around my neck. I straighten up and look to the group. I look at William and Kate and give them a small smile.

"Thank you all for your time, I have what I need."

* * * * * *

The next two days are a chaotic, crazy, stressful, fun breeze. Everything goes perfectly. I shoot thousands of frames, and go to bed each night absolutely exhausted and elated. The challenges that come up over the next 48 hours are minor, and my experience kicks in as I hope it does, handling everything with a reasonable amount of grace.

My client, for their part, loved the finished group portrait. And thankfully never asked me to see any more frames other than the one I presented to them.

I still don't know what happened with my lights that evening. As soon as everyone left the room, I tried triggering them again. And, of course, they fired perfectly. *Of course.*

17

WHIRLING WINDS

Apocalypse is the eye of a needle,
through which we pass into
a different world.

—GEORGE ZEBROWSKI

ONE OF MY FAVOURITE MOVIES HAS ALWAYS BEEN *Forrest Gump.*

On the surface, Forrest Gump was a rather plain guy. But he was an ordinary, simple guy who ended up in a seemingly non-stop progression of extraordinary circumstances. He just went about life with a naive positivity and experienced "life in the here and now" like the best of them. When you looked at the whole of his life, however, you realized that a lot of really great and a lot of really weird shit happened to him. People, places, tragedies, comedic moments and heartwarming occurrences. He found himself in the middle of situations. Really...he found himself in the middle of life.

Forrest Gump is fictional, of course. The writers of both the book and the screenplay could take whatever artistic liberties they wanted and "insert" Forrest into all kinds of larger-than-life scenarios. Our lives? Not quite as exciting. I like to believe, however, that everyone has a Forrest Gumpesque

component to them: we think nothing really extraordinary happens to us ("life is just passing me by and I'm just worried about paying the bills, and getting to work on time, and not forgetting my mother's birthday...again"), but I'll bet if we all took a step back and really analyzed our lives, we'd find a lot of the bizarre, hilarious, tragic and wonderful moments within. I'll bet if you really started jotting notes down about your own life, you'd have a pretty crazy list of near misses, triumphs and misadventures yourself. Not all misadventures involve getting injured or lost or dying. Thankfully. That would kind of suck for typing out said list.

I'm rather appreciative of the fact that most of my misadventures have been pretty benign, even if some of them have been unusual. Or defy probability. As you have read, and will read, in the pages that precede this one and in the pages that follow, I've had encounters with car crashes, polar bears, earthquakes, bar fights, kidney stones, SWAT teams and more. I take deep breaths every now and then and simply shake my head. I feel, on the measure, that life has been beautifully boring yet extraordinarily intense. I'm happy with my life. I'm happy, even, with some of the near misses, and shake my head at some of the happenstances that I was on the periphery of — even if I wasn't directly in the middle.

Take, for instance, tornados. I've been on the periphery of not one but two tornados in my life, both happening within the short span of a couple of years, and both defining a large part of my childhood. Tornadoes were a major part of my upbringing, yet I have never felt the terrifying horror of actually seeing one with my own eyes. Let me explain.

* * * * * *

The first time tornados came across my internal weathervane was as a young child watching the classic *Wizard of Oz*.

Between earworms like "We're Off to See the Wizard" and "If I Only Had a Brain" and visions of yellow brick roads and Munchkins, the legacy of that movie, to me, was the start of a lifelong fear of twisty grey clouds. This fear would appear in the form of a recurring nightmare: dark clouds would gather on the horizon, approaching me. As the twister neared, a swirl of debris and cows and the Wicked Witch of the West would suck me up and carry me off. I don't know what was worse: the sound of the churning winds or her green-faced cackle. I wonder how many children can relate?

It was the summer of 1986. I was a chubby boy of 8. Summer vacation.

My world was my BMX, hockey cards, G.I. Joes and excitement about an impending road trip to Nova Scotia. Every couple of years my parents would stuff themselves — along with six children — into an undersized motorhome. This wasn't one of the luxurious monsters you see on the road today; when we pulled into campsites, other vacationers would look on with awe and horror as all eight of us would roll out of our home-on-wheels, like a circus car spitting clowns. Our route would see us hitting the road from the far reaches of northern Alberta down through Alberta into Saskatchewan, and then east for what felt like an endless succession of campgrounds and roadside pee breaks. Our final destination was almost always a little piece of seaside heaven: Bayfield, Nova Scotia.

The camper officially had enough seat belts for six; there were eight of us. That meant if we were to follow the rules of the road, six of us would be safe and protected, while the other two were "floaters." This was an affectionate term that we hoped would never actually become literal. Oh, the '80s. At least it was a step up from the "seat belt" I remember Dad using for us when we were even younger: every time he would screech on the brakes his arm would shoot out to prevent us from taking a header into the dashboard.

Along with the eight of us — positioned strategically throughout the motorhome as we drove from the pine- and spruce-lined reaches of northern Alberta down into the wheat fields of central Alberta and toward the Saskatchewan border and the endless flatness thereafter — Mom somehow stuffed enough food, luggage and board games into that confined space to keep us alive for the week it would take us to traverse provincial borders and finally stop on the lawn next to an aging blue cottage on the edge of the ocean. We somehow avoided sibling murder charges and we somehow survived Dad's non-stop soundtrack of Hank Williams, Marty Robbins and cassettes of kids' music. One of the only times I ever saw him truly angry was when, after a three-hour stint of him flipping from side A to side B of one of Raffi's cassettes, I finally snapped and had enough. I pressed the eject button and literally drifted the tape out the window into the ditch as we drove 100 km/h down the Trans-Canada. The environmentalist in me today cries. The 8-year-old me never had a prouder moment — Dad's anger aside. Sorry, Raffi, but there's only so much "Baby Beluga" an 8-year-old can stomach.

It was the second night of the 1986 journey when we approached North Battleford, Saskatchewan. Anyone who has ever travelled through the Prairies in the summertime knows that your visual excitement doesn't come so much from the land around you (although today I appreciate a good endless wheat field) but the occasional weather event that you can see furiously forming on the horizon that slowly drifts toward you or parallel to you. They call this area (well, at least my father did) Big Sky Country, and prairie storms are stuff of legend. Massive thunderheads, electrical storms and one of the areas of Canada known for occasional tornado activity.

As we drove the last 20 or 30 kilometres into the out-skirts surrounding North Battleford, we watched as the

far-off horizon darkened into ominous black. The radio warned of an impressive thunder and lightning storm due to hit that evening. Dad was in his glory: the only thing he liked more than a fresh cigarette and a cold rum and coke in a Styrofoam cup at the end of a long day of driving was knowing his kids were all happy and that he had a storm to watch. "Oh boy! It's going to be a damn fine sight!" While Mom boiled hot dogs on the stove, he would get a fire going, pull up a folding lawn chair, sip on his rum and rest his eyes after 12 hours of driving, alternately staring at the fire and the dark clouds in the distance. We would dress up our hot dogs and join him.

Sleeping eight people in a motorhome designed for six posed obvious logistical problems. A few years earlier, when we were younger and comparatively smaller, Mom and Dad could stuff us into every nook and corner like a finely tuned game of Tetris. But as we got bigger, so did our need for space, and to avoid sweet bloody murder every night, Mom or Dad had the bright idea of buying a three-person dome tent that my older sister Audrey (she was 10) and I would set up each evening after we stopped, then haul out a couple of sleeping bags and give everyone else a little more space and sanity. I liked the tent and had no complaints with this set-up. As we hauled out our camping gear, lightning flashed on the horizon.

"Dad, the sky's pretty dark over there. Are you...sure we should sleep outside tonight?" (I was analytical, even at 8.)

"Oh that? Yeah, it's going to be a good one!"

"A good what?" (Clarification is key.)

"Oh, a damn good storm!" (Dad hated cursing, but he loved damning things.)

"What if the storm comes our way?"

"Oh, wouldn't that be great? Enjoy it!"

"Okay."

Well, that was settled.

Audrey and I set up our sleeping bags with the appropriate amount of space between — meaning as much as possible. With two years between us, we had a love/hate relationship, and during a week on the road with limited space, the hate could take over at times. She was bossy and I was annoying. Proudly, both. Audrey liked her space and usually took up in excess of two people in the three-person allocation, and would bark at me if I crossed her invisible line.

I could hear the rumble of the thunder in the distance: a low, booming, guttural warning of fury. Most normal people would have taken heed, and proactive, protective action, before zippering up the door to the tent. I peered from the tent into the window of the camper. My father, my mother and my four younger siblings, all warm and cozy and protected. I looked up into the sky and realized that the dark doom that was once safely on the far-off horizon was now almost directly overhead. A light rain started, splattering the top of the tent fly. *Whatever; I'm sure my parents know best.* I zippered up the tent and snuggled into my sleeping bag. Closing my eyes, I drifted off even as the rain picked up.

* * * * * *

BOOOOOOOOOOM!

I wake inside the bowels of a strobe light and the tent walls are shaking. *What the sweet carnation is happening?* The Royal Regiment of Canadian Artillery is exploding shells all around me and the G.I Joes surrounding my sleeping bag have all ducked for cover. The world is hammering down on us and the rain is falling so heavily it's bending the nylon roof; the winds shake the tent violently and I'm convinced it's going to lift Audrey and I up and deposit us in Winnipeg. Even at the age of 8, I've heard about Winnipeg, and I don't particularly want to go there.

Staying in this tent feels like a mistake — a *death trap*. I look over to Audrey, but instead of her, in my delirium I see the Wicked Witch of the West. Cackling and taunting me. All I know in my state of groggy fear is that I have to get inside. I tell Audrey that I'm heading in, *like it or not. You can stay if you want to*. It's every child for herself. She follows.

We end up on the floor of the motorhome; blankets are quickly found. My knuckles are white and I shiver in my little nest, damp from the rain and scared from the chaos. As the world explodes and flashes and whips around us, eventually — somehow — sleep returns. Everything drifts to silence...

* * * * * *

7:00 a.m. Light streams into my sleep. I cautiously open one eye, then another. I look down to my fingers and move one with trepidation. I see it wiggle. *Small victory*. I hear a whistling sound and look up to see Mom over me with pot of water on the stove. Making coffee, I presume. Dad, he's outside, puttering. His favourite thing to do — a mix of productivity and aimless wandering. I crawl out from under my blankets and say hi to Mom. She steps over Audrey, still sleeping on the floor, and passes me an apple juice. I stretch and head outside to see what stage of packing up Dad's in.

"Quite the storm, eh?" he asks me as I let the morning sun wash over me and blind me.

"That was scary, Dad."

"The first bolt of lightning hit and you and Audrey were inside without opening the door," he said with a twinkle in his eye. "It didn't even open. I swear I never saw you two move that fast..."

In my mind, we braved it for at least half the night before giving up and heading inside; he saw it differently.

"You guys didn't even last until ten p.m."

Whatever. You sleep outside in a tent in a major offensive.

Over the next hour or so the rest of my brothers and sisters slowly came to life, and while Mom fed us, Dad finished packing up our campsite. He let me sit with him in the front passenger seat as we pulled out of the campground and started down the road, eastward bound. Next stop: Kenora, Ontario.

"Dad, I'm not crazy...That was a major storm, wasn't it?"

I needed to justify my fleeing from my position so quickly. The generals in my G.I. Joe army certainly wouldn't approve of the desertion.

"That was a damn fine sprinkling!"

A sprinkling? A SPRINKLING??!!

I sighed and turned on the radio. There was no point looking to him for agreement or justification. He just smiled and drank his coffee and lit a cigarette as the morning sun climbed higher, spilling light across the endless fields. As the cabin filled with smoke, I breathed it in and fiddled with the dials on the radio, looking for a station before Dad got on a Raffi or Hank Williams kick.

"Well, THAT was a doozy of a storm...We hope everyone's safe this morning! To all of you in North Battleford, I hope everyone survived the tornado that touched down last night...Our heart goes out to everyone affected..."

* * * * * *

A year later. July 31, 1987. This is a day that will live on not only in my mind but in the minds of thousands and thousands of Albertans forever.

Living in Fort Vermilion in the far reaches of northern Alberta in the 1980s, we had an abundance of great life experiences but a noticeable lack of "conveniences" many

other Canadian children would take for granted: shopping malls, fast food restaurants, amusement parks, movie theatres and public swimming pools. Instead of malls, we had the local Bay store. Instead of fast food, we had the K5 Diner. Instead of swimming pools, we had sprinklers, muddy roadside dugouts and slip and slides.

With Dad being a teacher came that perk that teachers everywhere protect fiercely: summertimes off. The second that final bell rang in late June, Dad would beat the stream of kids running for the exit to head home, pack us all up and hit the road on some vacation and escape normal life for a week, a month or for the entire summer (depending on how tight money was). Our family could only afford to drive across Canada to Nova Scotia about every two or three years, but on the "years in-between," we would almost certainly make it at least as far as Peace River, Grande Prairie or Edmonton.

As a northern Alberta boy, I saw Edmonton as the Promised Land. Where dreams happened. It had everything I ever wanted in my young life, and any time I knew we were "heading south," my spirit sparked and my imagination soared. Edmonton had three of my all-time favourite things: McDonald's, the Edmonton Oilers (which featured two of the greatest hockey players ever, Mark Messier and Dave Semenko) and — the mecca of meccas — West Edmonton Mall.

West. Edmonton. Mall.

Even at the age of 43, those words give me shivers. A place with perhaps the unsexiest name in marketing history is somehow still one of the most magical places in the world to me. This is coming from a person who has had the good fortune to actually travel to some of the most beautiful places on Planet Earth.

West Edmonton Mall was, at the time, the largest mall in the world, which gave it international acclaim and turned it into a tourist destination. It was filled with every imaginable

store — every imaginable wonder, including toys, cotton candy, computer games and whoopee cushions. There was nothing you couldn't buy there, but it wasn't the stores that made so many children's (and adults') eyes sparkle: it was *everything else*. It had an aquarium. A theme park. A massive indoor waterpark with a wave pool. A street full of restaurants and pubs and comedy clubs. A pirate ship. An indoor ice rink. An Asian market. A bloody shooting range, even, if you felt like blowing off some steam. An arcade. A casino. In short, it had something for everyone.

We as kids idolized the place. If Mom or Dad ever had enough of parenting and wanted to abandon me anywhere, I would choose West Edmonton Mall. I was sure I could fend for myself for a few months there, stealing leftover fries from the garbage bins and living out my dreams of being Blackbeard on his ship. The Edmonton Oilers even made the occasional appearance to practise on the rink there. *Mom, I'm good. No, seriously. Wayne Gretzky will take care of me.*

Fantasyland.

Well, Galaxyland. It used to be called Fantasyland when I was a kid, but there was something about a lawsuit with the Walt Disney company and somewhere along the line it had to change its name. It's now known as Galaxyland, but Mickey Mouse be damned — it will always be Fantasyland to me.

Fantasyland. The second-largest indoor amusement park in the world. Home to roller coasters and the Swing of the Century and arcades and Whac-A-Mole and the Drop of Doom. All these attractions became place names in my map of the world, and they were common references for almost every kid in Alberta. Some kids were more partial to the World Waterpark. Some kids were in the Fantasyland camp. I obsessed about them both equally.

As you drove through the west end of Edmonton, West Edmonton Mall was such a presence you could see it from blocks away: the massive dome that encompassed the World

Waterpark, or the jutting towers that housed some of the taller rides within Fantasyland. As kids, every time we drove into Edmonton we would be on heightened alert and wake from whatever long road trip-induced crankiness we were in to try to be the first to spot it. After ten hours bouncing down northern Albertan roads with only the dream of a Happy Meal and the memory of the foghorn that would announce another series of waves within the Waterpark to fuel us on, spotting and going to The Mall was the highlight not only of the trip but the entire summer.

* * * * * *

July 31, 1987. The Brosha clan pulled up, late morning, in our Vanguard motorhome to one of West Edmonton Mall's many vast parking lots as Mom fought with us to get us all ready.

"You HAVE to stay together!"

"Why, Mom?"

"Because people will steal you. This place is full of creeps and deviants."

"Oh."

Deviants aside, we couldn't wait to get inside. We would basically tow Mom and Dad into the front doors and through the anarchic maze of halls, sections and attractions to get where we wanted to be. Today's mission: Fantasyland, everything else be damned.

I'm sure anyone happening upon our crew would have done a double or triple take. A clan of eight: two frazzled parents and six children between the ages of almost 0 and 12, dressed in a bright array of hand-me-downs, weaving their way through the hallways packed with shoppers, entertainment seekers and, of course, deviants. We were all ordered to hold the hands of at least one sibling, and had strict orders if we were to get separated to meet by the ice rink. At least if we

made it there, I guess, we could find a hockey stick to fend off the creeps. Somehow, however, we all made it through the throngs of shoppers, following the signs through the endless corridors to Fantasyland. The Promised Land. Pure joy. Just as Mom and Dad surely breathed a deep breath and prayed for energy and patience, all us children breathed in a deep breath of excitement and took in the dizzying spectacle of lights, sounds, energy and wonder.

* * * * * *

Three hours later. We've already made multiple laps of the place, jumping from lineup to lineup, ride to ride. My favourites are the Mindbender roller coaster and the Drop of Doom. They're for the real thrill seekers. To this day, I love a good amusement park ride, and put myself through all kinds of torture.

The final hurdle of the day for me is the "upside-down" boat. It's officially known as the Perilous Pendulum, but to me it will always be the upside-down boat. It's a boat that goes upside down, swinging a full 360 degrees at a height of over 50 feet in the air, often pausing at the apex of its terrifying height. As much as I'm a thrill seeker — even at that age — this boat terrifies me. Which means, of course, that I *need* to try it.

I get on and buckle up, by myself. No one in our crew is brave enough to try it with me. An attendant comes by and slides a shoulder harness over me and double-checks my belt. Nice and secure; I'm not going anywhere but up. My only job is to keep the cotton candy and burger in my stomach.

The boat starts up and rocks back and forth in ever-increasing arches, gaining momentum. Each time it reverses and swings back the other way — like a pendulum — it gets closer and closer to true vertical. My stomach slowly crawls

up my throat, and just as I think I'm about to puke, the boat swings down the other way and instead of being high in the sky, looking down, I'm now at the bottom with my feet in the air, looking straight up. This attraction is housed in an area with a glass roof, and before the boat swings back the other way, I notice the sky through the skylights above. It's pitch black. *Odd, that.*

The boat plunges in reverse and, within a second, once again I'm high in the sky looking straight down, only this time the boat doesn't pause and continues its terrifying arch, and I feel myself, pulled by gravity, fall tight against my harness; I'm truly upside down. My stomach clenches and somehow keeps the food in my stomach within. I wonder how many people have lost this battle. Mad respect for the janitorial staff...

I can't count how many times the boat completes this 360-degree arc, and how many times the blood rushes to my head. The world turns into a blur of dizzying plunges, black skies and every part of my body screaming for sweet mercy. Finally, the boat slows, then inches to a stop. Just as the attendant releases me and I unbuckle...I hear a loud whoooooosh.

* * * * * *

The lights went out. Fantasyland was plunged into darkness. This was not normal. *What the hell was going on?*

There were enough skylights in Fantasyland that it wasn't pitch black, and the emergency lights kicked in fairly quickly. As I walked down the off-ramp from the boat, I saw Mom waiting with a few of my siblings.

"Mom, why is it dark?"

"Power's off...not sure why. Must be because of the storm. It was supposed to rain today, and maybe thundershowers I think." She frowned. Something was not right.

* * * * * *

It's 45 minutes later. From various parts of West Edmonton Mall the family has reunited amid the power outage and Mom and Dad have made the decision that it's probably best that we hit the road. We're staying with family friends out in Sherwood Park, just to the east of the city. Despite the power outage, we've had a good morning at West Ed and us kids are over the moon yet again at having spent time in our absolute favourite place in the world. Most of my brothers and sisters are pretty young, but as we pile into the motorhome Audrey and I do our usual post-analysis: favourite ride, scariest ride, best new attraction and so on. Our babbling excitement is interrupted by Mom; she's staring out the window as we drive.

"Gosh, you'd swear there's been a tornado here."

Dad's navigating the motorhome through torrential rain, and the sky is so black it almost feels like night. Day has turned to darkness, and even for a family well versed in Alberta storm skies, this sky feels apocalyptic. Our thoughts of roller coasters quickly fade as we look out the windows of our moving home-on-wheels and try to make sense of the scene outside as we head east.

"Dammit, look at that, El!"

Dad is pointing across the meridian. There's an industrial area that we passed on our way initially to West Edmonton that now...now looks as if something exploded. There's garbage and sheet metal and debris spread all over, and large metal bins knocked over. There's the flashing lights of ambulances, fire trucks and police everywhere.

As Dad creeps along the road, Mom turns on the radio and adjusts knobs. Through the static, she tries to find a working station. Finally, she does: 630 CHED.

"A massive tornado just ripped through Edmonton, and reports of mass destruction..."

Jesus Christ.

* * * * * *

July 31, 1987. Black Friday. An F4 tornado ripped through parts of the city and Strathcona County, damaging or destroying parts across a trail of terror that covered over 30 kilometres. Over 300 people were injured and 27 people lost their lives that day; the tornado caused in excess of $300 million in damages and is considered one of the worst natural disasters in Canadian history. Aside from the "big one," there were four other tornados reported in Edmonton and area over the course of about 90 minutes that day, including during the very time frame when we were driving away from West Ed.

We were approximately 6 km away from the path of the largest tornado as it cut its swath of destruction.

As the reality of what was happening around us sunk in, we sat alone, terrified, in our thoughts.

There's no place like home.

213

18

THE STONES
OF BAFFIN

This too shall pass.

—UNKNOWN

BAFFIN ISLAND. THE VERY NAME BRINGS TO MIND FOR many people a place of remote, desolate beauty: an Arctic island full of snow, ice and polar wildlife. A place for hearty people and wayward adventurers. A land of rock and winter, imposing environment and barren beauty. Of course, on the other hand, a huge chunk of people, even in Canada, have no clue where or what Baffin Island is — or its home territory of Nunavut — and have only heard of Baffin because it's also the name of a boot company. Hey, we're a big country and it's hard to keep our endless geography straight. Nunavut? That's in the Northwest Territories, right? Iqaluit...that's the name of a rock band, right?

When I first moved up to Resolute Bay, Nunavut, it was a point of pride that I was actually going to be living *north* of Baffin Island. Resolute Bay is located about 74°N; Arctic Bay — the most northerly community on Baffin Island — was at a measly 73°N. *Bunch 'a wimps.*

Make no joke about it, Baffin Island is seriously *up there*, and the island has some serious geographical props. If you're talking Canadian Arctic, there's a good chance Baffin Island will come into the conversation. It's home to Iqaluit, the capital city of Nunavut. It's the largest island in Canada and at 507,451 km² it's the fifth-largest island in the world. It's been inhabited for over 3,000 years, has a 6000 km² ice cap containing some of Canada's oldest ice (some of it over 20,000 years old), and is home to perhaps one of the greatest mountains in the world — Mount Thor — which has a cliff face said to be the largest purely vertical drop of any mountain on Planet Earth, at about 1250 m.

This island is, well, the stuff of legends.

Baffin Island had long been on my radar and had marked a stepping stone for me numerous times over the course of my Arctic career. Flying from southern Canada to points farther north, you almost always went through Iqaluit, so whether I was heading from Ottawa to Resolute on a commercial flight, or to Canada's most northerly military base, Alert, on a military flight, I invariably almost always touched down on Baffin Island. Still, despite my many stops in Iqaluit, for many years I felt as if I had never truly *been there*. Not the Baffin Island of lore and dreams.

That changed over a beer in Yellowknife one late summer day.

"Brosha, check *this* out." This was Robbie Craig, one of my best friends in the world. Robbie, at that time, was a physical education teacher in the nearby community of Behchokǫ̀, Northwest Territories. Now he's one of Canada's better-known artists, painting stunning, bold scenes of our nation's landscapes and wildlife.

Robbie was looking at his phone in one hand, balanced by a beer in his other hand. My other friends, Tim, Elliott and Sam, were sitting in a circle nearby, chatting. All of them looked up, waiting to see what wisdom was contained

within Robbie's phone — fully expecting the latest meme or cat video.

This, it turned out, was a picture of a mountain known as Mount Asgard. The picture Robbie showed me was something from a Google search, and it caught my attention immediately. Man, was it beautiful. Asgard was a twin-peaked mountain surrounded by snow that looked like an upside-down pair of shorts. It was unlike anything I had ever seen.

"Where is this, Robbie? Greenland? Patagonia?"

"Baffin Island," he said wistfully. "Mount Asgard. In Auyuittuq National Park. Isn't it amazing?"

"Um, *yeah*."

"Let's go, Brosha. All of us can go," he said, pointing to the other guys as well. "I checked into it. There's one company that does guided hikes into it. It would take about two weeks; that would not only get us to Mount Asgard but would also bring us past Mount Thor en route — and wow, you have to look at Mount Thor too!"

Mount Thor was arguably even more beautiful than Asgard.

After one more beer, I was sold. On the spot. Mount Asgard, Mount Thor, Auyuittuq National Park, Baffin Island — *all of it*. This was the Baffin Island of my dreams. This was *serious business*. A two-week hike into one of the most remote parks in all of Canada with good friends in the summertime? The chance to visit a place only a handful of people got to visit each year? Yes, to all of it. *Hell yeah.*

* * * * * *

About a year later, I stood in the common room of the Auyuittuq Lodge in the small Baffin Island community of Pangnirtung, looking dubiously at the scene in front of me. On every table, every chair and across most of the floor were piles and piles of supplies. Pre-rationed packs of rice and

oatmeal and soup. Chocolate and fuel canisters and sleeping bags and trekking poles and camera equipment. An endless sea of survival, and we were all close to drowning in it.

"We" ended up — after a year of our group size growing and diminishing and going through more changes than a playoff hockey roster — being just Robbie, Sam and me. We had somehow survived a year of hurdles, logistics and life expenses to each figure out a way to make this trip to Auyuittuq work, and we were now just two days away from our planned departure. Micheil — Mike, our guide — looked at our frowning faces with amusement. He was an old Auyuittuq hand, a guiding legend, in fact, having made the trek countless times. Baffin was one of his favourite places in the world.

"Mike, we really gotta carry all this?"

"Well, yes. I mean, if you want to live."

Aaah, Micheil. Never one to mince words.

Once fully loaded, we stared at our massive backpacks with a look of fear and respect. I had done some pretty serious trekking before, but nothing with bags that looked remotely this big or ominous. Micheil was very diligent about splitting up the food and fuel equally (we watched him with eagle eyes, each of us ready to swoop in if we thought our pack was getting an extra fuel canister or package of rice over the other packs), and when he was complete, and we had jammed, stuffed and punched down the last of our own personal supplies into the overladen bags, it was time to try the impossible: lift these mean, impossible sacks and try them out for size. See truly what we were getting ourselves into.

I tried picking it up the way I normally would with a backpack — a straight lift up and with the intention of swinging it across my shoulders. Not a chance. I couldn't budge it off the floor. Not even close. Clearly, I should have had some more pre-trip workouts and training rather than endless

creative meetings with Robbie over beverages on the great art we both planned on making. Me, unique, compelling photographs of this fascinating park. Robbie, sketches and paintings as he went: he brought sketch pads and a couple of small canvases. More on that later.

Uh, guys. A hand? I looked over to Robbie and Sam for assistance, but both of them were grappling with the same problem. None of us could budge our bags. I locked eyes with Robbie. He looked defeated. Mike, on the other hand, just smirked at us. His bag, of course, was on his back. *Stupid, super-human Mike*, we thought. *Show-off.*

We eventually figured out that if we worked together — one guy crouching down and the other two guys lifting the bag up onto his shoulders — we each had enough power in our thighs and glutes to stand up. Barely. The weight was like nothing I had ever tried to carry before. Mike's estimates put it at about 80–85 pounds a bag. I took a tentative step, off-balance, and then a second one. It was oppressive. I went over to the couch in the common area and slowly, carefully slid the bag off my aching shoulders down onto the cushions. *Jesus.* We all shared expressions of fear and loathing. Were we really giving up our prized summer — our July — for this punishment? We looked to Mike. "Tomorrow's the day — who's excited!?"

* * * * * *

D-Day. Our planned 9:00 a.m. departure came and swiftly passed without movement. Our morning broke with news of a heavy wind and rain storm, and as we looked at the grey, angry bleakness outside our lodge's window, our spirits sank. Rain beat off the windows and the old building shook in the wind. The plan was to wait for a call from our boat driver, Joavee, when conditions were favourable enough for

him to bring us the roughly 35 km from Pangnirtung to the shores — and start — of Auyuittuq, but as we looked out at the ocean and at the heavy winds sweeping through the streets, it seemed impossible. Mike, of course, was annoyingly bubbly and optimistic.

Late in the day, just when we entertained thoughts of cracking open the flasks of Irish whiskey that were tucked deep in our bags — earmarked for the day on the trek that was our planned turnaround point of the journey, the arrival at or near Mount Asgard — Mike got the call from Joavee telling us that "conditions had improved and it was go time." As I quickly laced my hiking boots and geared up, I looked out the window. To my eyes, it didn't look any different than it had that morning. Rain still pelted the windows and the puddles on the dirt roads continued to grow in size.

We all helped each other put our packs on; struggling to take steps, we left the comfort of the lodge. As we walked down to the shoreline, our feet sinking in the muck under the weight of our impossibly heavy packs, the boat, although it was only a few hundred metres away, seemed as if it was on the other side of the world. *How the hell were we going to average 10–14 km a day*, I thought. All I could do was look down and try hard to keep my balance and not fall over. Finally, we made our way onto the boat.

Joavee was a man of few words as he navigated away from the community and down Pangnirtung Fjord toward Auyuittuq. Attempts at conversation would be met with a nod, or a look that said, "I'm concentrating; talk among yourselves, please." The water was choppy and the rain fell, at times, sideways. The three of us friends hid from the rain, huddled in the small cabin with Joavee and Mike, who discussed logistics and pickup times as the boat lurched in the swell. The thing about Auyuittuq is that once you're there, you're essentially *on your own*: there is no cell coverage, you are miles away from civilization and if anything goes wrong

a rescue is a pretty large and difficult undertaking. Auyuittuq National Park only gets a small number of visitors a year — a combination of climbers looking to make an attempt on Mount Thor or Mount Asgard, trekkers like our own group, or other thrill seekers: we knew of a planned whitewater kayaking attempt of the park's Weasel River later in the month. Day by day, however, you were extremely unlikely to encounter another person out there. Joavee told Mike that he knew of only two other groups in the park the week we were heading in: another group of trekkers, led by the same guiding company we were using; and a couple of European mountain climbers who were attempting to climb Mount Asgard. By my math, that made for roughly 12–14 people in a park that covers an incredible 21,470 km^2. As we listened, my eyes drifted to Robbie. His eyes were big. We both looked to Sam. He simply shrugged.

Joavee, of course, navigated the choppy waters expertly and without issue. In the swell and between crashing waves, we were able to get to shore and all our packs offloaded safely. As we watched the boat reverse and leave us, the enormity of our adventure hit us all: Joavee was gone and wouldn't return for two weeks. What we had on our backs we would live off. Nervous excitement ran through us all. I'd like to say that I, personally, was fearless and felt more excitement than nerves, but feeling the cold rain pelt across my face, feeling the oppressive weight of the bag pushing me down and watching that boat disappear back down the fjord was, well, intimidating.

"No time like the present, guys...Shall we?"

Mike. Oh, Mike.

We put our heads down and started with a first few tentative steps, swaying in the wind, our knees buckling under the weight. Soon, however, we hit a slow, painful rhythm.

That first evening was tough by every measure of the word. It was already late in the day when we landed onshore,

and we were only able to cover a few kilometres of tediously slow trudging: each step felt like a monumental effort — calves screaming and backs groaning. When Mike finally called it an evening, we were beat, hungry, done and in pain. As we gingerly slid the packs off our backs, we quietly congratulated each other, but each of us was silently wondering how we could possibly do 13 more days of *this*. Sleep, thankfully, came swiftly that night; I, for one, had nothing left in my tank.

Day two greeted us with some improved weather. The clouds were still dark and ominous, but the rain, thankfully, had stopped. As we sipped strong "camp coffee" and watched Micheil cheerfully prep our breakfast, refusing our offers of assistance, we finally took a moment to really take in our surroundings. This place — this vast and epic place — was really, truly beautiful, undoubtedly one of Canada's finest mountain ranges, but a mountain range that almost no Canadian ever encounters. "Way better than the Rockies," Mike mused. "No trees to block the view!"

Our campsite was situated in a valley, and on either side of us were endless peaks of granite — dramatic, jagged wonder. The coffee burned beautifully down our throats and the oatmeal that Mike conjured up slowly brought life back into us, partially erasing our consciousness of sore legs and blistered feet. We knew the day ahead would be a huge one. Yesterday had been brutal to our unseasoned legs, but it was really just a short tease. Today would be the biggest test, perhaps of the entire two weeks. A full eight to ten hours of hiking, covering as much ground as possible, with our legs still not quite accustomed to the burden and our packs at their heaviest. We knew, looking ahead, that each day our packs would progressively get lighter as our cooking fuel slowly diminished and our food supplies got devoured. Our legs and backs would get stronger with time. The hiking would become easier, even if the terrain, at

times, got steeper. It's the same in every long hike I've ever done: the first two days are pure hell; by day three or four walking becomes sort of a cathartic, meditative routine. You hit a happy place, and that's the point where a hike goes from pure punishment to pure glory. Relief would come, we knew.

The day co-operated beautifully, even if it was as demanding a physical day as I had ever done in my life. Sometime in late afternoon the clouds started parting and we started seeing signs of colour through what had been, to that point, omnipresent greyness. We navigated along the river and settled into a routine as we went: rarely talking, each of us in our own heads, pushing through our own limitations but getting more and more comfortable in our simple routine of step, step, step. Every hour or so we would stop, offload our bags, give our shoulders relief and have a drink of glacial water or a small snack. I even cracked out my camera once or twice to try to visually describe, in images, the magic of the overwhelming beauty we were encountering.

Late that afternoon, as we stopped and set up camp close to a small creek that snaked down from a neighbouring mountain, Robbie, Sam and I took stock as Mike went about prepping dinner.

"You surviving, guys?" I asked.

Sam, always a man of few but wise words, simply replied with a tired "Yeah, I'm good. Pretty place, eh?" Loquacious, he was not.

Robbie looked at us both conspiratorially. He motioned for us to move in closer, and his voice lowered.

"I did something I probably shouldn't have done."

Sam and I raised our eyebrows.

"My pack, boys. I had to do something. It was too heavy. I seriously couldn't go on. I had to do *something*."

We looked toward Robbie's pack. It didn't look any different. *What did you do, Robbie?*

223

"Remember that big hardcover book I brought with me? *World War Z*? Well, it seemed like a good idea at the time. I may have buried that under a rock. I mean, it's paper. It's biodegradable. It will dissolve, right?"

* * * * * *

Day three gave us a sign of promising things to come.

Although it was early July, the weather the first two days was more reminiscent of autumn or early winter in most parts of Canada. Cold, dreary and wet. Boat Day (D-Day) was hell, Day two was drier but still cold and windy. But day three? Day three revealed hints of blue skies and sunshine from the onset, even as we savoured our morning brew. Once we set out, we had to stop after about an hour. We peeled off a layer of clothing, trying to prevent excessive sweating under the force of the sun, which had finally broken through and spilled through the valley like soul medicine. It was still Arctic summer, and probably no more than 12–14°C, but it felt in that moment like conditions were perfect. Light bounced off the peaks and reflected off the river, and for the first time on the journey I found myself smiling ear to ear.

It was around early afternoon that Mount Thor finally came into view. Collectively, our jaws dropped, while Mike simply stood watching us as much as he was watching the mountain. It really, truly was as impressive as the photos we'd devoured online made it out to be. That cliff face...Wow. *This* is why people came to Auyuittuq. This was the hike I had come for.

By this time our legs were getting stronger and our bags slightly lighter and our pace quickened a little. The step-step-step routine of our hike was now well established and broken only by rest breaks, a quick snap of the camera or the occasional stream crossing, which involved removing

boots and socks and carefully making our way across usually thigh-deep, icy, glacial water.

Sam and I fared well on the stream crossings; Robbie, not so much. Whatever part of his physiology didn't agree with ice-cold glacial water, it was a very real and very immediate effect for him. Every single crossing Robbie would grimace as he leaped and danced and pushed through the water...and then disappear for about five minutes on the far side of the river as the rest of us gingerly dried our sore feet and put our socks and boots back on. When he finally returned, he looked sheepish.

"I don't know what it is, guys, but the second my feet touch that water...I really need to go take a shit."

* * * * * *

Day four was one of the best and worst days of my life.

At the end of day three we camped with Mount Thor still off in the distance; it was visible, but it seemed still a bit of a faraway dream. Day four, however, brought us increasingly closer to this planetary wonder. Its incredible sheer face — a cliff face that averaged only 15 degrees from pure vertical — was the stuff of legend. As our route along the river took us closer and closer to the base of it, we all felt an unspoken energy that fuelled and inspired us.

As the afternoon came close to an end, Mike stopped us as we stood almost directly at the base of Thor, with only the Weasel separating us from the face beyond. We were deep in the valley now, and as we stood in shadow, the light shimmered off the towering peaks.

"Guys, I want you to take this in. I'm going to go ahead and start setting up camp. I'll be about a kilometre up the river, you won't miss me. But seriously, stop and appreciate this. This is what it's *all about!*"

225

For the first time that trip, I took my camera out and actually tried photographing some images with intent, rather than quick, exhausted snapshots of our travels. The contrast between the golden peaks, the cloudless deep blue sky and the shadowed valley was breathtaking. Sam sat for a while to watch Robbie and I take photos and to take it all in before continuing on to help Mike. Eventually, we tucked our cameras back in our packs and continued the final kilometre toward camp. I felt light and happy and refreshed, even after a day in which we covered probably close to 10 km of trail. Fresh air, friends and creativity. Three of my driving forces. The day was pretty much perfect.

* * * * * *

It was sometime after dinner when my world changed.

As the endless evening light slowly faded (being so far north, it barely got dark in the Arctic summer night, only a form of dusk, and we had about 22 hours of light per day), and we sat and watched the cinematic display of magic light hitting Thor, I felt a strong urge to pee. I excused myself from the guys and walked a little distance away from camp, up and over a small rocky ridge.

I tried to pee, but only a little came out. I felt a strong burning sensation too. *Weird,* I thought. I had stayed quite hydrated that day, as with all the days so far — a plastic Nalgene bottle always tucked in the side of my pack with easy access. As I tried to pee, I felt a weird fullness inside of me and sort of laughed to myself. *Oh, maybe peeing is not what I need to do right now.* I retrieved some toilet paper and a book of matches from my pack. Burning your "evidence" was the preferred Parks Canada method of "taking care of business" in Auyuittuq National Park. I returned to my hidden spot behind the rocks and crouched. As I tried to

"go," nothing happened; the sensation of fullness turned to a dull, aching pain.

Not the time for constipation, Dave.

I remained there, balanced against a slab of rock, but still...nothing. At first. But then the dull, aching pain turned stronger and stronger. As it increased, I tried harder and harder to go — to get some relief. Again, nothing. No movement. Sighing, I finally pulled my pants back up and walked gingerly back toward camp.

I tried sitting with the guys, who were enjoying a game we played often en route called "Name That Tune." Someone would control an iPhone playlist and play a song, and the others tried to be the first to name the song. One point for the artist, one point for the song. It started as a drinking game for us in Yellowknife; in Auyuittuq it became a fun little way to pass the evenings and brag about our musical knowledge as we watched the days come to an end. After five minutes of sitting down, I had to leave. The pain was getting stronger. I excused myself and decided to try once again to use the bathroom.

This time I was successful, but emptying myself didn't bring relief; it only increased the pain. The burning intensified and shot from my spine through to my groin. *What is happening to me?* I thought. This is not the time or the place for *this*. I must have eaten something bad — maybe Mike didn't cook something properly. Or maybe I still need to get something *out*. I tried to use the outdoor facilities once again, but it didn't bring any relief.

I climbed into my tent and stripped down to my underwear and a T-shirt. I crawled into my sleeping bag and pressed my hand against my lower stomach. The pain seemed to be everywhere, and impossible for me to pinpoint. It was everywhere...and *nowhere*. I poked and prodded different sections of my abdomen, my side and even back toward my tailbone. It seemed no matter where I pressed, the pain

persisted, grew and intensified. It was as if someone had poked a red-hot iron in my entire midsection, and no matter which way I shifted in my sleeping bag, I couldn't get relief.

Eventually, I heard Robbie open the zipper to the tent. He climbed in and got ready for bed.

"Hey, Brosha. Wow, what a day."

"Yup, amazing," I replied quickly. I didn't tell Robbie of my pain because I didn't know exactly how to describe what the pain was. And surely this would pass?

He quickly fell asleep as I lay there in agony. The pain seemed to follow a cycle, almost to the point where I could predict it: it would build across my interior like a slow-breaking wave, crashing against my groin with razor heat, and then retreat toward my spine, only to repeat once again a minute or two later. Pressing with both hands hard against my stomach and groin gave a modicum of relief and allowed me to pretend I was doing something helpful — as if I was at least somewhat in control of my body — but the pain was just too much. Wave after wave after wave slowly broke me down. First physically, then mentally.

I don't know how long I suffered. I just remember silently rocking and rolling in my sleeping bag, trying not to wake Robbie, for what felt like eternity. Tears streamed down my face. Instead of Dante's Inferno, this was Dave's Inferno, and I was descending down the nine circles of hell.

Finally, I broke.

I don't know what time, other than it was sometime after midnight. Completely weak and in agony, I woke Robbie. He woke up with a start and blinked at me, trying to figure out what was happening.

"Robbie, can you get Micheil? I'm having some sort of medical emergency. I need...help."

The last word hung on my lips.

As he pulled on his pants and boots, and then crawled out of the tent, I took stock of the situation. We were four days

into our hike and likely about 25–30 km from our drop-off point. Even if we turned around, how could I possibly walk out in this state? Micheil had a satellite phone and could always call in a helicopter rescue, but did I really want to be that person? That guy? *The guy who needs to be rescued?* The thought of that ending to this journey pained me almost as much as the waves of burning agony going through my body. I had always considered myself tough and persistent. Not someone to complain or rock the boat. The last thing I wanted to do was be the person in our group who disrupted our trip. But, God, what was happening to me?

"Dave?"

It was Micheil, outside the tent. He first poked his head in and then his body followed. He was holding a medical kit.

"Dave, what's up? Talk to me."

I could barely stammer out what I was feeling. I rocked back and forth holding my gut and my groin as he tried to discern the issue. The look of worry on his face frightened me.

Something flashed in my memory — disjointed pictures. Four or five years earlier. An evening in Yellowknife shortly after I moved there from Nunavut. The same sensation, the same agony. A night in the hospital with a dose of morphine — or was it Demerol? A night of incredible pain and the same constant rolling wave of pain that seemed to be everywhere in my midriff. A night I had blocked from my memory for years — until that moment.

Kidney stones.

Fuck.

I mumbled this previous experience out to Mike as he took my pulse and he looked a little defeated. "Dave, I have to be honest...I don't have much that can really help you if that's what's going on. I have some Tylenol. That's it. I don't imagine it will help much, but let's try. Let's get some of that into you, and some fluids." I nodded and went back to rocking.

Micheil remained with me, and Robbie relocated to the tent with Sam. All Mike could do, though, was watch as I rocked, twisted, contorted and silently cried.

After an hour or two, he put his hand on my shoulder — just as I felt I was starting to go out of my mind, delirious from the pain.

"Dave, how are you doing? I can call in a helicopter from Pang. Just say the word, my friend."

No. As much as I was destroyed, I still wasn't *there*. Not yet.

I felt the sudden urge for fresh air. Without even putting on pants, I stumbled out of the tent and dropped down to my knees on the grassy flat we were situated on. The pain was everywhere, but the cool night air felt beautiful. The peaks loomed high in the dusky sky and looked down on me, offering up their sympathy. Both hands gripped my stomach tightly and my forehead dropped down to the ground. I closed my eyes. Surrounded by some of the most beautiful scenery on this planet, all I knew was darkness. The grass pressed against my face.

I don't know how long I was there, but the pain finally subsided long enough for me to get back to my feet. I looked over to the two tents sitting there peacefully. I looked to the river down below, its dull roar comforting. I looked up to Mount Thor and felt small and whole. Regardless of whatever turmoil I was in, everything just...*carried on*.

Stumbling up over the ridge once again, I leaned again against the slab of rock and dropped my underwear, shivering and pouring sweat. I wondered what someone would think if they came across camp at that moment. Me, with bewildered eyes in a T-shirt in the cool Arctic air, my pale white ass out — looking and reeking like death.

I pushed and pushed and pushed and pushed. I don't know what came out, if anything. I just needed some relief — some end — to this incessant agony. I don't know how

long I was there, or if I cleaned up after myself (or if I even needed cleaning). I just needed my body to do something — anything. Somehow, I ended back up in my tent, and sometime after that — I can't remember if it was five minutes or three more hours — I finally felt some relief. The pain stopped and a wave of stillness swept through my body. I was beyond exhausted and had no concept of time or place.

Finally, impossibly, I drifted away and slept.

* * * * * *

I woke to the sound of laughter, and an unusual feeling: the tent was actually warm to the point of almost being uncomfortable. After four mornings of waking up in the chill of dawn, this was a different sensation, and I knew we weren't continuing on as per the usual routine.

My entire body was stiff, and I felt as if I had run the Boston Marathon, but a tentative scan of myself revealed "all normal" internally. I tepidly pressed against my abdomen. No pain — just a rumble of hunger. I was fine, I realized. I could have cried out of happiness.

After slowly dressing, I wandered outside. The guys looked up and let go a collective "HEY!" It was early afternoon, and due to my predicament they were taking — and enjoying — a forced rest day. "Dave, man...how *are* you?" I could only sit next to them and offer a weak smile.

They were all, of course, relieved that I was okay, and didn't seem to mind the day of rest. At least that's what they said to my face. I didn't last long socializing, with just enough energy to put some fluids into me. I then pulled my sleeping bag out of the tent and fell asleep, hard, once again, this time in the warmth and comfort of the sun. It was a full-on blue sky day, absolutely glorious conditions — and I quickly slipped into a deep sleep coma, my body still

nowhere near functional after the ordeal it had gone through the night before.

* * * * * *

Sometime in early evening I woke up once again, only this time to the smell of food cooking. As my eyes focused, I felt my stomach twist. It had been almost 24 hours since I last ate anything. As paralyzed as I still felt physically, camp food is a hell of a motivating factor. I climbed out of the sleeping bag and joined the guys once again. Mike put a big plate of stew in front of me and I could have kissed his fuzzy, beard-stubbled face.

Robbie, Sam and I had all secretly stashed a special treat deep in our bags for the moment we reached our objective: somewhere near the base of Mount Asgard, we'd planned on sharing a sip or five of our Irish whiskey. The turnaround point of the trip. And another sip or five once we returned to the drop-off point. Seven days or so in, seven or so days back. But as we sat there, eating our stew and watching the light dance on Mount Thor once again, Robbie had the idea to crack one of the flasks now.

"Guys, if there was ever the time to have a shot of whiskey, it's when one of your friends doesn't actually die when you think it's a possibility. Damn, that scared me last night, Dave."

None of us could argue that, and we each poured a stiff shot of Jameson. And then another. And then one more. Before we knew it, not one, not two, but all three flasks were a distant memory and the night turned to dusk and the laughs got louder and the conversation sappier. "I LOVE YOU, dudes!" rang out into the night sky and echoed off the peaks.

No regrets, even with another late start and a heavy head the next day. It's not every day you survive a kidney

stone passing without any real medication in the middle of Baffin Island.

<p style="text-align:center">* * * * * *</p>

POSTSCRIPT The kidney stone ordeal was just one of several we would face that trip.

A few nights after we were held up by my medical situation we — after another impossibly long day — contemplated a camping site at the base of another unnamed peak. It looked like a beautiful spot, lined by large boulders that would form a nice natural perimeter and wind block. It was so tempting, but by whatever grace of God we decided to press on another 500 metres to slightly higher ground. That night, sometime in the wee hours, we woke to thunder and damnation. It sounded as if a comet had struck the Earth. We woke with a start and scrambled over each other and in fear to unzip the tent door to figure out what the fuck was going on. A whole slab of the mountain had given way, coming crashing down with house-sized boulders all over the valley floor; massive clouds of dust and debris roared up into the sky. We looked in shock, horror and ultimately relief when we realized this had all happened...exactly where we had initially debated setting up for the night.

<p style="text-align:center">* * * * * *</p>

On one of our final days of the trek, we set up camp in an absolutely beautiful spot surround by three or four giant slabs of rocks overlooking the valley, and just in time. The afternoon had been really windy, with strong gusts pushing down the mountains and into the valley. We struggled to set up the tents but ultimately got them secured. After we ate,

we slid into our tents for the night...just before things really went haywire.

Within an hour, mayhem hit. The winds went from gusty, to really strong, to "hold on for dear life." Venturing outside our tents was impossible, and all we could do was hunker down and wait it out. Once again, I was tenting with Robbie, and our eyes widened several times that night as we literally felt the tent lift off the ground. It was one of the only times in my life I've ever been thankful for not being 30 pounds lighter. That night, sleep — in a recurring theme not only on this trip but in my life — was nearly impossible. Finally, late into the next day, it slowly died down. We later learned from residents of nearby Pangnirtung that the wind there was clocked at 182 km/h. For reference, a hurricane is defined as winds between 118 and 133 km/h.

* * * * * *

POSTSCRIPT #2 Fourteen days after Joavee dropped us off in rough sea swells, we watched on a perfectly calm day as his boat returned to pick us up. We turned around as he approached and took one last, long, hard look at this wonderful, scary, incredible, fucked-up park, giving each other hugs and high-fives.

Each of us said our silent goodbyes to this remarkable land, and one by one we got on the boat.

SKUNKED #2

Never take life seriously. Nobody
gets out alive anyway.

— SYDNEY J. HARRIS

MY FATHER, LOUIS GEORGE BROSHA, WAS A SKINNY farm kid from Heatherton, Nova Scotia, born in the late 1940s into a massive, Catholic, birth control-shunning family with 12 siblings, two old-school, hard-working parents, many dairy cattle and a childhood of more shenanigans and misadventures than I've ever been able to learn and properly keep up with.

Dad was, in short, a character. I come by misadventures naturally, to be certain. My mother, of course, would come to know this. In fairness, she should have known right from the very start of their life as a young couple. Her first introduction to him was via her friend, Sheila. Mom was a "proper townie" from nearby Antigonish, and Dad was a full-on, ill-mannered country bumpkin; he was the opposite of "proper." Still, Sheila thought they should meet and she decided one week to play matchmaker. On the fateful evening they met, Sheila went to the front door of my mother's house, knocked on the door and smiled excitedly when

my mother, Eleanor, answered the door. "El, how ARE you? I have someone to introduce you to!"

My mother just looked past her, confused.

Sheila looked at Mom's face and then turned around. Louis, who she thought was behind her...well, he *wasn't there*. "Ah, um...he was just here. Lou? LOUIE??"

My mother was the first to spot him. Her eyes scrunched up, not really comprehending what she was seeing. But, oh yes, dear God, she was seeing it exactly as it was: Dad was in her flower bed, pissing on her family's flowers.

"Oh, hi there!" he shouted to them...smiling. He was always smiling.

* * * * * *

I'm 7, maybe 8. Dad and I are driving the dusty back roads of Fort Vermilion, Alberta, looking for ruffed grouse to hunt. Sometime in the last year Dad has taught me the subtle art of shooting grouse with a .410 gun. It's one of the smallest of shotguns and it doesn't bruise my shoulder the way his "big" shotgun does. I appreciate that. I love my .410, but I love not having bruises on my shoulder even more.

Hunting ruffed grouse is easy, I find, because even when you line up a shot and miss (I missed a lot in the early days), the grouse often don't move. They just stand there, looking stunned, pondering why their head feathers shook on a non-windy day, and why thunder is loudly booming, even when the sky is blue. In the year that I've been hunting (*who lets a 7-year-old shoot a gun?*), I've progressed from blasting a bird in the middle of the body and filling it up with pellets to being able to aim with enough precision to make a headshot almost every time. It helps that I can basically walk up to within 10–15 metres of the grouse we find and they don't fly away. Grouse aren't the brightest

of birds. Anyway, we'll find the grouse on this drive — we always do.

* * * * * *

Dad needs to roll a cigarette.

Instead of pulling over, he just looks down as he drives and pulls out his pouch of tobacco and starts rolling the cigarette. I've been through this before; I slide across the endless seat (pre-seat belt laws) of our big green Oldsmobile and I grab the wheel and peer over the dashboard and steer down the dirt road. Dad doesn't look up once — he's busy — unless I tell him there's a turn coming.

"Hey Dad, you might want to slow down...turn coming up!"

He doesn't slow down. On these occasions I'd grip the wheel, terrified, as the car skidded around the corner, its back end always seemingly moments away from fishtailing and spiralling us out of control and into the forest or into Billy Lambert's wheat field. But it never happened, at least not while I was steering. He knew the precise speed to stick to that allowed him to successfully roll his cigarette. And he trusted me.

When he finishes rolling his cigarette, he takes back the wheel and I slide back to the passenger seat. As he goes to light it, however, he realizes he can't steer and light his cigarette at the same time. Solution? He passes me the cigarette and his matches and tells me to light it. "If it won't take, put it between your lips and suck in a little while lighting it... that should do the trick." I do, of course, and choke down a mouthful of putrid smoke. It's gross, but I'm happy: I've successfully lit the cigarette, and he's beaming. He continues barrelling down the road, smiling and smoking, and as he stares out his side window scanning the trees for grouse, we hear "thumpthumpTHUMP." He stops, we get out and see a dead grouse behind our car.

"I knew we'd find them! That's how it's done, boy..."
Success.

* * * * * *

It's 1988; I'm 11. I'm in the back of our 1979 Vanguard motorhome, a purchase Dad made a few years back that made him beyond happy. A portable home-on-wheels for his own misadventures. A hunting camp, cabin and rolling cottage all in one. The *thing* that would allow him to transport his family of six kids and his wife — my mom — all the way from northern Alberta to Nova Scotia every few years to spend his large, coveted, teacher's vacation "back home" in the Maritimes. Our cross-country trips were the stuff of legend: breakdowns in northern Ontario, that time we left Mom behind at a gas station in Saskatchewan and didn't realize it — even as she chased the motorhome down the highway — the time we picked up the two sheepish Hell's Angels who were hitchhiking after their rides broke down, and the time Dad drove through rush-hour Montreal traffic, once again steering with his knee — trying to roll a cigarette. We loved those cross-country trips, despite the sibling fights...and despite Dad's continuous country music playlist.

I'm in the back of the motorhome. It's dark outside and we're parked at a campground. I'm reading one of my *Dragonlance* books by means of a small reading light. The rest of my siblings are back home in Fort Vermilion. The Fort. That little, dusty, weird, beautiful community on the edge of the mighty Peace River. The place I was born, along with all my siblings.

It's late, but how late I'm not really sure. One of my friends (whom I met through one of Dad's good teacher friends) is here in the motorhome with me. I'm sitting down

in the bunk that by day is a table but has been folded down into a bed by night to accommodate me. My friend — we'll call him Peter — is up in the top bunk. He's also reading. Our reading lights are supplemented by flickering light streaming in through one of the windows. A campfire burns somewhere *out there*. We hear the murmur of endless stories and laughter.

Peter's father (whom we'll call Michael) is outside with my Dad. We have fished most of the day, as with the day before. Our fathers do this every year: an annual pilgrimage from northern Alberta across the border to the southern rivers of the Northwest Territories. They first drive to their farthest point on the journey and spend a day or two fishing on the shores of the massive Mackenzie River near Fort Providence, and then slowly make their way back home, fishing the smaller rivers and streams en route. Dad has been doing this trip for years — it's one of the highlights of his year. This is one of the first years he's taken me. I'm *finally* old enough. I am proud.

We've caught a decent amount of fish: whitefish and northern pike and pickerel — and our haul included a few monsters. Jackfish so big they'd be as tall as me when held up. Sweet holy hell, the mosquitoes. Small airplanes buzzing loudly, their spears deftly poised. The only relief for us kids is the motorhome: our books and Game Boys. Our fathers use firesmoke and an endless spray of Muskol and even more bountiful supply of rum to forget about the constant invasion. After making a few initial trips into the motorhome to mix their rum and cola, they finally wise up and simply take the bottles out to the fire with them.

Somewhere through the night, Peter and I crash out — my book open and resting on my chest as I dream of that perfect cast earlier in the day: the one where I felt a nibble and yanked *just hard enough* to snag the big jack, the biggest one I've ever caught. "It takes a lot of patience, my boy," Dad

would say again and again as my frustration mounted over fish after fish biting, laughing and swimming away to their freedom. But this time I *landed it*. I was proud. Dad was even more proud. I did it; *I deserve to be here*.

The door slams open with a crash. I jump up.

"Go...we have to GO!"

Dad and Mike. They both barrel into the camper by means of the side door — and one of them quickly locks it behind him. Mike has a 60-ounce bottle of rum in his hand and it's near empty. They both look panicked. Peter and I don't know what's going on, but both of them are scared. And yelling at each other. "Let's get OUT OF HERE!"

Dad jumps into the front seat of the Vanguard and fumbles with the key, which is still in the ignition. Mike is looking out the curtains and yells, "Lou...let's get OUT OF HERE!"

The ignition squeals for a few endless moments before the motorhome roars to life. Peter and I lock eyes. We're confused and terrified.

We lurch forward, and all the bottles, bowls of chips, plates and utensils that were on the counter go flying, rattling and crashing their way over the floor and spilling a sludge of fried fish, butter, onions, ketchup, salt-and-vinegar chips and cola everywhere. I fly across the bunk toward the wall and have to throw out my arms to protect my head. I'll be all right. Peter is holding on for dear life up in the top bunk.

We bump and bump and bump and bump our way through the campground; I catch air several times. At least we assume we're still in the campground; Peter and I are in the back, in our pyjamas and trying not to get thrown across the motorhome. With a final huge bump and a hard crash back down, the path smooths out. We've left the campground and are out on the gravel highway. The rolling home fishtails and stabilizes. Even as it speeds down the gravel road, everything becomes calmer.

"Holy shit, what a bunch of idiots!"

This isn't said by Peter or me, referring to our fathers, who are clearly "slightly" under the influence and driving with their sons down a lonely gravel road in the Northwest Territories in the middle of the night, neither of us wearing seat belts or having any real idea of what's going on. This is Michael, referring to two random strangers they shared drinks with around the fire. Dad would never ever utter anything harsher than "damn."

Now that they're seemingly "in the clear" from whatever perceived threat to all of our lives they've encountered (they never did share), they both start laughing and laughing and laughing as they continue on down the road. Finally, Dad spots something and slows the vehicle: a pullout into the woods. He slams on the breaks and Peter and I brace ourselves again. Once again, we're proud that we avoid serious injury. He swings onto the side road and pulls in far enough that we're tucked behind a cluster of trees and out of sight of the main road. He puts the motorhome into park and turns it off. "Well, boys, this will be home for the night..."

We shrug, dust the chip crumbs off our blankets and lie back down. Before we can fall back asleep — hearts still pounding — Dad looks back from the front seat as he pours a final rum and cola — a nightcap. "Please don't tell your mother about this, okay?"

* * * * * *

In 2013, I lost my Dad. He had been struggling with multiple sclerosis (MS) for many years, but his death came at a relatively young age, all things considered, and hit the entire family suddenly and unexpectedly. I got the call when I was living in Yellowknife, my home for the better part of a decade. My brother phoned in the middle of the night; I

was told that he was, as they say, "on the way out" and that I should get my ass home. I did.

I made it home, and just in time. About 12 hours after I landed, I knelt by his bedside in a Halifax hospital and squeezed his hand. Shortly thereafter he took his final breath. I got to say goodbye, which I'll be eternally grateful for. My older sister Audrey also passed suddenly the following year. In that case I wasn't so fortunate.

The few days following his passing were what one might expect: a lot of tears shed among my siblings, my mother and me — along with his many brothers and sisters and friends and former students and customers. Dad was a well-loved teacher for 25 years in northern Alberta before he and my mother took over a highway-side convenience store, and I don't think any of us (especially us "kids") quite realized how many people he had impacted. Mom, of course, knew better, and as the outpouring of love and tributes came in for him, our tears gradually turned to smiles. As the stories about him flowed (with a little help from a few trips to the local liquor store), the laughs started and didn't really stop. Dad — Louis George — "Louie" — we all knew, was a character through and through, and it's perhaps fitting that a man who loved nothing more than a good story and a good laugh with friends would find himself the subject of so many himself. And it was really rather perfect, then, that his own funeral would result in one of the best stories about him.

* * * * * *

Funeral day. Heatherton, Nova Scotia. A little town in the middle of the rural Nova Scotia countryside. The community where he grew up, where his own father and mother raised their massive clan of children. It's fitting that he is to also be buried here, close to his own parents. We're sitting

in church. Sadness. *It's what funerals are, aren't they?* All I knew is we felt so much pervasive sadness that day, such a heavy weight. It's not a cliché, "heavy weight" — it's the simple reality.

My mother, she's sitting a few people down from me in the front church pew in the small church. A few siblings separate her and me. The funeral, overall, is progressing "nicely." We're going through all the motions and everyone is sufficiently and genuinely sad. The priest says what he's supposed to say and the songs are nice and tragic and we're all just getting on with it. One part stoic, one part drained, two parts emotional mess.

As the priest continues leading the service, I see the funeral director slowly and quietly making his way up the aisle to my mother. I'm intrigued and a little confused as he whispers in her ear. I can tell she doesn't really grasp what he's saying to her. She scrunches up her face at him; she is asking him to repeat what he has just said to her, only more slowly and clearly.

He does. I see him lean in really close — his lips almost touch her ear. There's no way I can pay attention to what the priest is saying. *What the hell is going on?* Why is he interrupting right now, in this moment?

He finishes saying what he has to say. She processes. Time ticks on. And on. And on.

Then it happens.

She lets out a huge laugh. Like a massive, full-on, rip-roaring guffaw. Right in the middle of church. During a funeral. My own mother.

I'm a little shocked and dismayed. *Dear God, what has she done?* The entire church is looking at her — at us. This is no time or place for laughter. I sink down into my seat, trying to hide from all the stares. Hide from her laugh, which is still bouncing off the pew and the holy water and the communion wafers. The priest looks up, startled. *Concerned.* He scowls

— and then realizes that it's my mom and he relaxes. *She's going through a lot*, the look on his face says. *Damn right she's going through a lot*, I think. I'm kind of mad. At her, not him. And entirely confused. I can't help it. I glare toward her, my eyes screaming, "What is going on?" Only she doesn't see me: there's two sibling heads between her and me.

She whispers to one of my sisters, Tricia. Like a scene from *Groundhog Day* the cycle plays out again: Tricia scrunches up her brow, processing what she's just heard. She asks Mom to speak slowly and to repeat. Tricia starts laughing, loud. She's dying. At a funeral.

This plays out yet again. She leans in and whispers to my brother, Stephen, who is angrily looking at both of them. He also repeats the cycle and eventually starts loudly laughing. The entire bloody church is now staring at us. The Broshas. The family of stark raving lunatics. I'm still in the dark, but finally this little whisper procession reaches me. I glare at Stephen, and he leans into me and whispers. I blink...and then blink again, processing. I look back at him with my eyebrows raised. He leans in again and whispers more slowly. I can't believe what I'm hearing. I...laugh. Hard.

I learn that the burial, which is supposed to directly follow the service — has to be postponed per the funeral director. This, of course, isn't funny. It would actually be quite alarming, that little piece of news — dangling on its own. I had never heard of — at least around those parts of Nova Scotia — a burial being postponed. I've stood through burials in sideways rain. Sleet. Snow. Usually they're short affairs. A few words from a priest, a few prayers. A coffin being lowered. A handful of dirt thrown in or — in many Nova Scotia funerals — a sprinkle of rum or whiskey. Rain or shine, you suck it up. You have to pay your respects. It's what *you do*.

The small ripple of laughter has now turned into a wave, like the type you'd see at a sporting event. It has spread

through — and infected — the entire congregation. The church is laughing as one. Even the priest can't help it. Someone whispers in his ear and he also breaks out in a grin.

Through the night a skunk has somehow made its way down into the open grave. And, well, it's settled in there pretty good...daring one and all to try to move him. And, well, no one wanted to dare. At least in their good clothes. No, sir, we'd wait this one out. Eventually, the skunk would move on...in its own damn time.

Somewhere we all knew that my father — Pepé le Lou — was having the last laugh.

* * * * * *

POSTSCRIPT Miss ya, Dad.

EPILOGUE

The only journey is the one within.

—RAINER MARIA RILKE

LET ME TELL YOU ABOUT A PERSON. I'LL CALL her Audrey.

Audrey was a bit of a remarkable person, even from the youngest of ages. She was the type of person people paid attention to, that people liked. As a child, she not only showed great intellect — routinely finishing with the best grades in her class — but she was just one of those children who seemed to *love life*. She was involved, seemingly, in everything. Piano lessons. Volleyball. Public speaking. Girl Guides. Gymnastics. She could sing beautifully, loved the outdoors and was always directing her friends and her siblings through plays, baking, singalongs and an endless stream of make-believe. She had a vivid imagination and a wisdom that was far beyond her years: not only did she have the respect of her own peers, she could speak to — and command the attention of — adults. She was a natural leader. When she spoke, people listened.

As she progressed through school, she got invited places and to do things — based on her drive, know-how and spirit — that others often didn't get invited to. Youth parliament. Yearbook editor. Class valedictorian. She was the most sought-after babysitter in town. Later in life she would

become a residence director at university. Of course, she was a black belt in taekwondo. She would marry her college sweetheart, Melvin, an equally remarkable guy who shared her exact birthday. She would work for a major political figure in Canada, and she would also own a business or two.

She, too, had many adventures. And, of course, she had the accompanying misadventures. Some of these misadventures were absurd, some humorous and some terrible and tragic. One night, while she was babysitting, a husband and wife were supposed to head out to a dance. They didn't. As Audrey sat on the shag carpet of their living room, playing with the couple's children, the couple fought. The husband drank, and then drank some more. He got belligerent, yelled at all of them and drank some more. Audrey was at first nervous, and then scared. The man had always been nice before, even kind. She had always liked babysitting for them. When it became clear to the wife that they were not to be going anywhere that evening, she made the decision to drive Audrey home. Thankfully, for Audrey, and Audrey's relieved family at home. Not for the wife, however, or her children. When she returned, her husband locked the door behind her and took his entire family hostage. She managed to call the police at some point. When the RCMP arrived, he started shooting his rifle at the police. A standoff went on all night. In the quiet hours of the morning, he released his terrified family. He then took his own life.

This was one awful experience for Audrey, but for her, there was always a beautiful experience to counteract the bad. Well, almost always. She was always dancing and cartwheeling and bouncing her way through life — her impossible mop of long, curly hair often announcing her presence before her smiling face followed. While she was on her journey to becoming a taekwondo black belt, Melvin started and built one of the biggest schools for taekwondo in the area. He, too, was a black belt, and was a former

national-level champion. He was full of life, wit, mischief and kindness. He was her perfect match. Together they ran the school, and they became mentors and great friends to their many students. Their students loved them very much; both Audrey and Melvin had a huge impact on the people around them. They were best friends themselves.

Melvin was also a pilot. One day while working a flight contract, the small plane he was flying clipped some trees. The plane crashed. Melvin didn't survive — he tragically lost his life in the accident. This happened on, of all days, Valentine's Day. Audrey wasn't just heartbroken, she was shattered. Everyone around her was naturally heartbroken too — his own family, his friends, their students and the entire community. Melvin had made an incredible impact on the world; he was also one of those people everyone loved and felt was a joy to be around.

Heartbreak hits everyone differently; everyone faces the reality of loss in their own way. In time, Audrey succumbed to the weight of the world around her; the weight of her own heart became too much. Her journey over the next number of years could fill the pages of an entire book; maybe someday that story will be told. In the end, Audrey found that carrying on as if life was normal was impossible for her. In fact, life became too difficult at times, and she struggled in many ways. Her body eventually failed her — even if her spirit wanted to carry on. One of her brothers found her on a cold December day, about ten days before Christmas, a time normally spent celebrating friends and family and all that is good in the world. He found her, and called his mother with the news. She was gone. She left this world as we know it to be with her husband again.

When the end came, it came with all the usual peculiarities and formalities of someone passing: a funeral with many tears. A recounting, among friends and family, of tales spanning the wonderful, wacky, hilarious and heartbreaking of

her too-short existence. A cremation happened. An obituary appeared in the newspaper. A headstone was carved. After it was all said and done, all her family and friends were left with were memories...and stories.

The obituary that ran was short but sweet; it was heartfelt and captured the usual details of one's life. When and where she was born, who she was related to, who passed on before her and what the details of the funeral would be. The obituary that ran was 331 words total, and that *included* the web address of the funeral home.

Audrey was 39 years old when she passed — only 39 years old when her life ended and was reduced to 331 neat, concise words. A life lived — full of adventures, misadventures, laughs, tears, accomplishments, love, heartbreak, travels and experiences — but a life lost, in some ways, because those larger experiences were hardly referred to in the 331 words. They barely got a mention. All that she truly was — and she was wonderful and terrible and beautiful and ugly and strong and weak — just like us *all* — wasn't shared in that final obituary. That's not what we as society are accustomed to doing.

We conveniently scrunch up a life when it ends, tucked between the bookends of a born: 1975 / died: 2014, and then neatly file that life away. Not everyone is guilty of this, of course: there are many people, to be certain, who keep the memory of a person's life alive. Keep the light burning bright, so to speak. Audrey's mother does, for instance. She's never stopped and never will.

On the whole? Lives are not properly captured and celebrated and stories often forgotten. As one gets older, the deaths of family and friends and colleagues inevitably stack up; it becomes harder to remember all the details. It becomes harder to keep it all clear. This doesn't reflect a lack of love but only the limitations of the human brain. Family trees over time become a very short, static reckoning of names on

a sheet of paper with a few pertinent details like date of birth, date of death, date someone is married and where they might live. As years pass, as those closest to a person who perishes *themselves* exit the land of the living, the shared memories fade and the tales disappear.

Audrey's vibrant life in many ways was reduced to a 331-word obituary. The writer of her obituary wasn't trying to be callous or take shortcuts. He knew she had lived many great moments, and had a whole, beautiful series of misadventures. She filled some rooms with song, and other rooms with boundless energy. She made some people smile and other people mad. The writer was simply doing what was expected at the time — an expectation that was derived from tradition and society. If someone passes, an obituary must be published. *People need to know the facts. The pertinents.*

The man who wrote the obituary would have written more if it was expected — but it wasn't. It was considered "perfect" at the time. Exactly what was needed.

The reason I know this is because the man is *me*. I wrote Audrey's obituary, and she was my sister.

* * * * * *

A life is made of experiences, and these experiences often become stories.

You've just read a few of my experiences — my stories. So many stories — and oh, gosh, I have so many more. I never did get to the part where I almost hurled on a famous NHL legend during a photo shoot, or to the part where I found myself going delirious with endless insomnia in the high Himalaya of Bhutan. I didn't get to the terrifying Drake Passage storm, or to the time I was sweating bullets in a high-stakes interrogation by a frightening US immigration official at a hotel in the middle of the night. There was also

the time my snowmobile broke down in the middle of the Arctic, which resulted in a huge, harrowing hike for miles right after someone warned about polar bears in the area, and the time we made a midnight run through a forest fire to escape a city cut off from the rest of the world. I guess I could have also written about the times I experienced bad frostbite, hernias, spinal fusions, a vacuum falling on my head and splitting it open, and almost choking to death — only to be saved, quite literally, by an onlooker.

Many of my stories and experiences — my misadventures — have not yet been written. Many of my misadventures, time and health willing, have *yet to happen*. I know I will experience more, and I genuinely hope I take the time someday to capture and recount them. I don't need to document them for "look at me" reasons, or to try to sell copies of some future book. Truthfully, I don't care if I sell one copy of this book (although my publisher might disagree). Rather, I hope to write them down, to capture them, because I know from my own experience in losing friends, classmates, my father and my sister, that so many of their stories and their spirit left when they did. My father's own numerous stories often bounced off me as a young man; now, I wish I was made of superglue. I wish each and every one of his stories — even the cheesy — had stuck to me so that I may recount them to others. I can recount some, sure — but I've forgotten way more than I remember. I only wish that someone had thought to capture them, to record them or to write them down. What a precious gift to his friends, his children and his grandchildren. I don't want to repeat that cycle. I have the capacity to write: I'm going to use it for as long as I can.

I want to continue recording some of the chapters of my own experience — some of the highlights. They are the only experience I truly know. My *own*. Why? In the hopes that it might serve as a form of record for my children, to give them their own permission to experience and share countless

adventures and misadventures, and hopefully inspire others to do the same. You may not think you have a story to tell — but let me assure you, *you do.*

A lot happens in a life lived, and when a person really sits down to think about the multitude of experiences and all the memories of the hardships, the weird and the wacky — it's truly *remarkable* what emerges. At the start of this little journey, I shared that I don't think *I* personally am particularly remarkable, or that my own experience is any more remarkable than anyone else's. I've always thought that I'm *not* and it *isn't.*

That's not true, though. I *am* remarkable. I see that now. But you are too. We all are.

We *all* have chapters of different shapes, sizes and moods, and maybe, just maybe, if we would all take the time to think back and recount some of these chapters, we would all realize that *all* of our lives are interesting. Beautiful, even. When you add it all up — the moments of joy, sadness, struggle, toil, the mundane and the exhilarating and yes, of course, the adventures and the misadventures — an exquisite picture emerges. A picture that is intriguing, intoxicating and memorable. Everyone's life tale is beautiful; everyone's life is an album of photographs with anecdotes written tenderly on the back. So share your own anecdotes, and curate the anecdotes of those who are important to you. Whether it's words on a page, video recordings or memories and experiences shared around the crackling campfire — share the tales that are sometimes heartbreaking, sometimes hilarious and sometimes a little tall. Share what went wrong and all that went right. Share the adventures, and share the misadventures.

These lives we live — they're all we got. Let's celebrate them.

Celebrate yours.

DAVE BROSHA has had exhibitions of his work in the Northwest Territories and elsewhere in Canada as well as in the United States, the United Kingdom, Spain, and Germany. His images have appeared in *Photo Life*, *Practical Photography*, *Canadian Geographic*, *Maclean's*, *The Independent* (UK), *The Globe and Mail*, *The Sunday Telegraph*, *China News*, *The Guardian*, *Tehran Times*, *Montreal Gazette*, *Outdoor Photographer* and many more. He and his family live in St. Ann, Prince Edward Island.

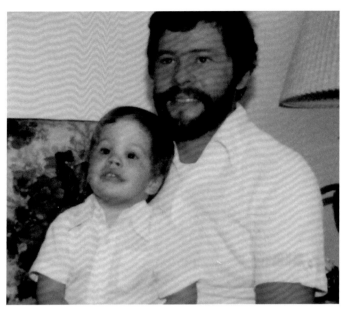

TOP Dave and his father, Louis. Fort Vermilion, Alberta, 1980.

BOTTOM Dave in kindergarten. Fort Vermilion, Alberta, 1982.

TOP Dave, Northern Alberta. 1982.

BOTTOM The Poor Little Boy with the Broken Leg.
Lower South River, Nova Scotia. 1994.

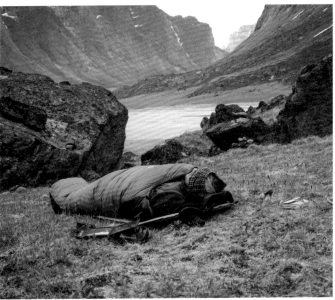

TOP Dave sporting a shiner. Antigonish, Nova Scotia, 1995.

BOTTOM Dave, sleeping off a kidney stone.
Auyuittuq National Park, 2013.

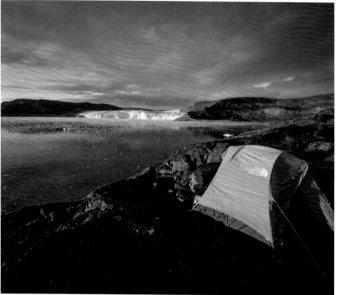

TOP Dave, walking on water. Canoe Cove, Prince Edward Island, 2018.

BOTTOM Stephen DesRoches, waiting to hear word from Paul Zizka. Eqi, Greenland. 2016.

OPPOSITE, TOP Dave, photographing the local Scottish wildlife. Scottish Highlands, 2018.

OPPOSITE, BOTTOM Dave, Antarctic Security aka SEAL Forces. Antarctica Peninsula, 2019.

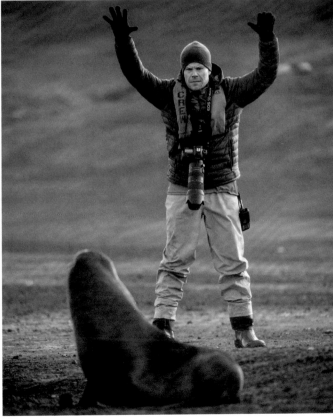

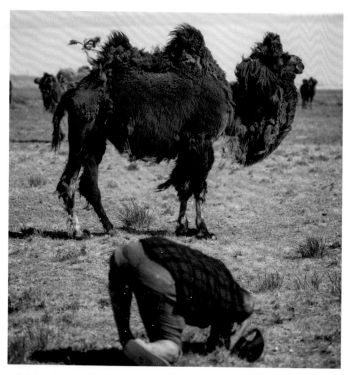

TOP Dave, exploring the Mongolian underbelly. 2019.

BOTTOM Tom Smitheringale, setting off down the Nile. Egypt, 2011.

TOP Dave, hours before his Namibian dune ordeal.
Big Daddy, Namibia, 2018.

BOTTOM Exploring the canyons of Resolute Bay. Nunavut, 2003.

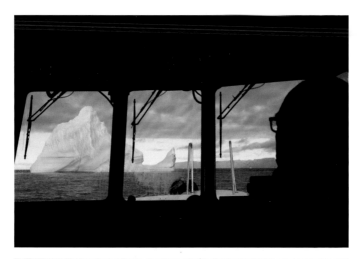

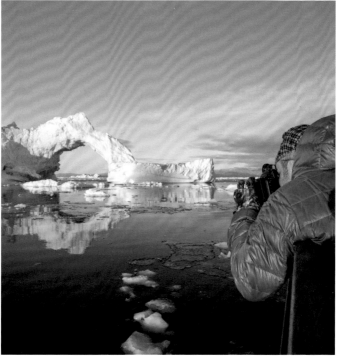

TOP On the Disko Island ferry. Greenland, 2016.

BOTTOM Exploring the Ilulissat Icefjord. Greenland, 2016.